IMAGES
of America

RICHMOND HILL

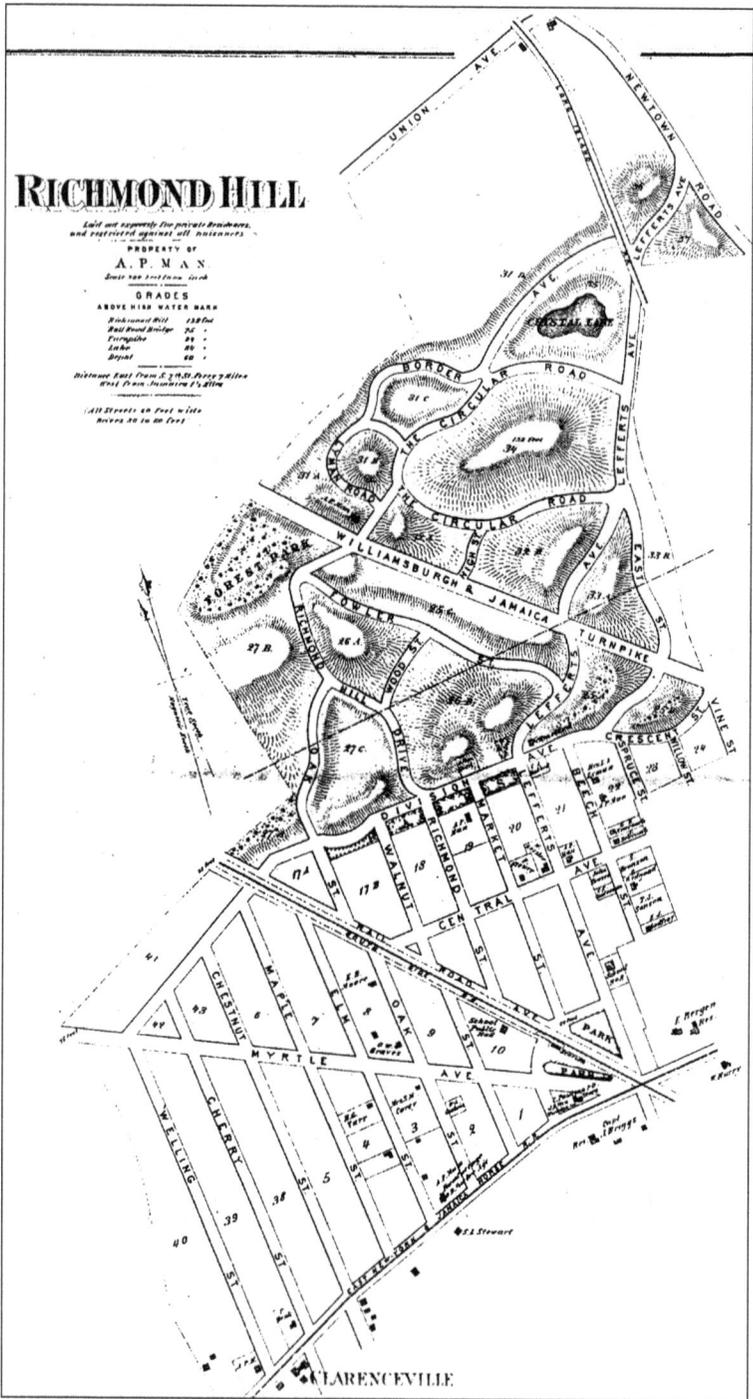

AN 1873 RICHMOND HILL MAP. The earliest map of Richmond Hill is dated 1873. The town was conceived when Albon Platt Man and Edward Richmond purchased the Lefferts farm on June 29, 1868. The earlier village of Clarenceville, seen at the bottom left-hand corner, was established in January 1853. The village of Morris Park was developed by William Zielger in 1885 and was located below Richmond Hill. All of these towns have since become one.

IMAGES
of America

RICHMOND HILL

Carl Ballenas and Nancy Cataldi
with the Richmond Hill Historical Society

ARCADIA
PUBLISHING

Published by Arcadia Publishing
Charleston, South Carolina

Library of Congress Catalog Card Number: 2002102376

For all general information contact Arcadia Publishing at:
Telephone 843-853-2070
Fax 843-853-0044
E-mail sales@arcadiapublishing.com
For customer service and orders:
Toll-Free 1-888-313-2665

Visit us on the Internet at www.arcadiapublishing.com

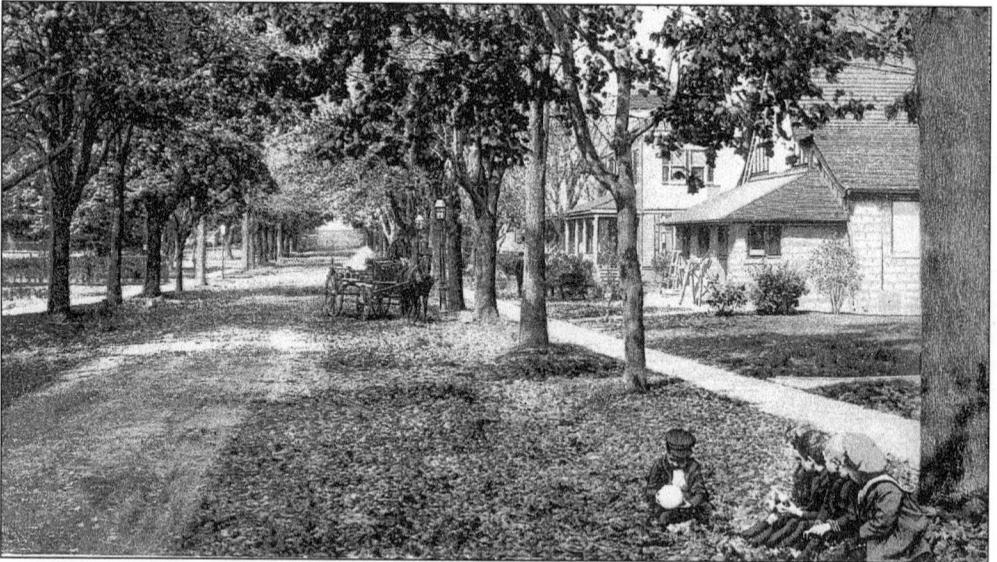

RICHMOND HILL. Children play on Church (118th) Street near the Church of the Resurrection in 1904. (Courtesy the Lucy Ballenas Collection.)

CONTENTS

ACKNOWLEDGMENTS

In creating this book, we have sought to reawaken the past and pay tribute to the struggles, dreams, and hopes of those who came before us. Along the way, we have encountered individuals and institutions that have offered their invaluable services to our endeavors. The authors wish to thank especially the members of the Richmond Hill Historical Society, including Diane Freel, Rita and Julius Gambardella, Ron Layer, Ellen Leone, Ivan Mrakovcic (text of chapter 8), and Rita Werner. We also wish to thank Philippe Angelino; Dr. Carlos Ballenas Laos; Dr. Edgar Ballenas and family—Vanessa, Ryan, Jason, and Margo; Dr. Nancy Baxter and family—Douglas, Robert, and Catherine; Wallace Dailey of Harvard University; Joseph DeMay Jr.; Anna L. Eckert of St. Benedict Joseph Labre Church; the Forest Park Trust; Councilman Dennis Gallagher; Alfred Grebe; Helen A. Harrison; Margarita Haugaard; William E. Haugaard; Frederick E. Hueppe; Ivan and Tamm Idrobo; the faculty and students of Immaculate Conception and St. Catherine of Sienna Schools; Lucy Man Jinishian; William Krooss; the Long Island Democrat; Albon Platt Man IV; Ann Mancaruso; Sister Manuella; George "Dave" Meier; Karen Margrethe Melbye of Ribe Archive; Lester Mike and Bill Lee Studios; Steven Palo; Robert Parylak; Patrick Polisciano; Queens Borough Public Library (QBPL), Long Island Room (LID); the Richmond Hill Post Office; Mehrdad Sadigh of Sadigh Gallery; Ann Sarcka; John Sommese and William Simonson; Robert Wooldridge; the Woolley family; and Bonnie Yochelson.

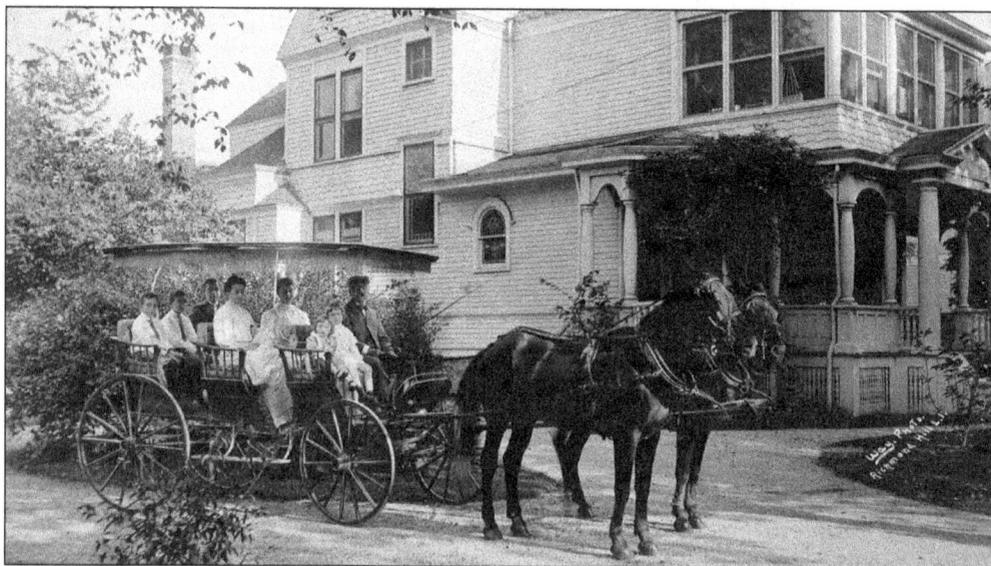

THE QUORTRUP FAMILY. "August Quortrup's new house on Beech Street, between Hillside and Central, is now complete and any who wish to see it are invited to do so at any time. The house is magnificently furnished, and some novel electrical effects have been installed." —*Richmond Hill Record*, 1909. (Courtesy Helen A. Harrison, Quortrup Family Archives.)

INTRODUCTION

The elevated backbone of Long Island stretches from east to west and was formed during the last ice age more than 10,000 years ago. Tucked into its side, in New York City's bustling borough of Queens, arose the community of Richmond Hill. In 1868, it began its existence on farmland already rich in history—land made sacred by the struggle for freedom during the Revolutionary War. Albon Platt Man, a New York lawyer, and his associate, Edward Richmond, heard of the laying of a new railroad line from Williamsburg in Brooklyn to the old and noted village of Jamaica. With keen foresight, they acquired a farm owned by the Lefferts family and a large part of the Welling farm alongside the new railroad. The land had been purchased by the two families from Native American inhabitants to initiate a new idea: a planned community with all the conveniences of a modern city of that era. The land was located in the western section of Jamaica near the community of Clarenceville, a farming village founded in 1853 and named after Clarence Miliken, the teenage son of one of the original settlers.

By 1870, Man and Richmond had transformed the former 250 acres of farmland into lots suitable for private residences. The Richmond Hill passenger depot had been built, and a new community entered history. The new village consisted of well-built, cottage-style dwellings and convenient wells, cisterns, and macadamized sidewalks. Some 4,000 shade and ornamental trees were planted, and various streets, avenues, and drives were laid out around the most desirable portions of the property. The land was described in an 1870 advertisement as "perfectly healthy." The dwellers had full benefit of the ocean breezes, cooler in summer and milder in winter. All the upland was on a gentle ridge, with a southern slope affording beautiful sites that overlooked the ocean and brought into view every vessel entering or leaving New York Harbor. Their intention was to make the place attractive to families who sought comfortable homes near the city, to provide all reasonable conveniences, and keep the property free from every kind of nuisances. Once the village was erected and ready for habitation, Man procured the assistance of Oliver Fowler as land agent.

The heart of the village is at the junction of Myrtle, Jamaica, and Lefferts Avenues. This was a well-traveled corner near the train depot and small grocery store–post office (later to become the Triangle Hofbrau). In 1872, a wooden schoolhouse was one of the first public buildings erected. In 1875, 70 wooded acres north of the village that had been widely used for possum hunting were purchased for the creation of Maple Grove Cemetery.

Richmond Hill's earliest religious community was a mission church of Grace Episcopal in Jamaica. Services took place in the train depot in the summer of 1869. From this humble beginning, the Church of the Resurrection soon erected a wooden church in 1874 on land donated by Man. Still standing today, it has been surrounded by a handsome facade of fieldstone. In 1900, Gov. Theodore Roosevelt attended a wedding at the church. He witnessed the marriage of the daughter of his close friend Jacob Riis, one of Richmond Hill's most famous residents. Roosevelt became vice president and, later, president of the United States. Riis became his personal advisor and America's first photojournalist. The population of Richmond Hill continued to grow, and business flourished.

Households depended on wells for water, which in a drought usually dried out. In 1880, a well was constructed on the Man property and a reservoir built for the purpose of supplying the

residents with pure drinking water. At the depth of 38 feet, a vein was struck, and the water came up so rapidly that the workers had to make a hasty retreat.

A milestone was reached in 1883 with the opening of the Brooklyn Bridge. The residents ascended to the grounds north of the village and were able to view the illuminations and fireworks at the opening ceremonies, the rockets and colored lights distinctly visible.

Local newspapers acknowledged Richmond Hill's attractiveness. They wrote that the town was laid out with parks and grassy lawns, with tasteful cottages dotting the area, stretching up to the hill, making a pretty picture. The church and public school gave the town dignity, predicting that as the village grew it would prosper and become a beautiful suburb.

Houses—both cottages and large, magnificent residences—were built, bought, and rented with a rapidity never dreamed of in previous years. The talents of brothers and renowned architects Henry and William Haugaard (who by the beginning of the 20th century had designed more than 1,000 homes in the Victorian style) were widely used. The homes they designed featured elegant piazzas (porches), stained-glass windows, servant's quarters, libraries, music rooms, extraordinary woodwork, and formal gardens.

One could take a pleasant drive to Brooklyn by way of Myrtle Avenue in those days and meet nothing more formidable than a market wagon. By the end of the 1800s, trolley cars were found in abundance on the main roads.

In 1894, the three separate hamlets—Richmond Hill, Morris Park, and Clarenceville— consolidated as the Village of Richmond Hill. Alrick H. Man, the son of Albon Platt Man, became the first village president. Village life came to an abrupt end when in January 1898 Richmond Hill was swept into the whirlpool of Greater New York City.

A sense of community formed, and different civic organizations developed. One of the earliest was the Twentieth Century Club. It was intended as a war-relief organization for the Spanish-American War and became a club to aid the basic needs for Richmond Hill, such as starting the first library.

The history of Richmond Hill continues on, and a new renaissance is taking place. The authors' goal is to make the readers aware of the rich history and the contributions of those who prepared the groundwork for the present and future generations. The Richmond Hill Historical Society is preserving our heritage by creating a Historic District and is awakening interest with walking tours, lectures, restoration fairs, and the establishment of an archive of treasured mementos from the past.

One

EARLY VILLAGE LIFE

The eye takes in at once the beauties of that portion of Richmond Hill lying nearest the road. This includes a number of commodious dwellings and many neat cottages, with the handsome church, schoolhouse and depot; but not half of the beauty of the place can be seen without visiting the hills which overlook all that part of the island and the ocean itself.

—Long Island and Where to Go, 1877

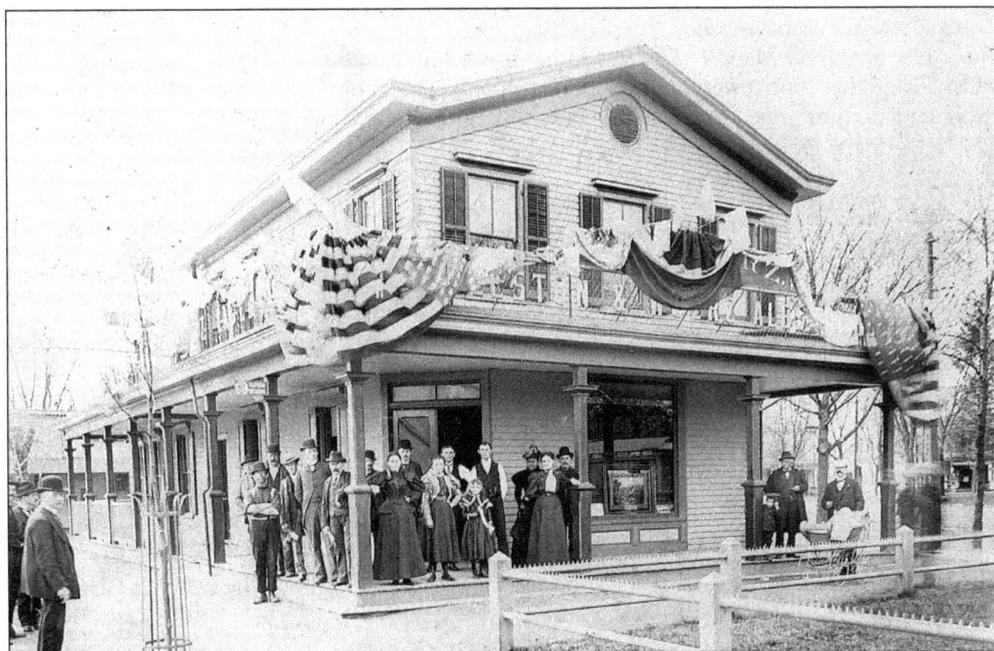

THE TRIANGLE HOFBRAU. In 1868, Charles Paulson purchased a triangular plot of land from the Bergen farm. He then erected a building and rented it to Jacob Van Wicklen, who opened a grocery store and the first post office. In 1886, John A. Smith, who opened a hotel on the site catering to farmers, purchased the building. In 1893, John Kerz purchased it, calling it Kerz's Hotel. With the popularity of bicycling, he changed the name to Wheelman's Restaurant. In 1898, the restaurant, hotel, and saloon were sold to William H. Mullins, who called it the William H. Mullins Hotel. In 1902, it was sold to William "Doc" Doyle, who renamed it Doyle's Triangle Hotel. Paul Gesche replaced Doyle in 1907, and it became known as Gesche's Triangle Hotel. In 1911, it became Waldeier's Triangle Hotel, and the restaurant was called the Triangle Hofbrau Haus. In 1920, Anton Waldeier rented it to his chef Emile Four and his brother Marcel, and it became the Four Brothers. (Courtesy the Lucy Ballenas Collection.)

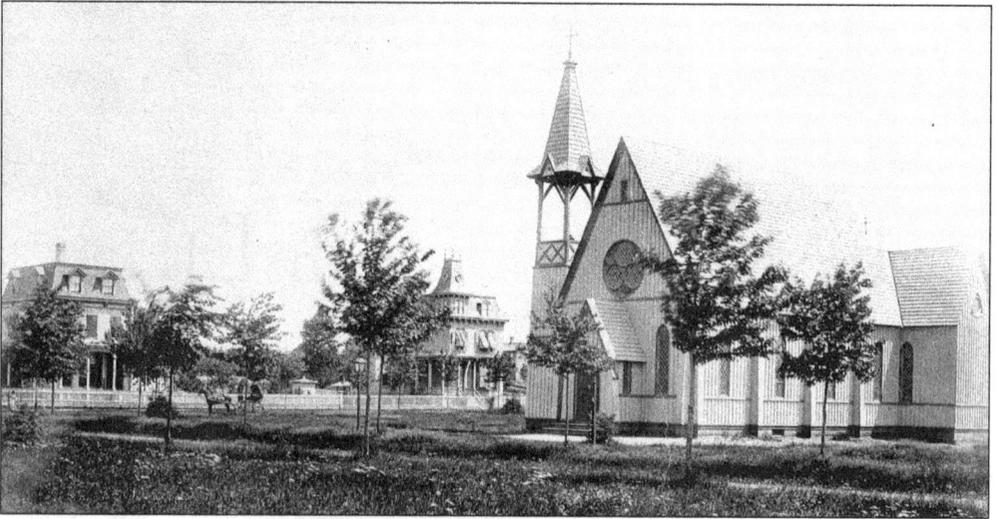

THE CHURCH OF THE RESURRECTION, EPISCOPAL. This was the first church established in Richmond Hill. It began in 1869 as a mission of Grace Church in Jamaica at the depot. Soon, a chapel was set up over a shop. In 1874, Rev. Joshua Kimber took charge. With the donation of six lots by Albon Man, a wooden Gothic-style church was built. In 1897, the church was widened and the stone tower built. In 1904, a second cornerstone was laid when the old wooden structure was transformed into a stone church. (Courtesy the Church of the Resurrection.)

AN ENGRAVING OF THE OLD PUBLIC SCHOOL. "Built in 1872 with a 'very complete' interior, besides the Main School Room there are Class Rooms, Hat and Cloak Rooms. It was opened on September 16th under the care of Miss Ella G. Gale." —*Illustrated Advertiser,* 1873. Many social functions were held here, according to an 1874 article in the *Long Island Democrat:* "The entertainment was a success. The upper part of the Public School building fitted up for this affair was well arranged. The program was long, but not tedious. Richmond Hill is a great place for pretty girls. Girls outside of the place say there are lots of nice young men there. What more shall we say?" (Courtesy the Lucy Ballenas Collection.)

ALBON PLATT MAN. Man is known as the founding father of Richmond Hill. "It seems that grandfather Man, when driving in his buggy from Wall Street to his summer home, would pause to enjoy the sunny slope, which dropped gently southward from the 'backbone' of the island. Its well-kept farms and woodland were perfect for a rural community where city workers could escape from turmoil, and enjoy peaceful homes." —Elizabeth Man Sarcka, 1976. (Courtesy Lucy Man Jinishian.)

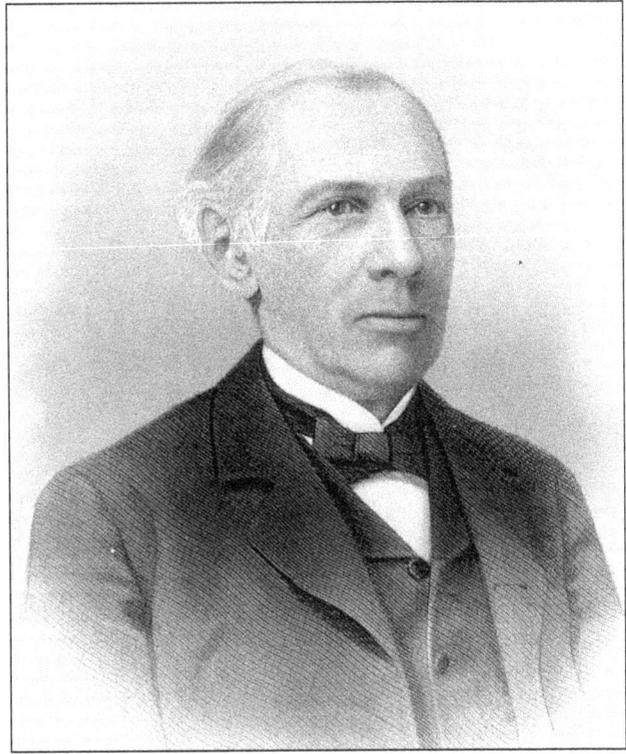

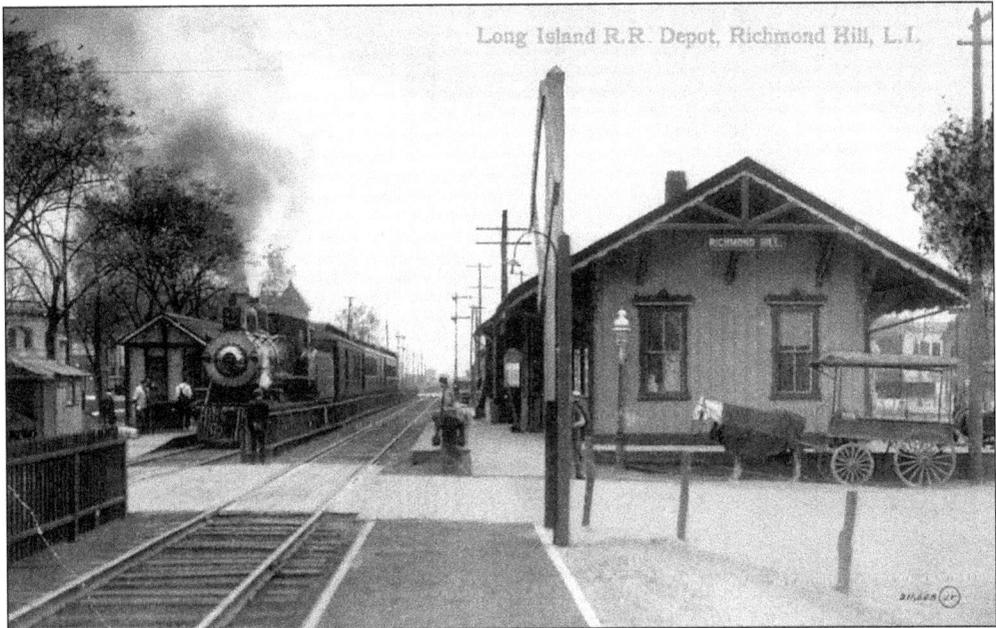

THE RICHMOND HILL DEPOT. "The Village of Jamaica is to build a new Train Depot. It is to be an exact copy of the Richmond Hill Depot. The building is to be 22 x 48 feet, 14 feet high inside, with two rooms, ticket office, ladies room fitted up in a neat and tasty manner, with Brussels or ingrain carpet, cane seat settees, mirror, washstands, and the necessary articles for toilet use." —*Long Island Democrat*, 1871. (Courtesy Nancy Cataldi.)

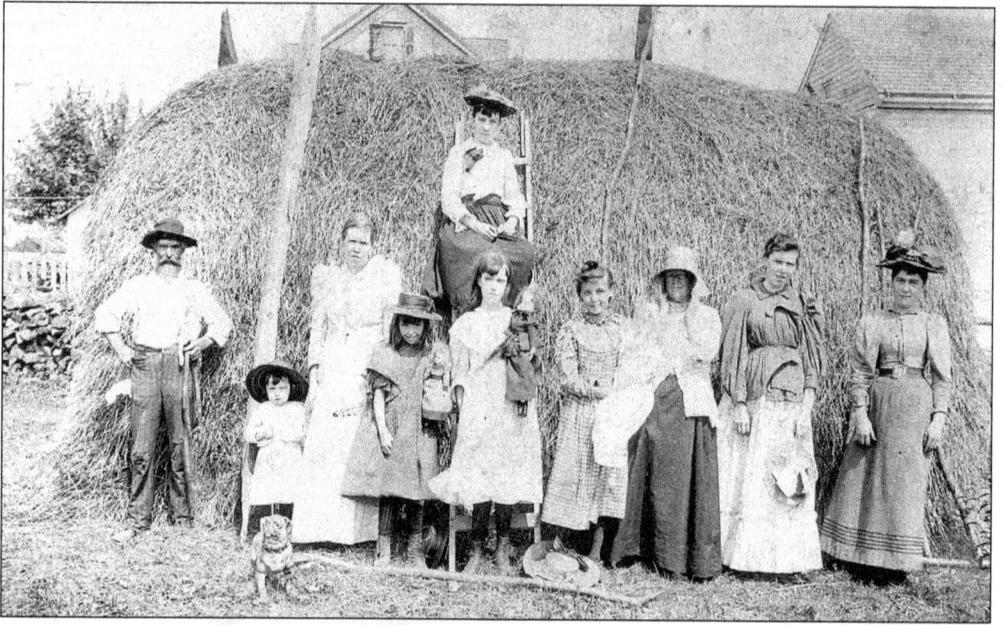

THE DEEHAN FAMILY AT THEIR FARM. The Deehan family poses in 1894 in front of a large haystack on their farm at 111th Street just south of Atlantic Avenue. Timothy Deehan lived in Richmond Hill for 56 years. His son James became a well-known civil engineer and surveyor in Queens. (Courtesy the Lucy Ballenas Collection.)

THE FARMHOUSE OF MARTIN G. JOHNSON. Johnson Avenue (118th Street), which ran from Jamaica to Liberty Avenues, was named for the Johnson family. Their farm was situated on Liberty Avenue from 116th to 124th Streets. John Johnson bought his farm on October 5, 1744, beginning a long line of family members who lived on it. Martin G. Johnson was born in 1816 and lived here until his death in 1887. Martin was a surveyor and surveyed many farms in the western part of Queens. (Courtesy QBPL, LID, the Richmond Hill Collection.)

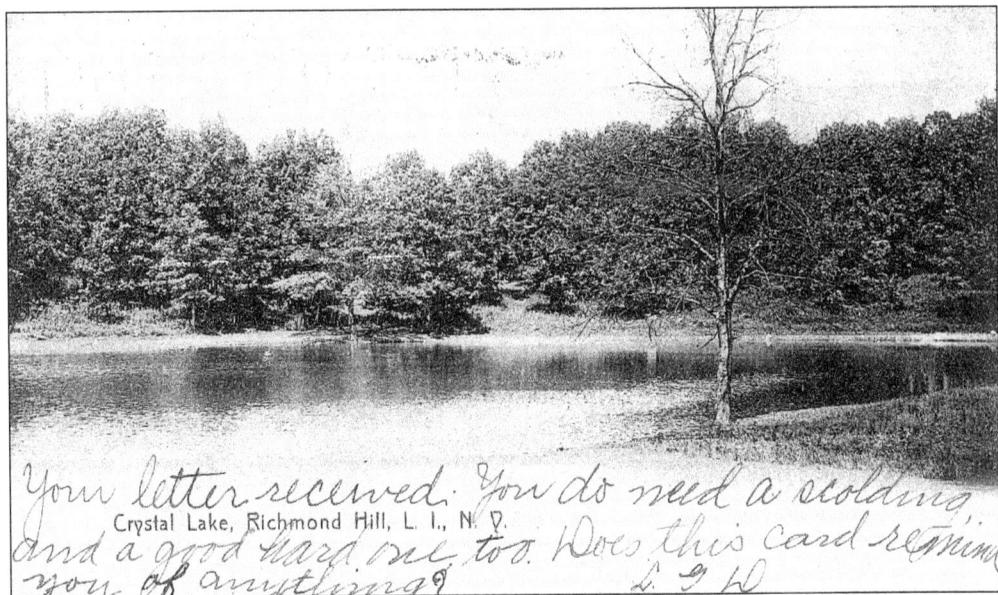

Crystal Lake, Richmond Hill, L. I., N. Y.

A CRYSTAL LAKE POSTCARD. A 1908 article entitled "Clad as Nymphs—Brooklyn Girls Go Swimming in Crystal Lake" told the story of 10 girls who, while lunching at Crystal Lake, decided to go for a swim in spite of the obvious handicap of not having bathing suits. "The bathers attracted the attention of a photographer who crept up to the edge of the lake, and his camera was in focus. 'Girls! Girls! A photographer!' screamed one of the bathers, just as the camera snapped. He took to his heels, but it was too late. He and his light summer suit were plastered with mud. It was not all sunburn that suffused the girl's faces as they hurried to the trolley car and sped away from Richmond Hill." (Courtesy the Lucy Ballenas Collection.)

CRYSTAL LAKE. Residents would often ice-skate, picnic, boat, or fish on the glacial pond west of Lefferts between Austin and Grenfell Streets. In the mid-1890s, the lake was used as a hazard in a golf course. In 1909, it was filled in. It later became the site of the Kew Gardens Rail Road Station, and the golf course became the community of Kew Gardens. (Courtesy the Man family.)

13

THE CAPT. JEREMIAH BRIGGS FARMHOUSE, 1922. Capt. Jeremiah Briggs was born in 1792 and went to sea at an early age. After the War of 1812, during which he fought on a gunboat, he sailed ships all over the world. Later, he founded the Briggs Swift Shore Line of packets, hauling freight between New York and Philadelphia. In 1830, he married Jane Hedges, and in 1847 the couple moved to what would become Richmond Hill, where he bought a farm covered with orchards. Briggs's house faced Jamaica Avenue between Lefferts Avenue and 117th Street. Briggs was known to spend many hours on the widow's walk with a spyglass, watching the ships on Jamaica Bay. The captain died in 1876, and Jane followed in 1899. The house was moved in the early 1900s and stands on 117th Street, previously known as Briggs Avenue. (Courtesy QBPL, LID, the Eugene Armbruster Collection.)

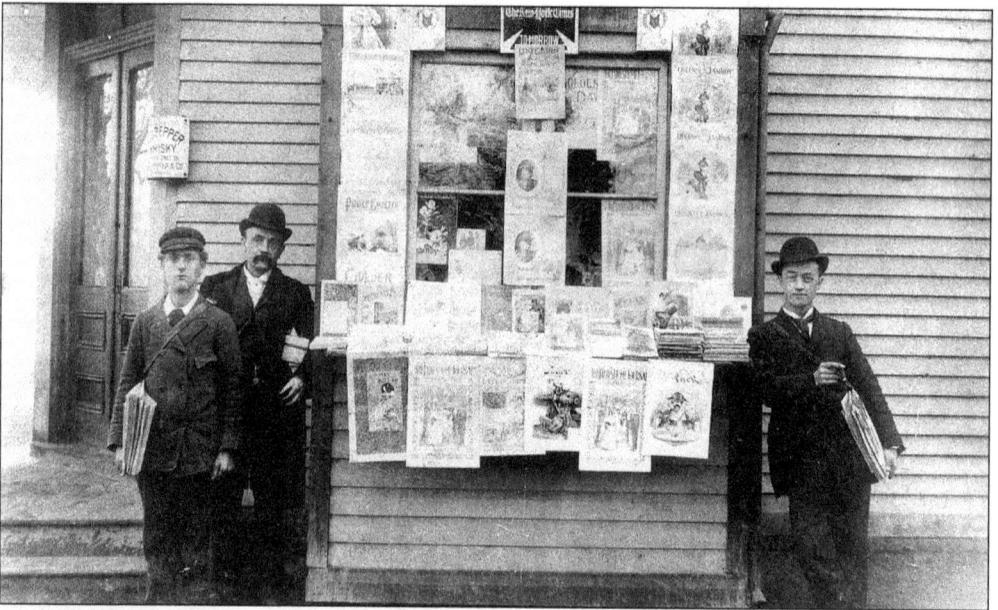

A NEWSPAPER STAND. This newspaper stand faced Myrtle Avenue in front of the Triangle Hofbrau. Lawrence Bangert was the first newspaper dealer. In 1894, with $1.38, he embarked upon the business of supplying the residents with newspapers. His first stand was an old kitchen table on Myrtle and Jamaica Avenues. By 1900, he had rented a building nearby. In 1919, he owned a three-story brick business and apartment building, employing five boys and an automobile to deliver the papers. (Courtesy the Lucy Ballenas Collection.)

14

MARIA ARMBRUSTER AND DAUGHTERS, C. 1866. Maria Armbruster (née Ries) and her first husband, Adam Lippert, had two daughters: Katie in 1857 and Rosa in 1861. After the death of her husband, Maria married Charles Armbruster in the 1870s. Together they opened the Richmond Hill Hotel in 1871. A hotel for boarders, it was also used for political meetings and balls. Charles died in 1880. Katie, age 29, died in 1886 of consumption. Her sister Rosa married Ernest Weiden and continued to run the hotel with her husband. (Courtesy Frederick E. Hueppe.)

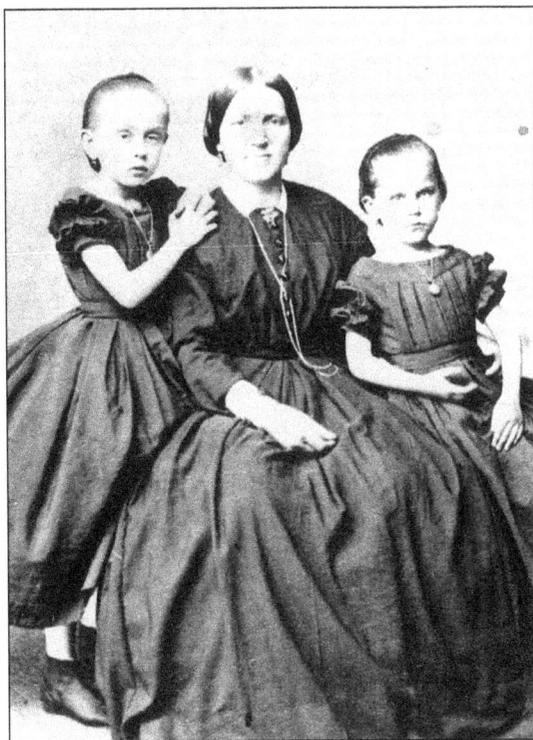

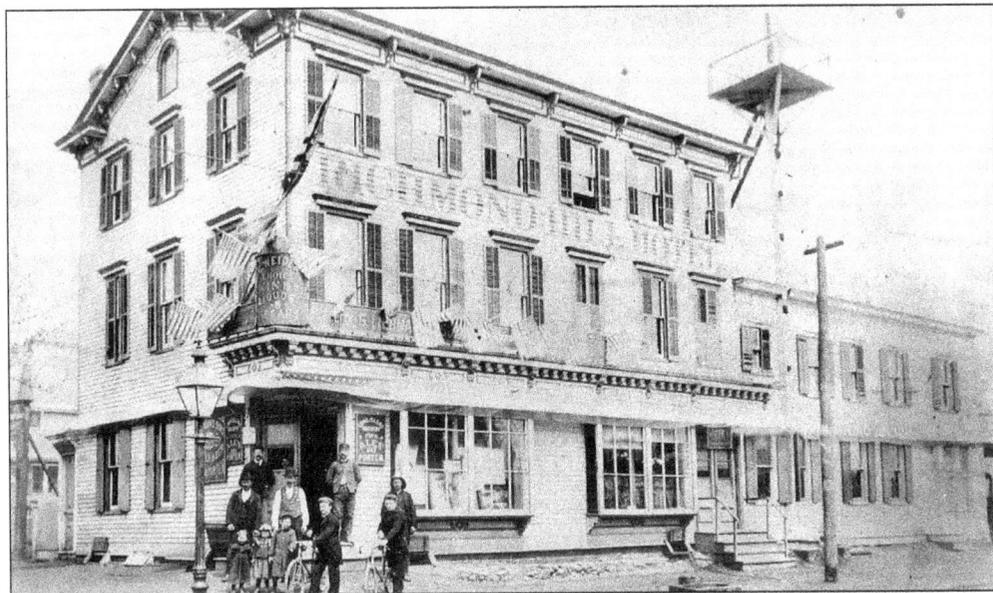

THE RICHMOND HILL HOTEL, C. 1895. Ernest Weiden is shown at the entrance of his hotel with his children Carl, Louise, and Robert, all born at the hotel. The *Long Island Democrat* reported the following about the hotel on October 19, 1886: "The large hall was handsomely decorated and good music was in attendance, for the amusement of all who danced. About 30 couples were present, and the evening was spent very pleasantly. A good collation was spread to which all did justice. Everything passed off very quietly and those present wish for a repetition of another in the near future." (Courtesy Frederick E. Hueppe.)

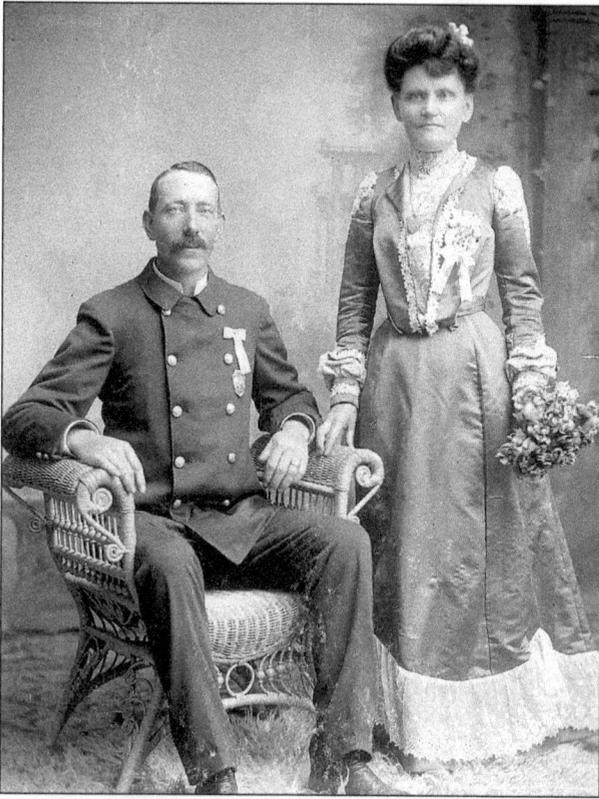

ERNEST AND ROSA WEIDEN,
c. 1893. Ernest and Rosa
Weiden were married in 1888
in Jamaica. Maria Armbruster
bought 16 lots of land behind
the Richmond Hill Hotel and
erected a 70- by 90-foot dance
hall in 1892. One year later,
Ernest Weiden took over the
management of the pavilion
(originally known as Richmond
Hill Park), changed its name to
Columbia Park, and made his
wife the hostess. The Weidens
managed the hotel and pavilion
together until Rosa died in
1910. In 1911, Ernest died,
only two weeks after leasing the
business and purchasing a farm
in Brentwood, hoping to revive
his failing health. (Courtesy
Frederick E. Hueppe.)

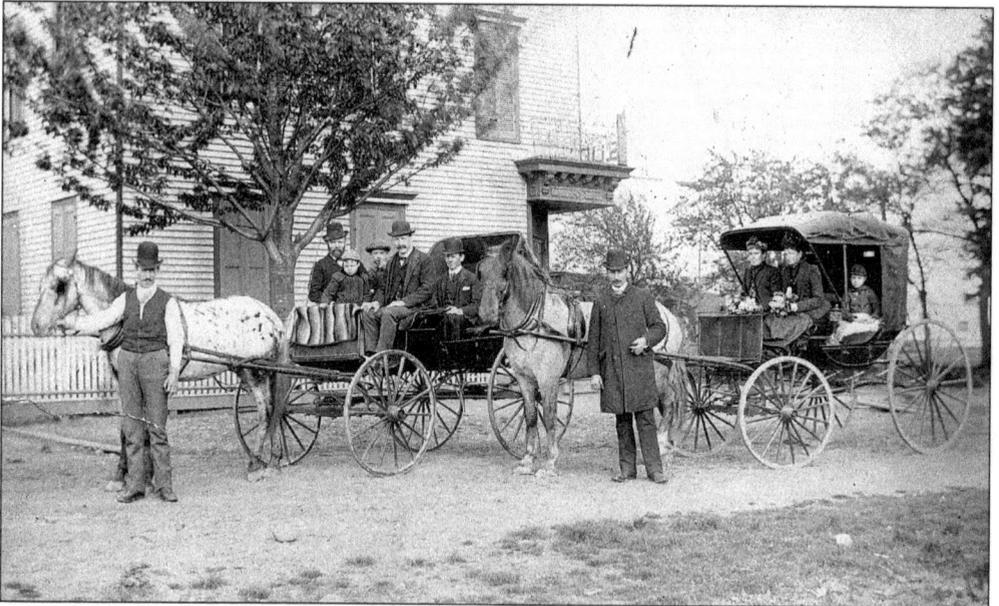

FAMILY AND FRIENDS OF THE WEIDENS, C. 1895. Leading the horse on the left is Ernest
Weiden. Sitting in the carriage is his brother Robert Weiden with family and friends. Standing
before the horse on the right is another brother, Herman Weiden. In the front seat are Herman's
wife, Josie (left), and Robert's wife. (Courtesy Frederick E. Hueppe.)

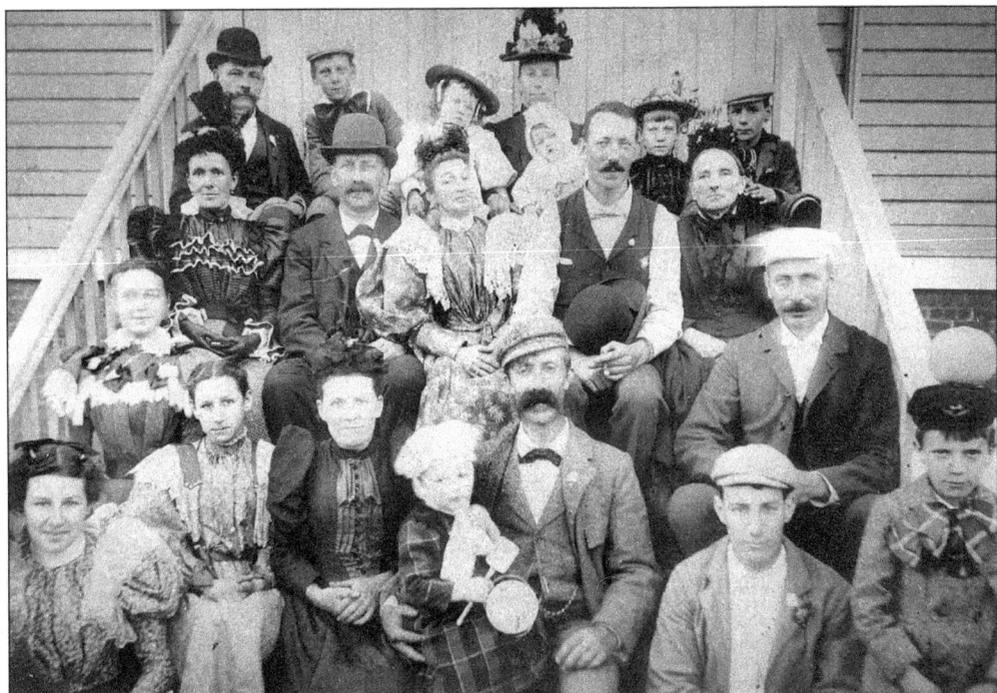

THE WEIDEN FAMILY ON THE STEPS OF COLUMBIA HALL. Ernest Weiden, wearing a vest and holding his hat, poses with his family. Rosa did not pose in this picture because she was supervising the preparation of the meal for this large family reunion in 1896. (Courtesy Frederick E. Hueppe.)

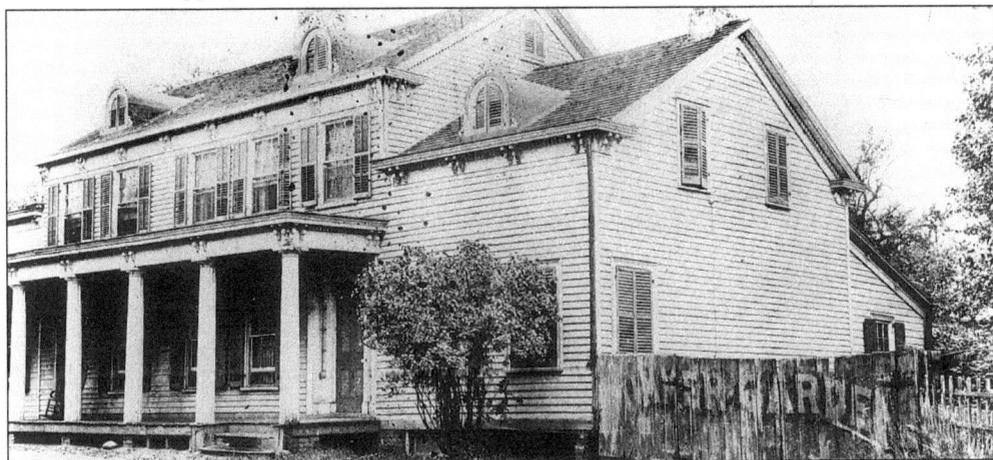

THE CAPT. WILLIAM A. LIGHTHALL FARMHOUSE. Capt. William A. Lighthall lived on Jamaica Avenue and Wickes (127th) Street. Born in 1805, he later became a steamboat engineer. He built the engines for the steamers *Champlain*, *Troy*, and *Empire*. Under Pres. James K. Polk, he was appointed superintendent and constructing engineer. In 1854, he was appointed superintendent engineer of ocean steamships belonging to Commodore Vanderbilt. In 1857, he invented the surface condenser, which was used to produce drinking water at forts during the Civil War. He later developed a business around the construction of the condensers, which were used all over the world. He died at his Richmond Hill home in 1881. (Courtesy QBPL, LID, the Eugene Armbruster Collection.)

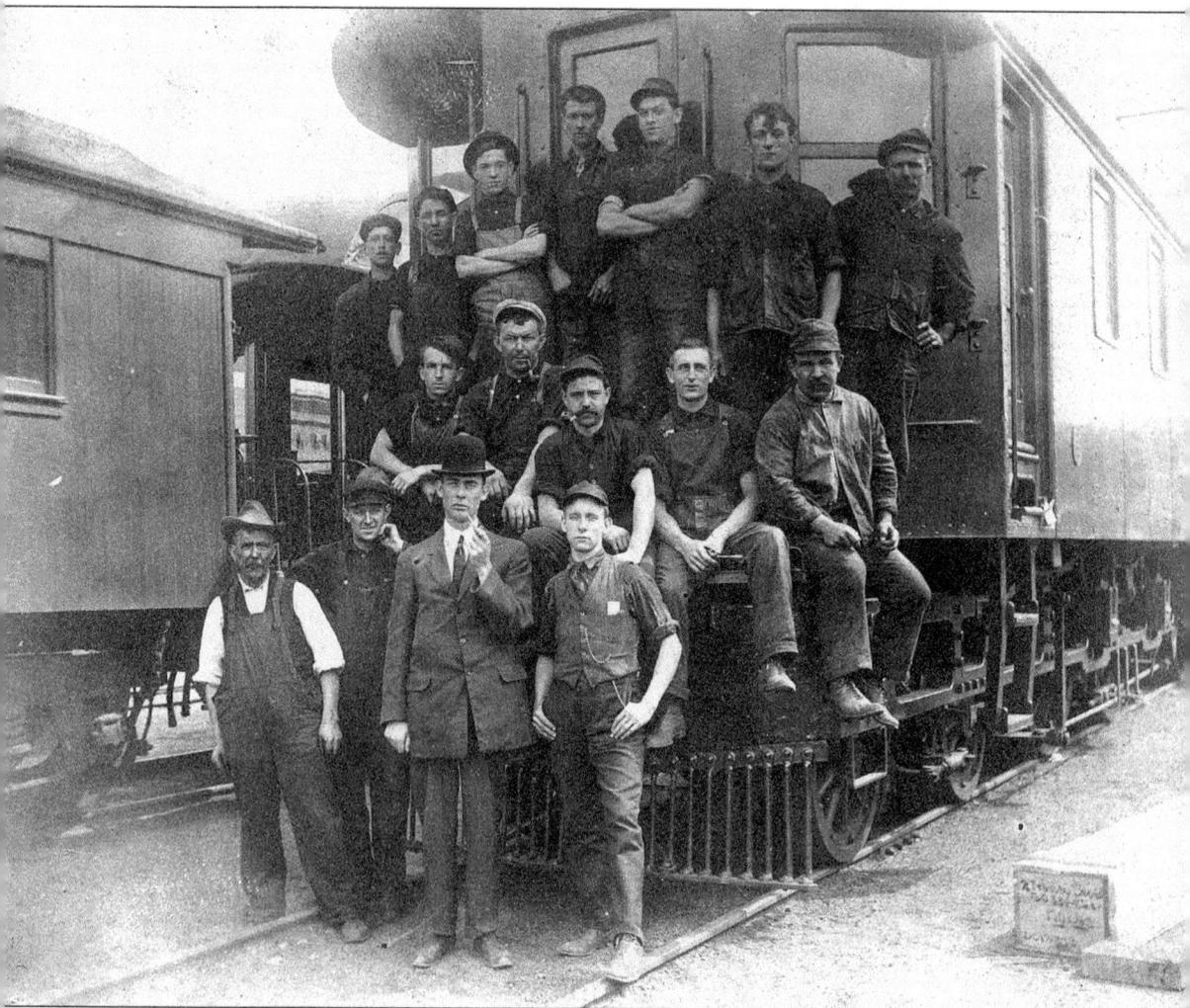

LONG ISLAND RAILROAD WORKERS AT MORRIS PARK. Employees of the shops pose in 1908. "Between seven and eight hundred men are employed in the machine and car shops of the Long Island Railroad at Morris Park, overhauling cars and engines for the summer travel." —*Long Island Democrat*, 1891. (Courtesy the Lucy Ballenas Collection.)

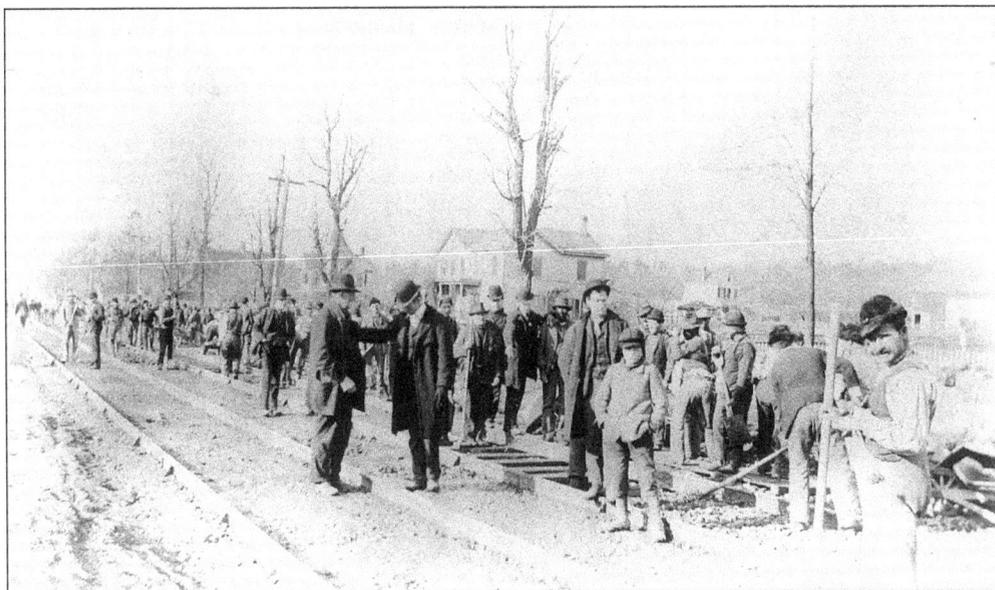

CLARENCEVILLE AT JAMAICA AVENUE, 1887. Workers lay down tracks for the electric railroad line along Jamaica Avenue. Clarenceville was an early farming community developed on Jamaica Avenue and 111th Street in the 1850s. "An electric railway would supercede the present horse road running between Jamaica and Brooklyn. The road is now in an advanced stage of progress, and its projectors hope to have it in operation before many weeks." —*Long Island Democrat*, 1887. (Courtesy QBPL, LID, the Richmond Hill Collection.)

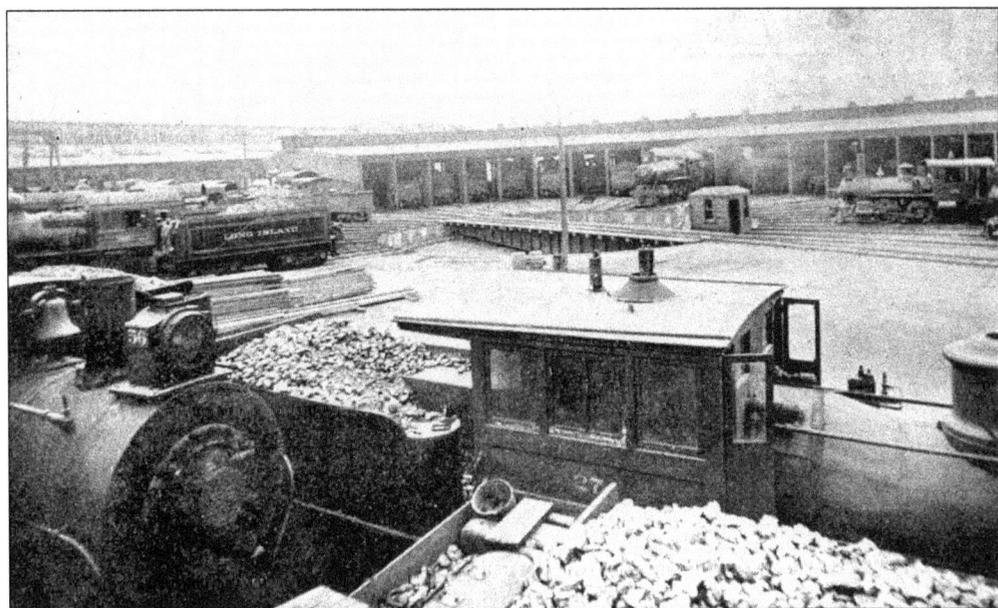

LONG ISLAND RAILROAD SHOPS AT MORRIS PARK. "The new machine and car shops of the Long Island Railroad which are to be erected at Morris Park will be built under the supervision of Mr. Chas. A. Thompson. The buildings, which have already been commenced, are to be completed by May 1, 1889, and will be fitted up with every improvement suggested." —*Long Island Democrat*, 1887. (Courtesy the Lucy Ballenas Collection.)

19

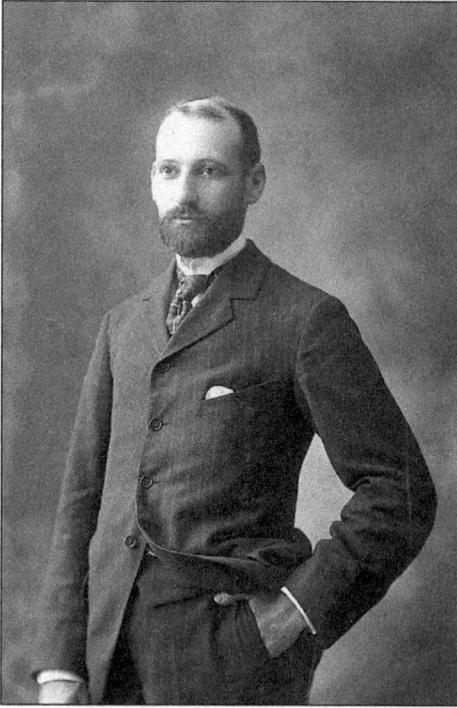

ALRICK HUBBELL MAN, C. THE 1880S. In 1891, Alrick Hubbell Man brought his bride, Lucy Edwards Russell, to Richmond Hill. He soon succeeded his father as the "first" citizen of Richmond Hill. In 1895, as the first elected president of Richmond Hill, he sold bonds of the village at public auction for higher prices than U.S. bonds bearing the same rate of interest commanded at the same time. (Courtesy the Man family.)

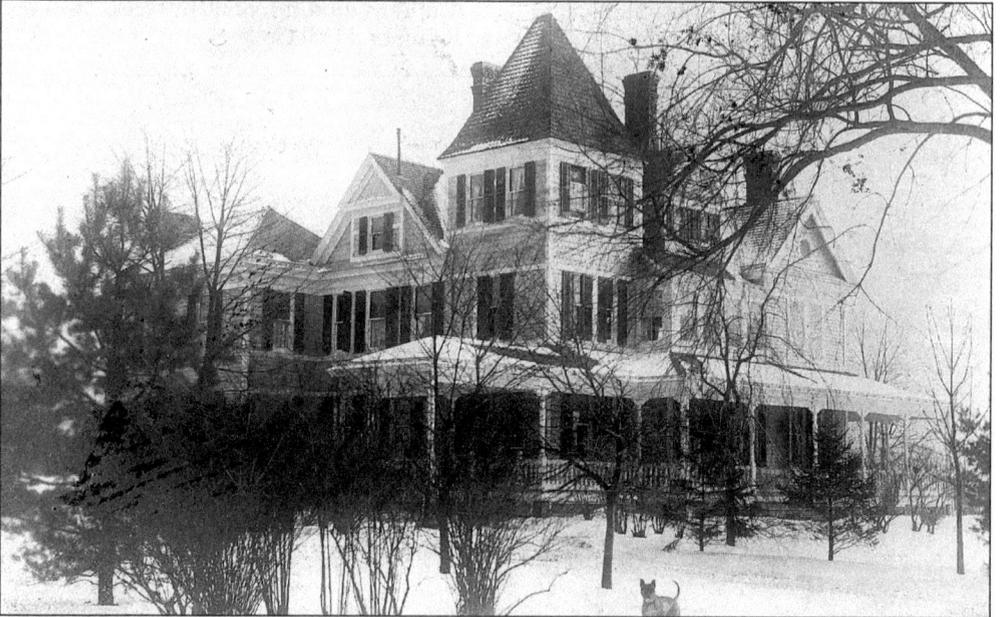

THE MAN MANSION IN THE WINTER. Albon Platt Man III wrote in 1913, "Yesterday roses, geraniums, chrysanthemums, dandelions and other flowers were blooming outside; but this morning was a 'black frost', that ushers in our real winter. My fingers are cold to write." The Great Blizzard of 1888 hit the village of Richmond Hill very hard. "It was a fearful snowstorm and blizzard, 9 degrees above zero. The snow was two feet deep and in many drifts as high as 10 feet. Those doing business in the cities were unable to leave our village." —*Long Island Democrat*, March 13, 1888. (Courtesy Anne Sarcka.)

20

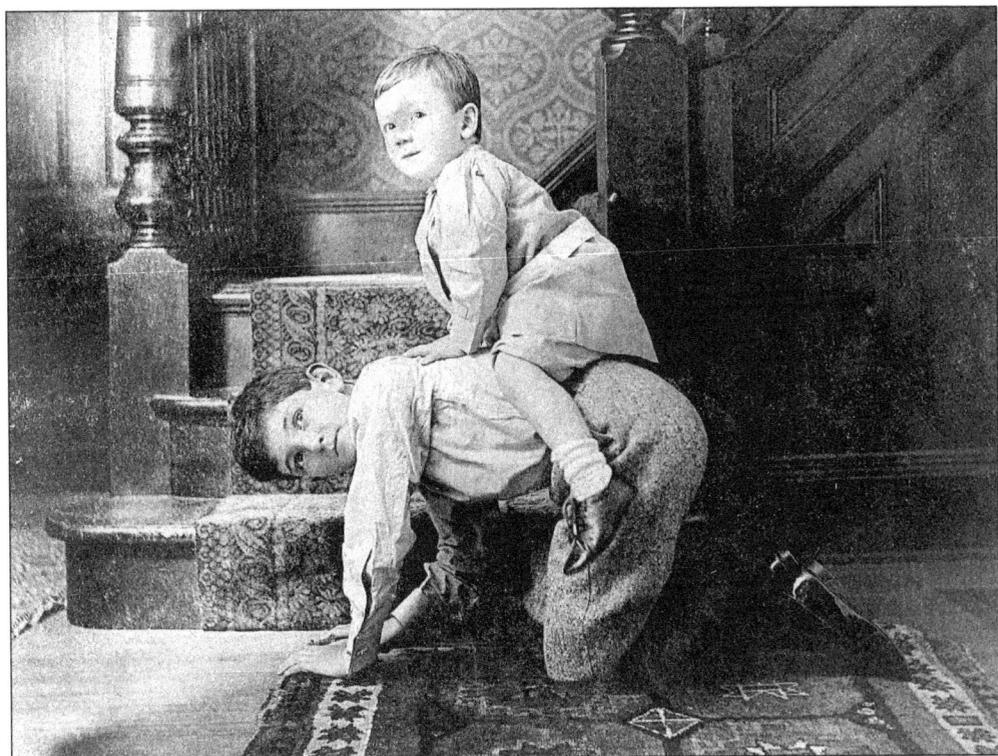

A PIGGYBACK RIDE. The sons of Alrick Hubbell Man play in their Richmond Hill mansion in 1900. Older brother Alrick Jr. gives his younger brother James Nelson a playful ride. (Courtesy the Man family.)

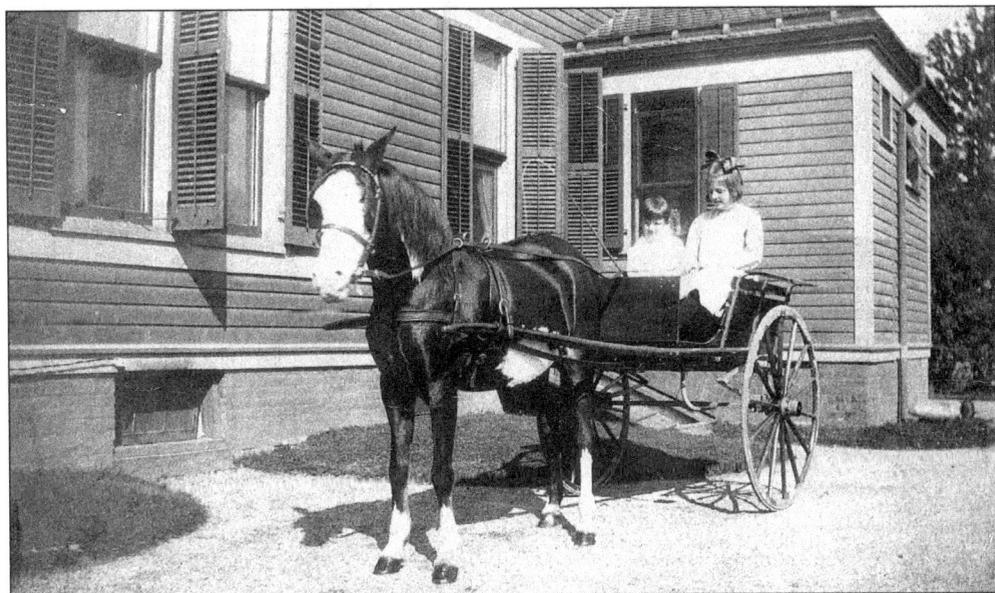

ELIZABETH AND NELSON MAN. The children of Alrick Man enjoy a pony ride on the grounds of their father's home. (Courtesy Lucy Man Jinishian.)

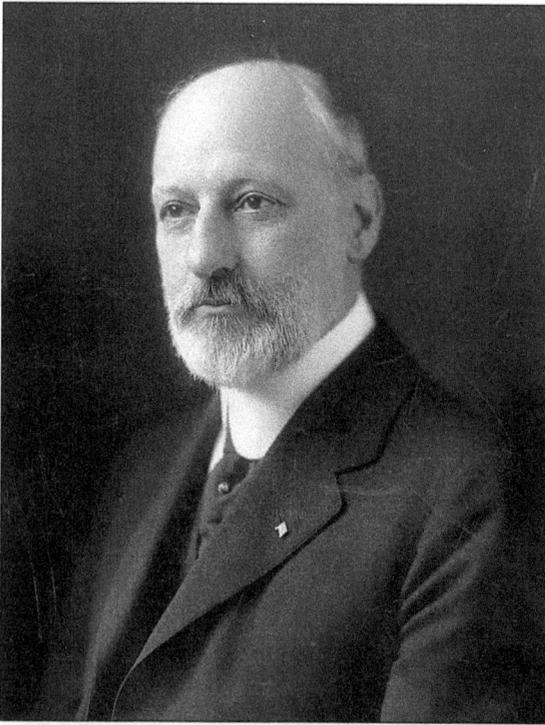

ALRICK HUBBELL MAN, 1925.
Alrick Hubbell Man was president
of the Richmond Hill High School
District from 1891 to 1894. In
1895, Clarenceville, Morris Park,
and Richmond Hill merged into
the Village of Richmond Hill, and
Man was elected the new village's
first president. In 1912, he became
president of the Kew Gardens
Corporation, a position he held until
his death. He was also president of the
Queens Council of the Boy Scouts of
America from 1915 to 1930. (Courtesy
the Man family.)

THE MAN FAMILY. Shown in this 1918 photograph are, from left to right, Alexander Marcus
(holding daughter Reba), Albon Platt Man II (with daughter-in-law Estelle), and Albon
Man III (holding daughter Vera). They are standing in front of the Richmond Hill Golf
Clubhouse, which they used as a home. "We are still occupying temporary quarters while our
'Golf-Club-House' is being refitted. It has been moved to where the tennis courts were," wrote
Albon Platt Man II in 1913. (Courtesy Albon Platt Man IV.)

A FAMILY PORTRAIT AT CONEY ISLAND. From left to right are the following: (front row) Elizabeth Man; her mother, Lucy Russell Man (wife of Alrick Man); and Jean Moir; (back row) Alrick Man Jr. and Duncan Moir. (Courtesy Lucy Man Jinishian.)

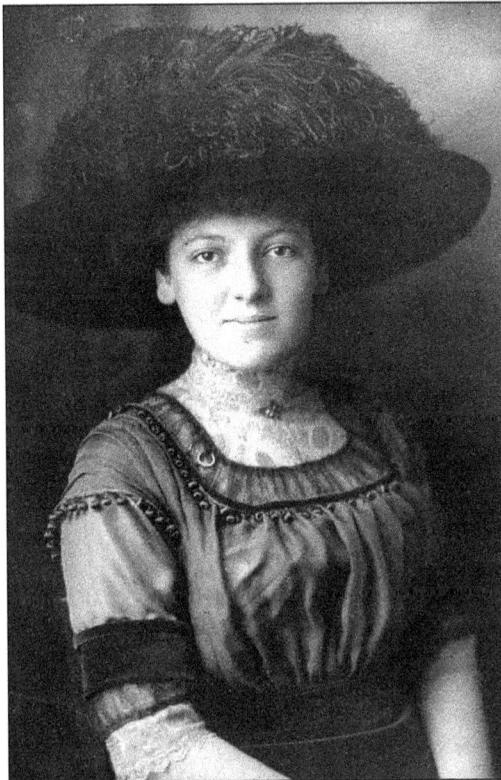

ELIZABETH MAN, 1917. "In those days, we could look off to the Atlantic on the South, the Sound on the North, and to Manhattan rising far to the West—a thrilling sight! It was this long view that decided grandfather on the name of his village," wrote Elizabeth Man Sarcka in 1976 of early-20th-century Richmond Hill. She married Wayne Sarcka and, in 1985, received the Barnard's Medal of Distinction from Barnard University. She left as a legacy her memoirs of Richmond Hill. (Courtesy Albon Platt Man IV.)

23

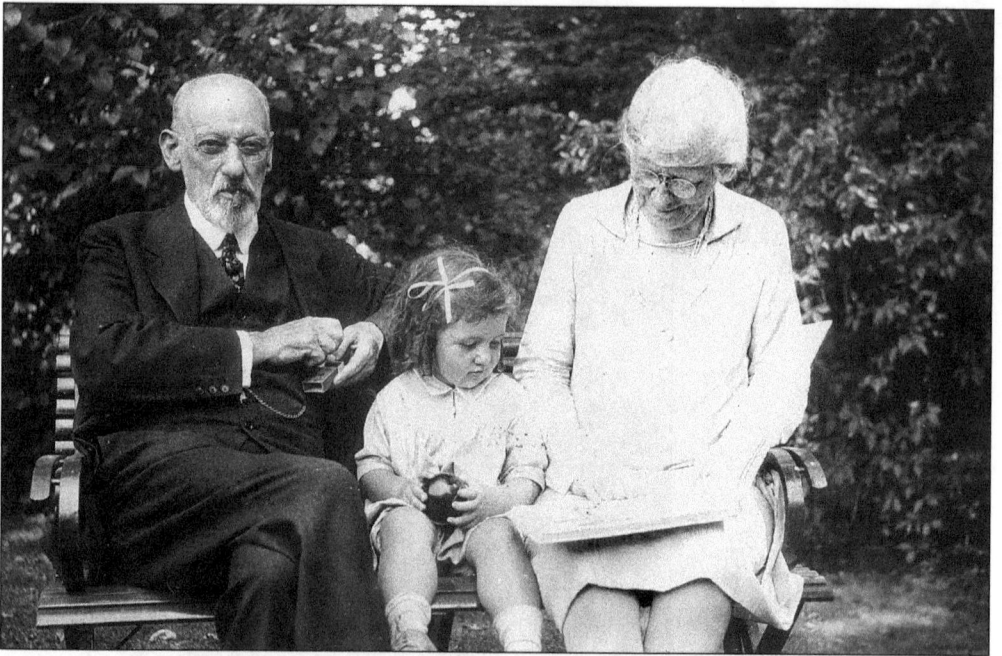

MR. AND MRS. ALRICK MAN WITH GRANDDAUGHTER. The couple sits in the Man garden, reading to their granddaughter Lucy Frances Man in 1929. (Courtesy Lucy Man Jinishian.)

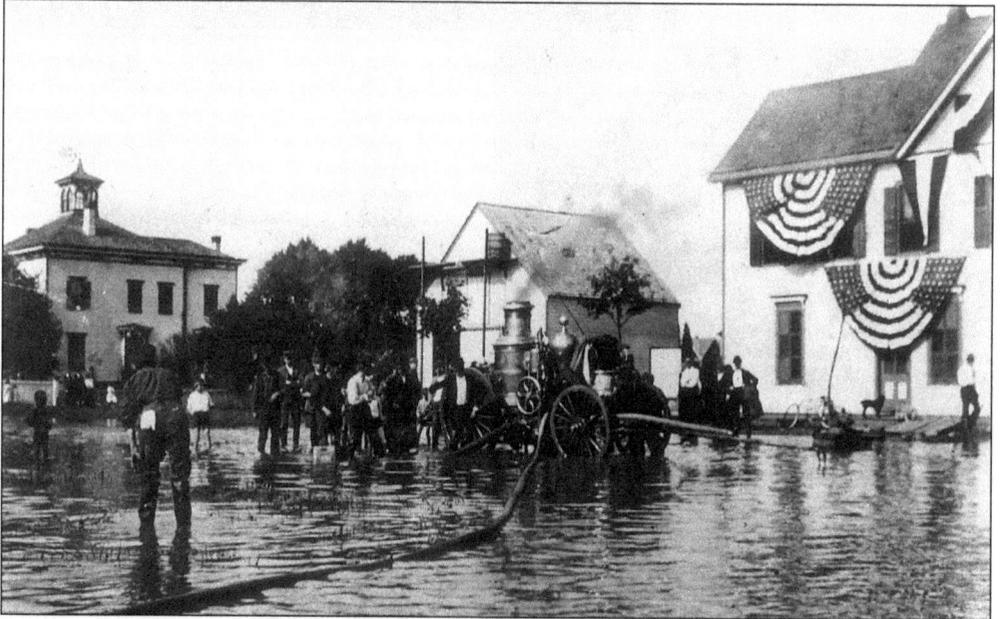

LABOR DAY PREPARATIONS. This photograph was taken on September 1, 1901, at 111th Street and 91st Avenue. Friendly but competitive games against other "vamps," the name given to other volunteer fire departments, were the planned activities for the following day. Rain the night before had flooded the street, a frequent occurrence until sewers were installed in 1913. In the photograph, firemen drain the street dry. Hours later, while they slept, it rained again. They arrived at 5:00 a.m. to drain the street again, not wanting to disappoint their many fans. (Courtesy QBPL, LID, the Borough President of Queens Collection.)

Two

BUSINESS AND SOCIETY

*Had it not been for their farsightedness, self-sacrifice, large investments with
the possibility of failure and probably ultimate ruin of the businessmen, we
would still commute, for a loaf of bread, a pair of shoes, a stick of furniture
and a suit of clothes. To the tradesmen the success of this section is due
in a great measure because without them existence would be incomplete.*

—Richmond Hill Record, 1926

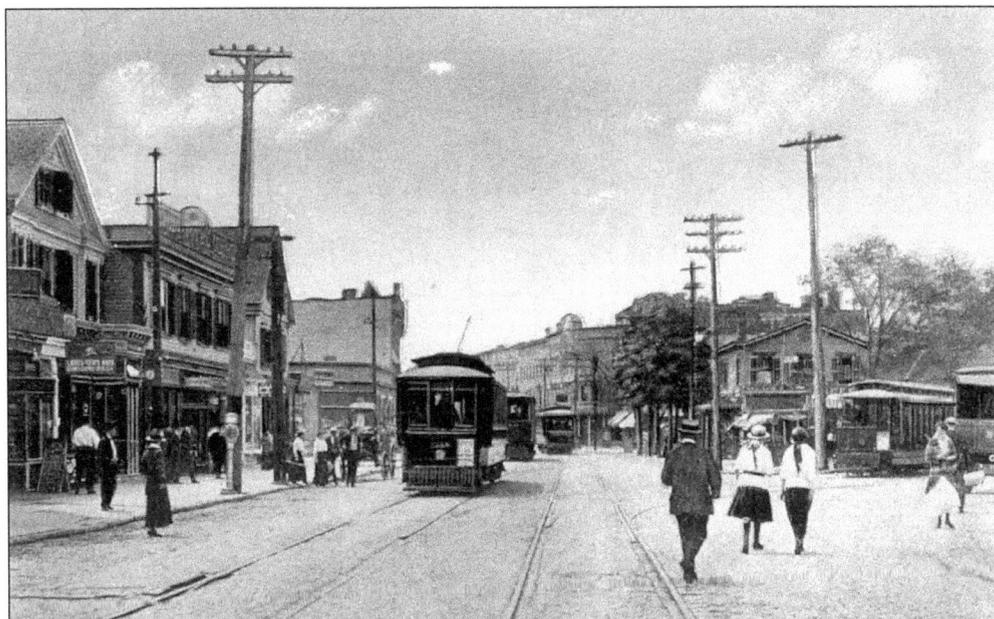

JAMAICA AVENUE, LOOKING WEST FROM LEFFERTS. Trolleys run on both Jamaica and Myrtle
Avenues past the Triangle Hofbrau, which divides the two avenues. "May 31, 1903—Yesterday
they began running a new kind of cars on Jamaica Avenue. Three cars and a train, which runs
up an incline onto the elevated. Very ungainly! People do not like them." —*Diary of Miss Ella
J. Flanders.* (Courtesy the Lucy Ballenas Collection.)

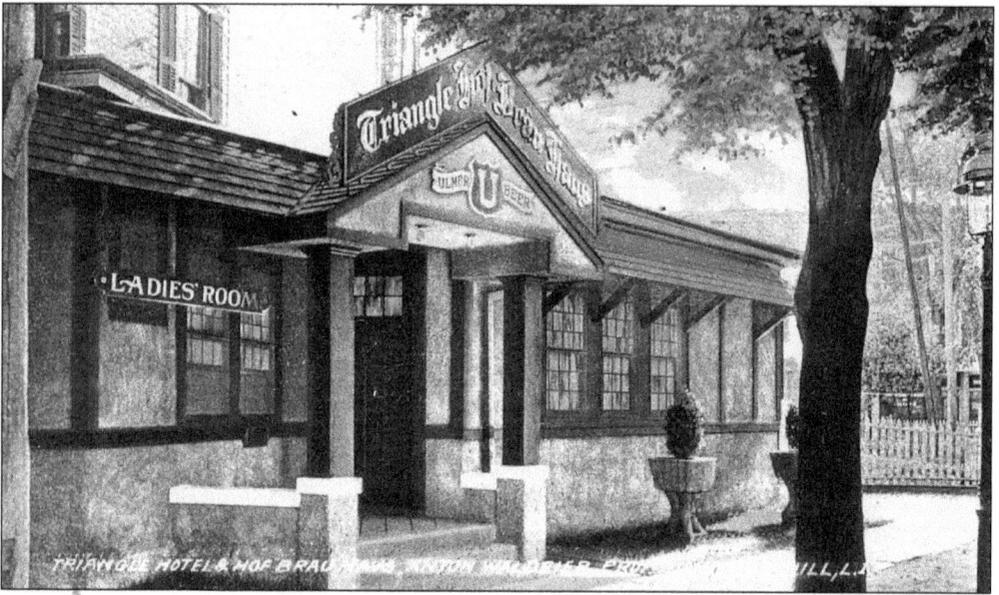

THE TRIANGLE HOTEL AND HOFBRAU. Among the patrons who frequented the hotel were New York Yankee home run king Babe Ruth, whose favorite meal was fried eel and ice cream. Composer Ernest Ball wrote "When Irish Eyes Are Smiling" above the restaurant in one of the hotel rooms. It is reputed that Mae West was routinely booted from the establishment for smoking and creating a ruckus. Lefty Gomez, another Yankee from the 1930s, as well as Paul Berlanbach, who was the light heavyweight boxing champion of the world in the mid-1920s, are also known to have been frequent visitors. (Courtesy Nancy Cataldi.)

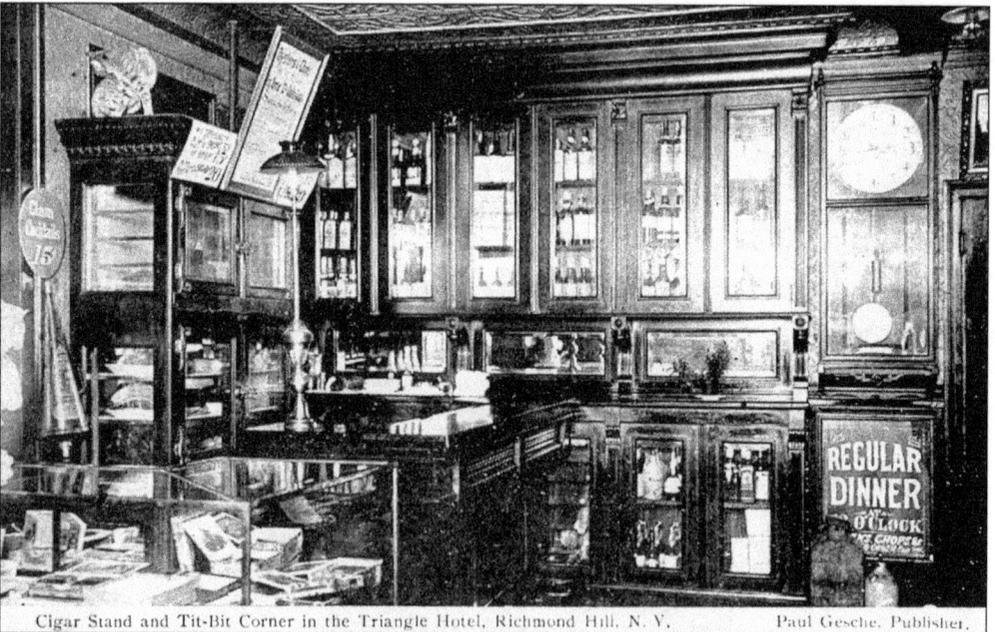

Cigar Stand and Tit-Bit Corner in the Triangle Hotel, Richmond Hill, N.Y. Paul Gesche, Publisher.

THE CIGAR STAND AND TIT-BIT CORNER. In 1916, a full, seven-course Sunday dinner at the restaurant was $1.25. An annual event at their restaurant was the venison dinner, which always made for a full house. (Courtesy Marianne Veidt.)

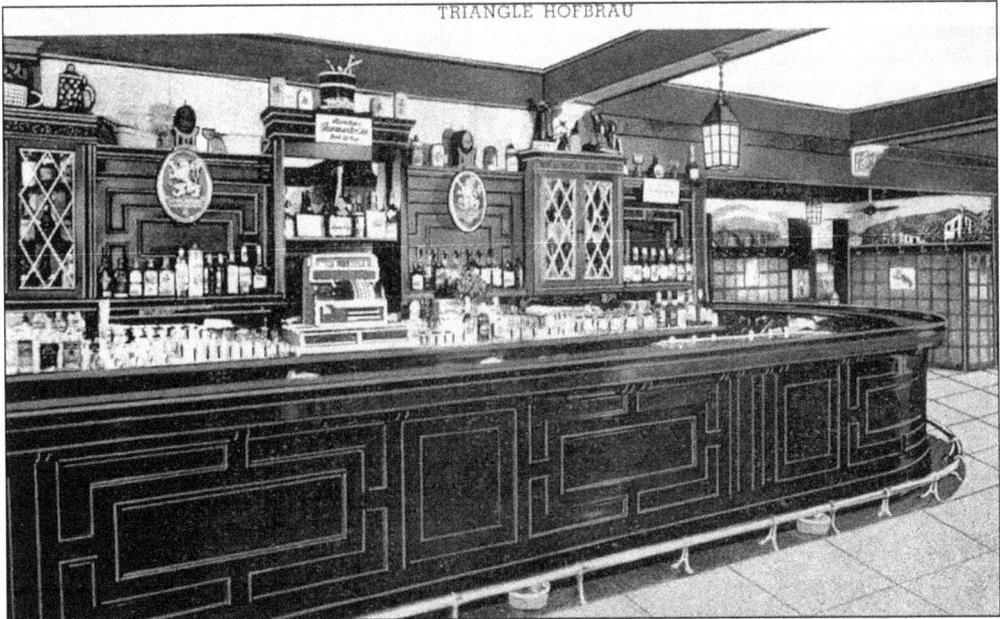

THE TRIANGLE HOFBRAU BAR. The Honduras mahogany bar was designed for the steamship *President* and bought by the Four brothers, who installed it in 1934. Over the bar was a brass bell that was rung every time someone bought a round of drinks and for last call. (Courtesy Helen Day.)

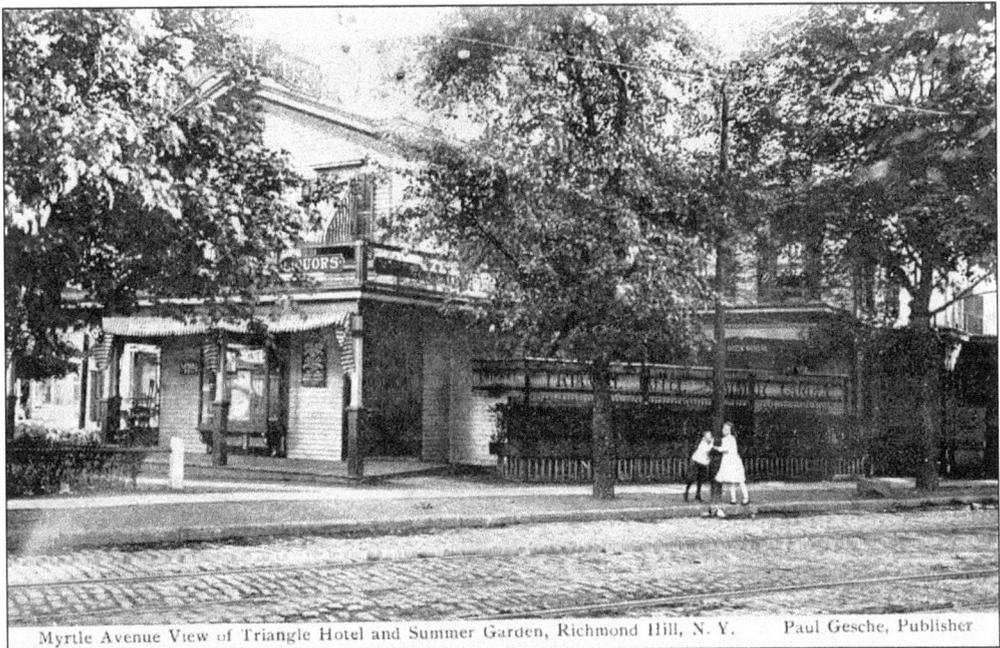

Myrtle Avenue View of Triangle Hotel and Summer Garden, Richmond Hill, N. Y. Paul Gesche, Publisher

THE TRIANGLE HOTEL AND SUMMER GARDEN. In 1902, newspaper reporter and author Jacob Riis was a regular patron of the Hofbrau, as was his close friend Theodore Roosevelt. (Courtesy Marianne Veidt.)

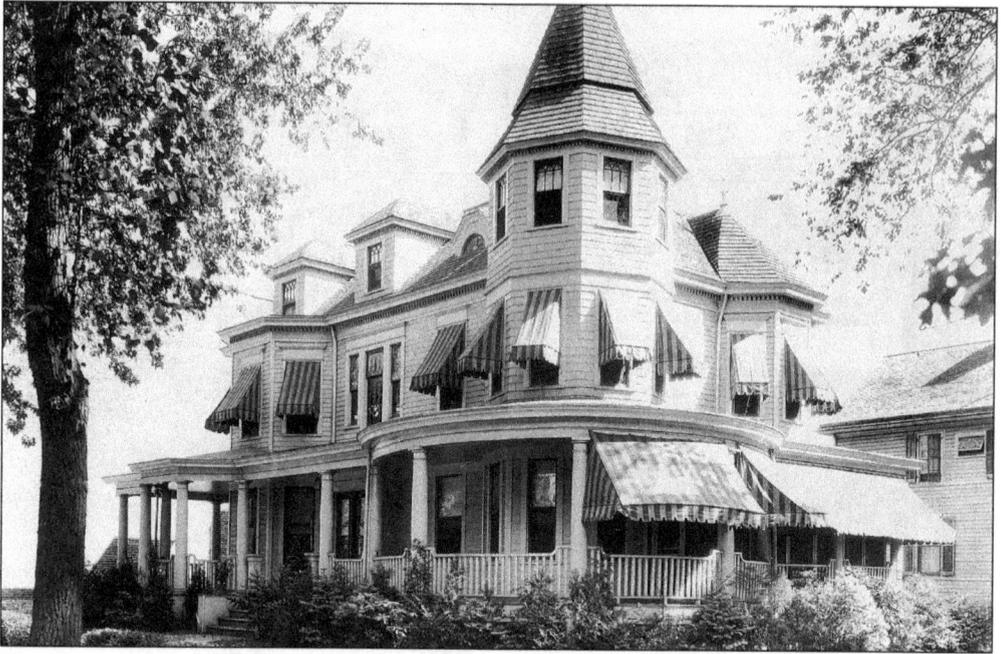

THE FORMER VETTER MANSION. A prominent turret, wraparound porch, and canvas awnings make this outstanding Richmond Hill Victorian home a classic. Located at the corner of Hillside and Lefferts Avenues, the home became Simonson's Funeral Home. (Courtesy Simonson's Funeral Home.)

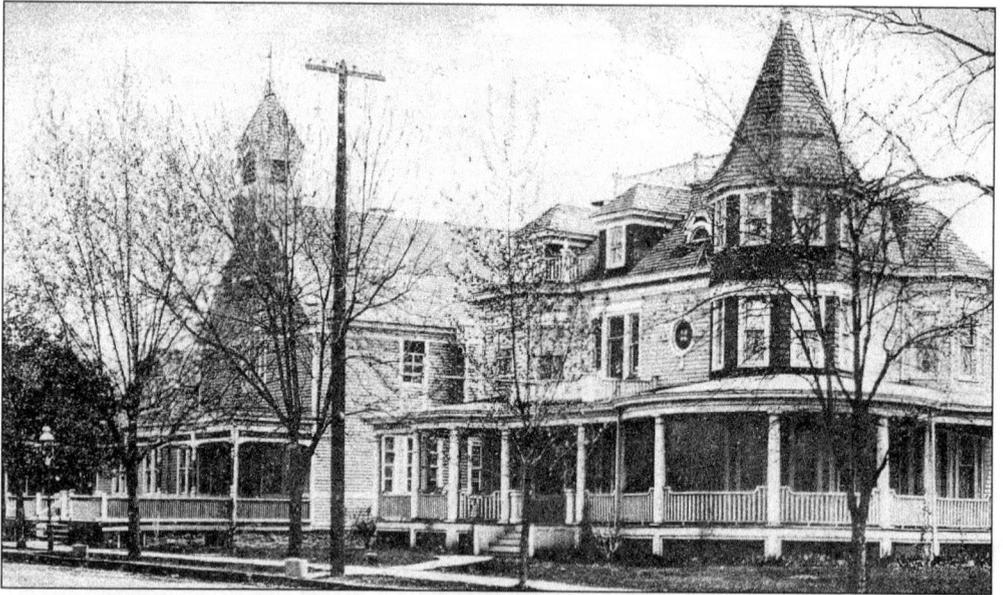

SIMONSON'S FUNERAL HOME. In 1887, William H. Simonson, a pioneer in his line of work, established himself in the funeral business in Woodhaven and opened a branch in Richmond Hill. In 1923, he died at his home at the corner of Hillside and Lefferts Avenues. The business passed through the generations and is now operated by William C. Simonson and John Sommese. The second floor is the Richmond Hill Historical Society Archive Center. (Courtesy the Lucy Ballenas Collection.)

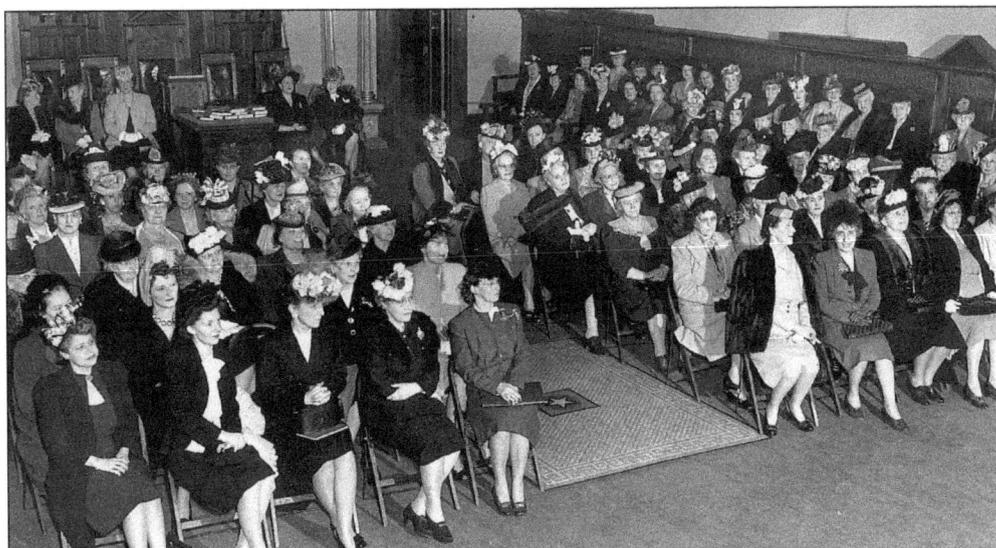

THE TWENTIETH CENTURY CLUB. Begun in 1898 as a war effort with the Red Cross to gather bandages for soldiers, this group of women went on to contribute greatly to Richmond Hill. Their 1903 incorporation charter reads, "The Twentieth Century's objectives are: To provide for the women of Richmond Hill a center for organized work, and to improve the philanthropic, educational, civic and social interests of the community of Richmond Hill, Borough of Queens, City and State of New York." Ella J. Flanders was the first secretary of the club, and the meetings that year were at the Richmond Hill Clubhouse. This photograph was taken at a meeting in the 1940s. The group disbanded in 2000. (Courtesy the Twentieth Century Club.)

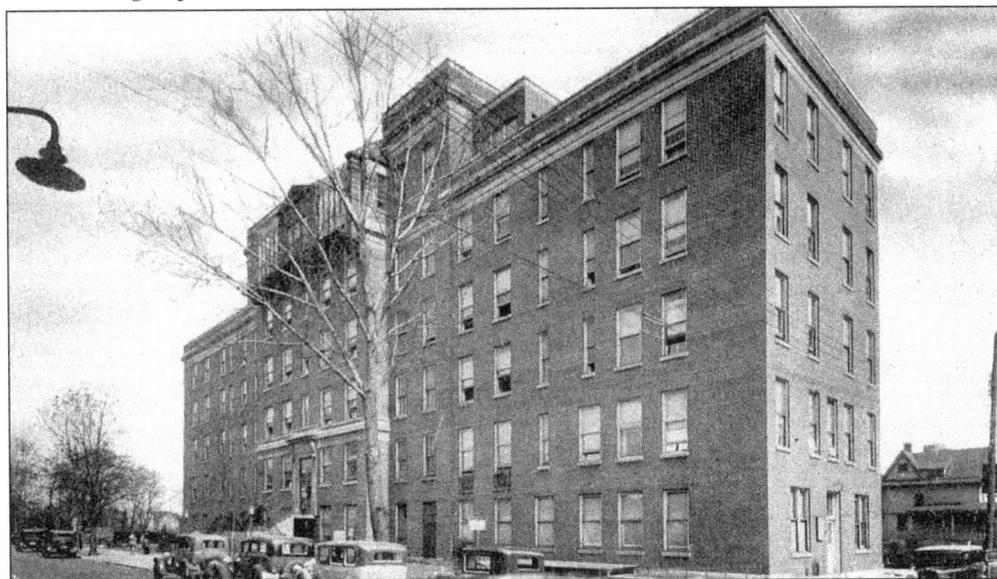

JAMAICA HOSPITAL. Many civic groups in Richmond Hill worked for years unselfishly to make this hospital a reality. "Ground for the new five story building which the Jamaica Hospital is about to erect, will be broken. A feature will be the fact that two children who have been undergoing treatment in the orthopedic clinic will turn the first spade full of earth. These little ones, ones hopelessly crippled, will demonstrate the excellent results achieved at the clinic." —*Richmond Hill Record*, 1922. (Courtesy the Lucy Ballenas Collection.)

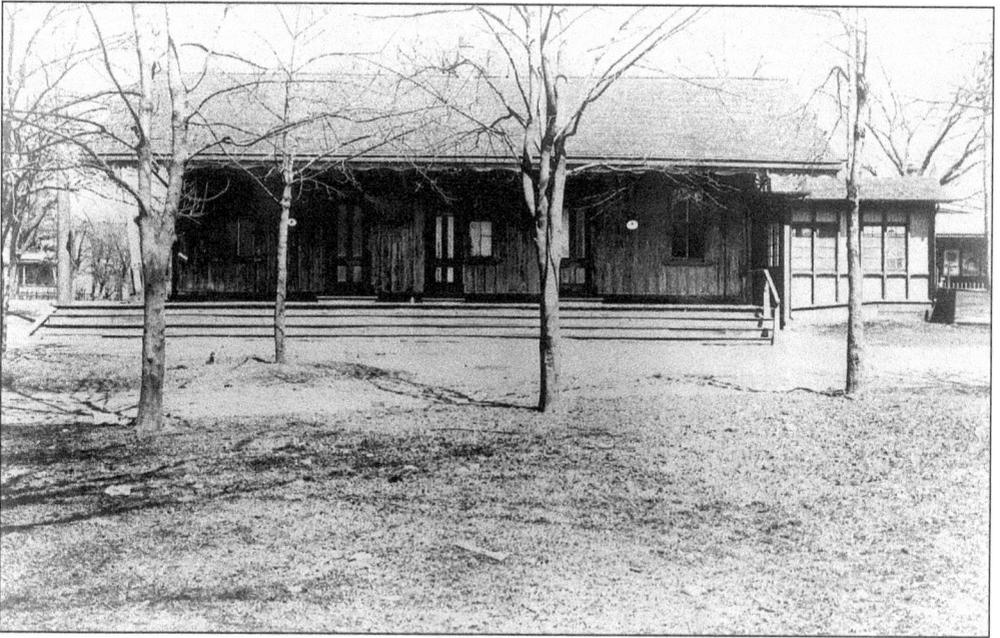

THE RICHMOND HILL TRAIN DEPOT, 1916. In December 1918, excitement abounded when a film crew came to shoot scenes at the depot for a silent film comedy called *Grimesey*, directed by "Charlie" Dickson. There was one scene in which a hotel bellhop, concealed in a big trunk on the station platform, suddenly sprang out and pointed a big gun at a fierce, black-mustached villain, causing him to throw up his hands. (Courtesy QBPL, LID, the Rugen Collection.)

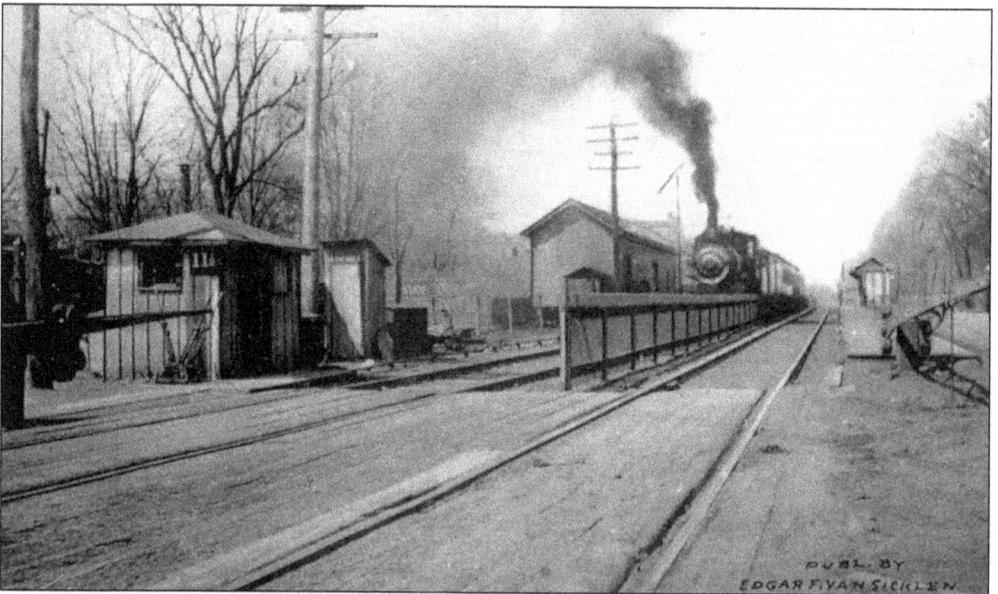

A TRAIN COMING INTO RICHMOND HILL. "Richmond Hill with its neat churches, gardens and summer cottages presents a pastoral picture, the restful quiet of which is only disturbed by the shriek of the iron horse after which the post office becomes a greeting center." —*Long Island Democrat,* 1886. (Courtesy the Lucy Ballenas Collection.)

RAILROAD STATION, RICHMOND HILL. "A commodious and elegant passenger depot (said to be the best on Long Island) has been built upon the premises, and nearly all the trains stop at it." —*Long Island Democrat*, 1870. (Courtesy the Lucy Ballenas Collection.)

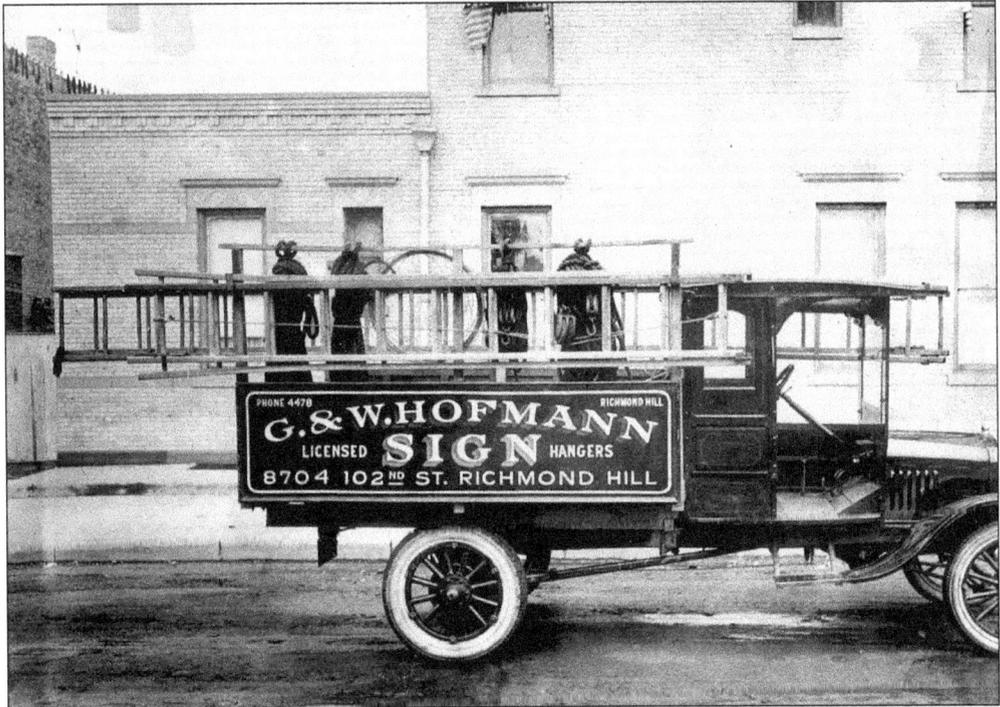

G. & W. HOFFMANN. This business, located at 102nd Street and 87th Avenue, made and hung signs and advertisements throughout Richmond Hill and its neighborhoods. "The merchant is at all times seeking to improve the general appearance of his establishment and each improvement means a step in the general direction for the improvement of the entire locality." —Stanley Payne, president of the Richmond Hill Board of Trade, 1926. (Courtesy the Lucy Ballenas Collection.)

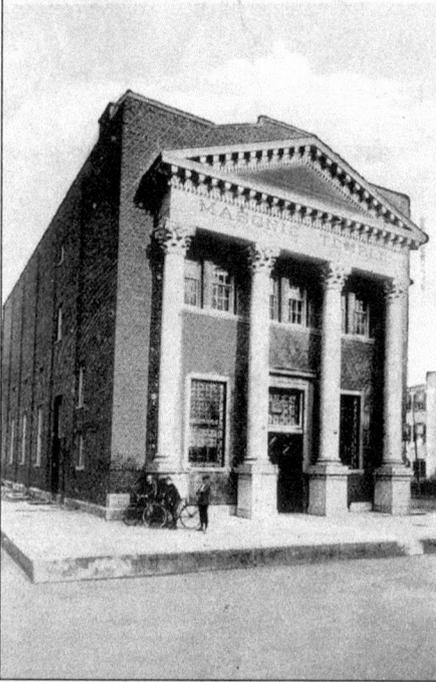

THE MASONIC TEMPLE. The Masons chapter was instituted in 1911. Originally, meetings were held at Arcanum Hall. This building was erected on 114th Street near Jamaica Avenue and was designed loosely after the style of the Temple of Diana, with wide columns in front. It was designed by one of its members, W. Ralph Squire. (Courtesy the Lucy Ballenas Collection.)

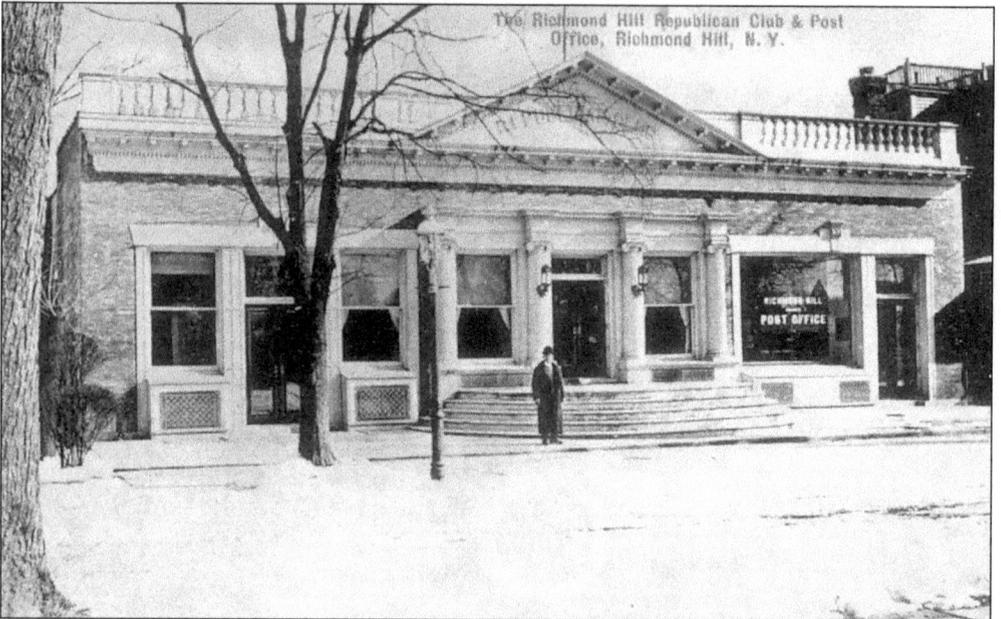

THE REPUBLICAN CLUB. The Republican Club was first organized in 1901 at a clubhouse on Johnson Avenue (118th Street). The next clubhouse was on Jefferson (116th) Street and Jamaica Avenue. In 1908, a new clubhouse was erected on Lefferts Avenue and designed by architect Henry E. Haugaard for a cost of $30,000. The cornerstone laying was on May 16, 1908. Mayor Bell and Republican Club president William H. Wade made addresses. It had been village folklore that Pres. Theodore Roosevelt attended this ceremony, but he and the governor of New York both sent their regrets and did not attend. (Courtesy the Lucy Ballenas Collection.)

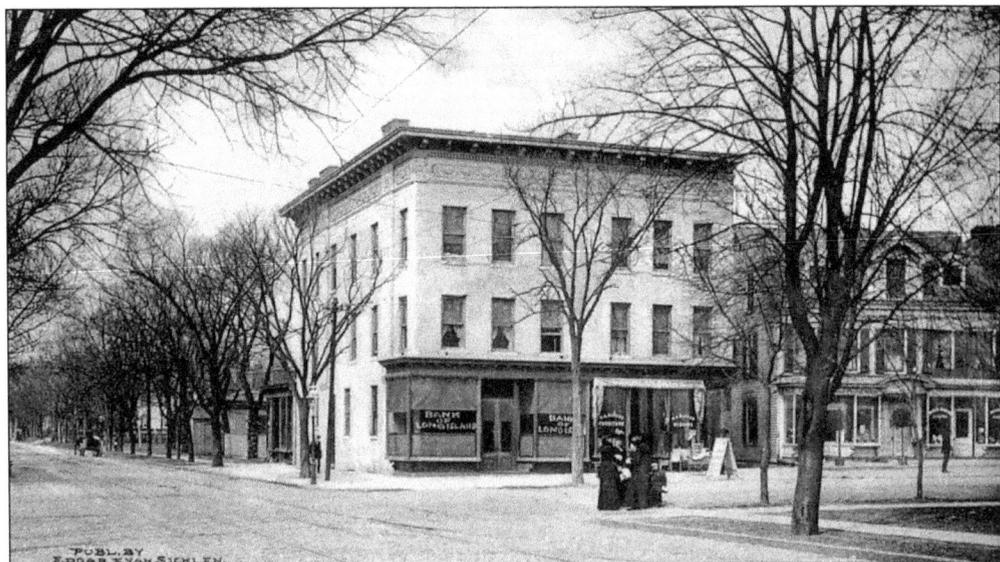

THE BANK OF LONG ISLAND. This building is at the corner of Myrtle Avenue and Park Street (Hillside Avenue). In 1901, the bank was a branch of the Bank of Jamaica at Jamaica Avenue and 117th Street, sharing the building with Joel Fowler Real Estate, and then moved to the site in this photograph. In 1903, it was absorbed by the Bank of Long Island and, in 1920, by the Bank of the Manhattan. It moved from Myrtle Avenue in 1911, when a new building was erected at the corner of 115th Street and Jamaica Avenue. (Courtesy the Lucy Ballenas Collection.)

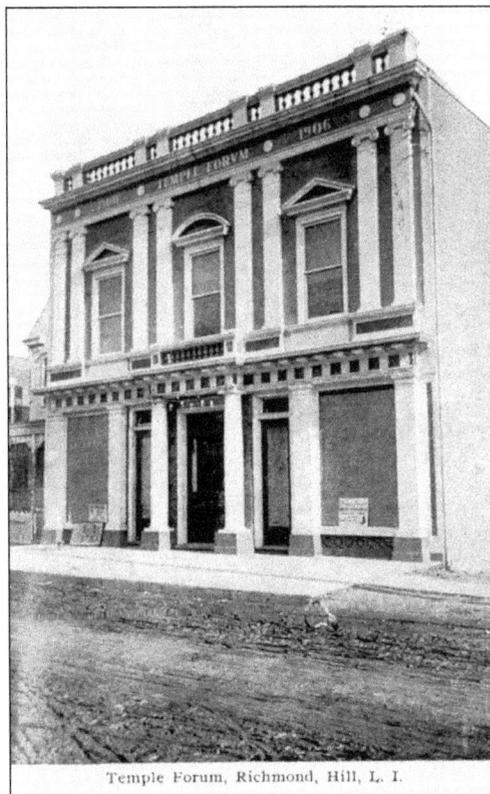

Temple Forum, Richmond, Hill, L. I.

THE TEMPLE FORUM. This club was originally formed in 1901 by Dr. C.F. Field among his Sunday school pupils but later branched out to include young men of all creeds and denominations. In its time, it was the leading club of Richmond Hill in social and athletic life. It closed in 1916. (Courtesy Marianne Veidt.)

33

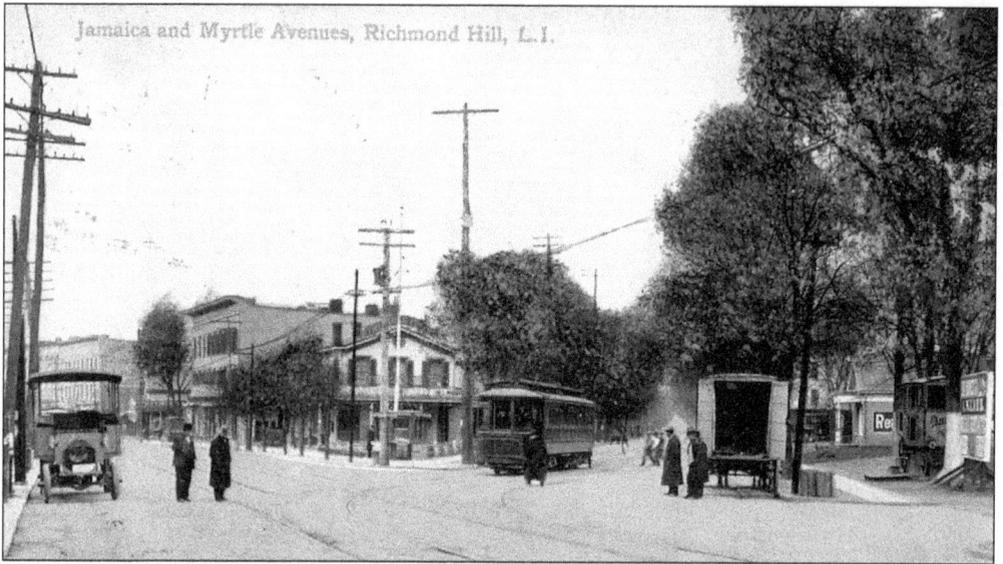

THE RICHMOND HILL POST OFFICE, FIRST LOCATION. The post office has been located in eight different places throughout its history. The earliest post office was located at the country store of Jacob Van Wicklen, now the Triangle Hofbrau. In 1868, it was the Clarenceville post office, named after the older farming settlement at 111th and Jamaica Avenue. The post office was renamed Richmond Hill in 1872, with Van Wicklen the first postmaster. In 1893, it moved to the corner of Myrtle Avenue and Park Street. (Courtesy Nancy Cataldi.)

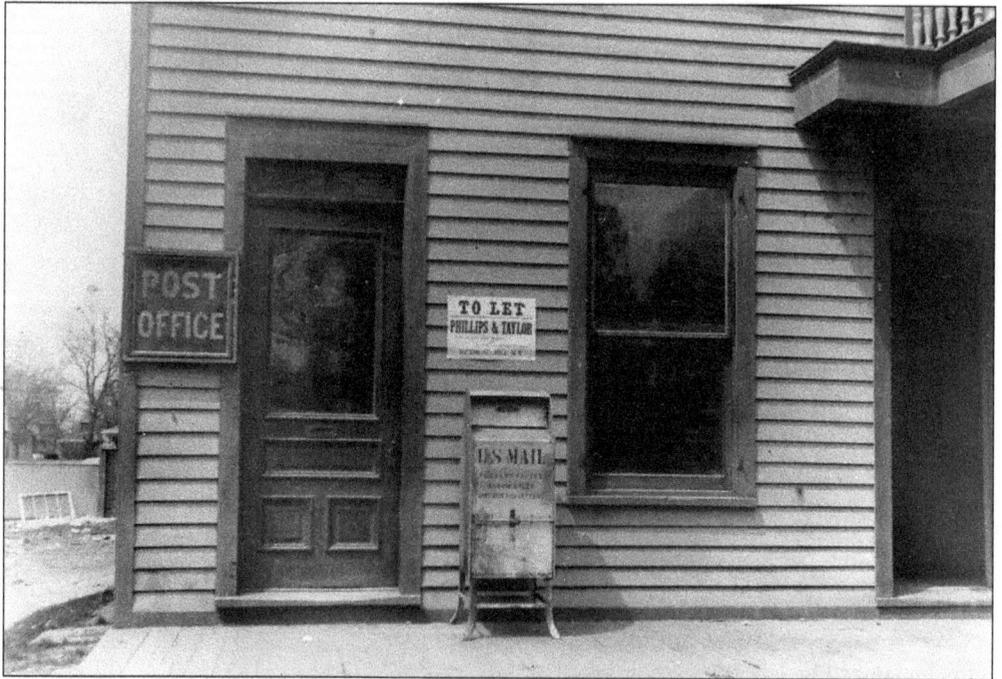

THE THIRD LOCATION OF THE POST OFFICE. Sometime after 1893, the Richmond Hill Post Office was moved to another building in the middle of Park Street (Hillside Avenue), shown in this photograph. The RKO Keith's now occupies this sight. (Courtesy the Lucy Ballenas Collection.)

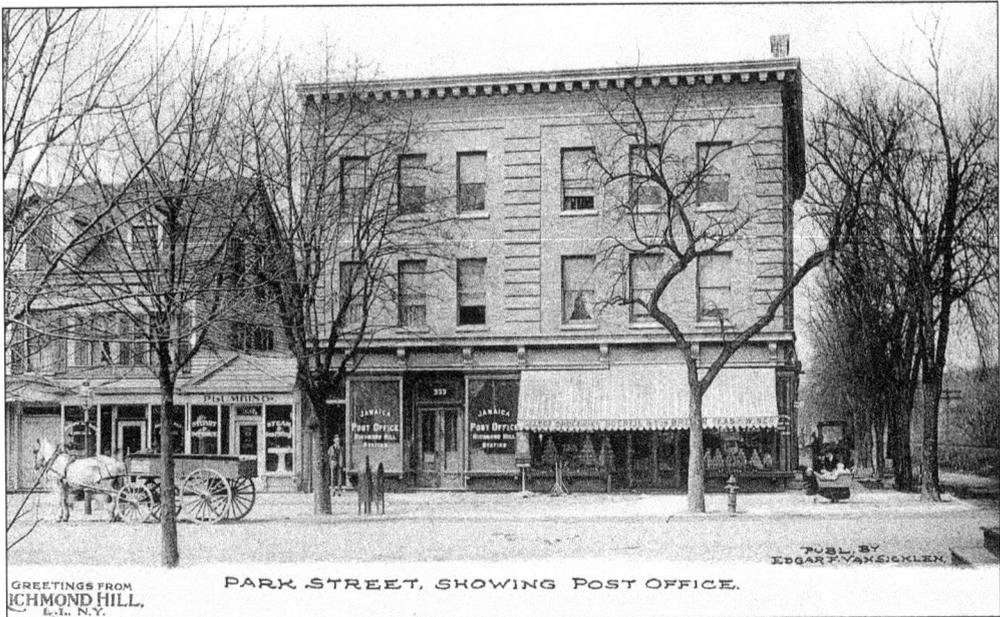

GREETINGS FROM RICHMOND HILL, L.I. N.Y.

PARK STREET, SHOWING POST OFFICE.

PUBL. BY EDGAR F. VANSICKLEN.

THE RICHMOND HILL POST OFFICE, PARK STREET. This is the fourth site of the post office, also on Park Street, just one building over from the previous location. In 1908, it was moved to the newly built Republican Club. Ten years later, it relocated to Church (118th) Street south of Jamaica Avenue. (Courtesy the Lucy Ballenas Collection.)

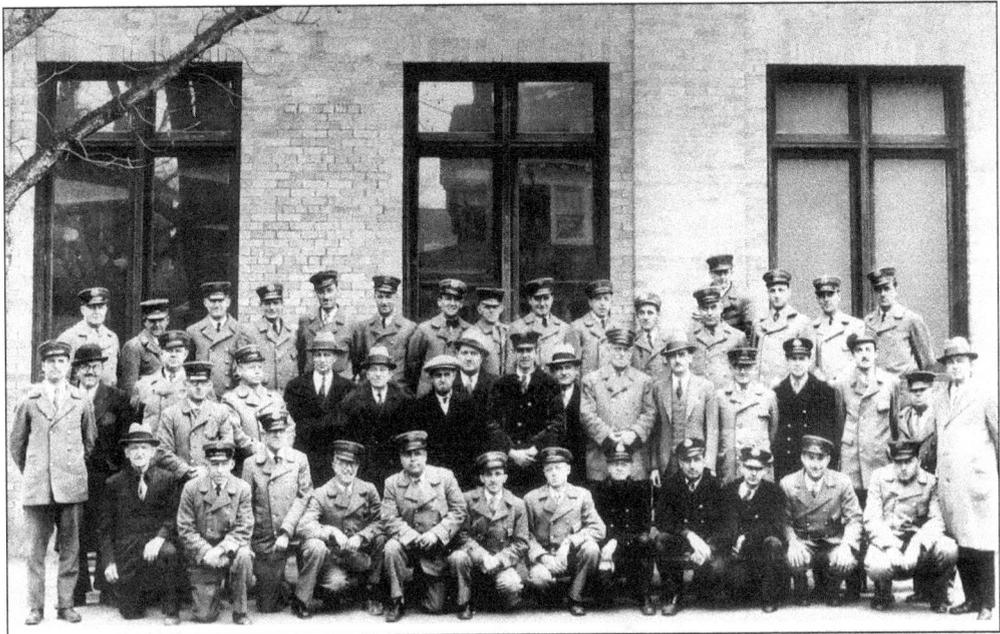

RICHMOND HILL POST OFFICE EMPLOYEES ON MYRTLE AVENUE. In 1928, the post office moved to its seventh location, on Myrtle Avenue and 115th Street. It remained there until 1960, when it moved to Jamaica and 122nd Street. This photograph of postal employees was taken in 1938. (Courtesy the Richmond Hill Post Office.)

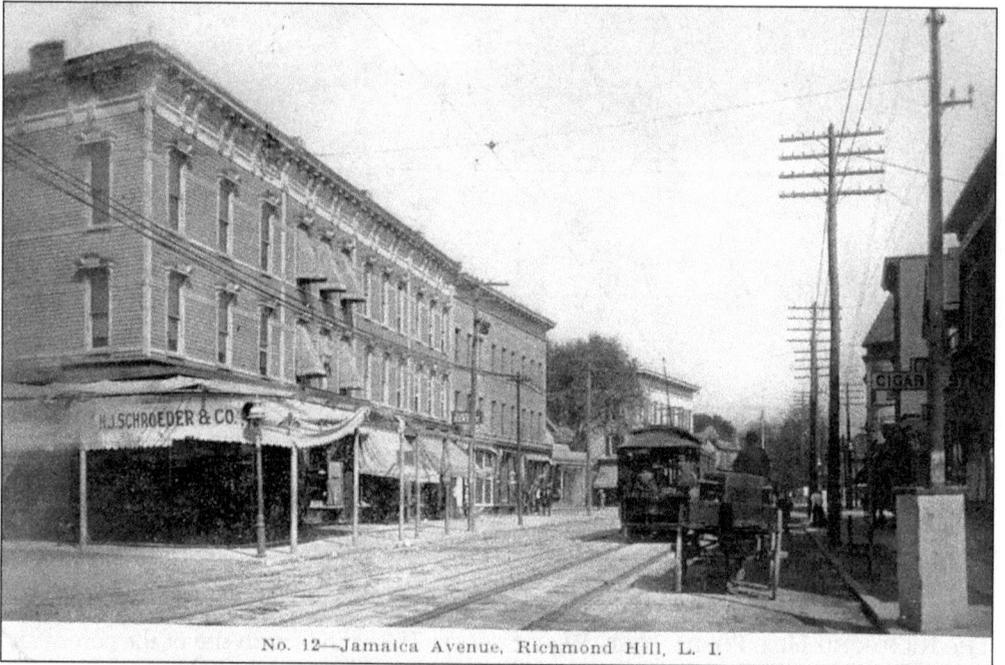

No. 12—Jamaica Avenue, Richmond Hill, L. I.

TRANSPORTATION ON JAMAICA AVENUE. This view looks east on Jamaica Avenue from 115th Street. "The change from the old horse motive power to electricity and the improvements in electricity have all worked together for the advantage of this locality." —*Richmond Hill Record,* 1909. (Courtesy Nancy Cataldi.)

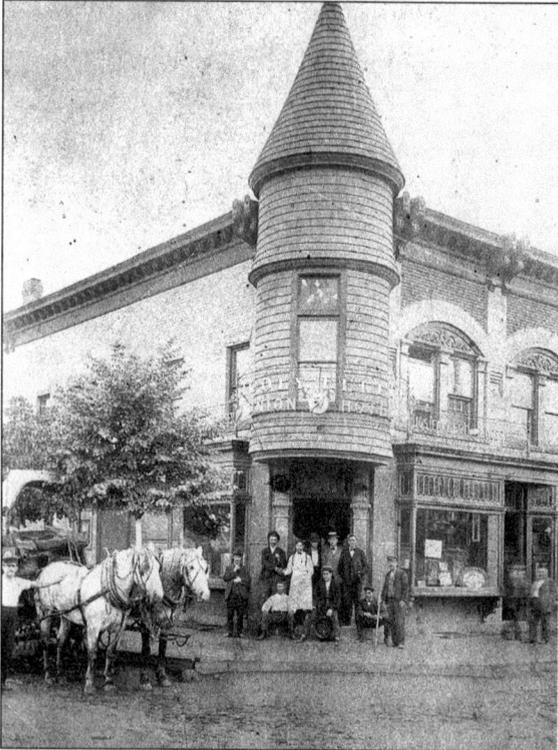

THE UNION HOTEL. This late-19th-century photograph shows Nicoly Felliti's Union Hotel, at Union Place (102nd Street) and Atlantic Avenue. This building today has been beautifully restored and is operated by Dallis Brothers Coffee Company. (Courtesy the Felliti family.)

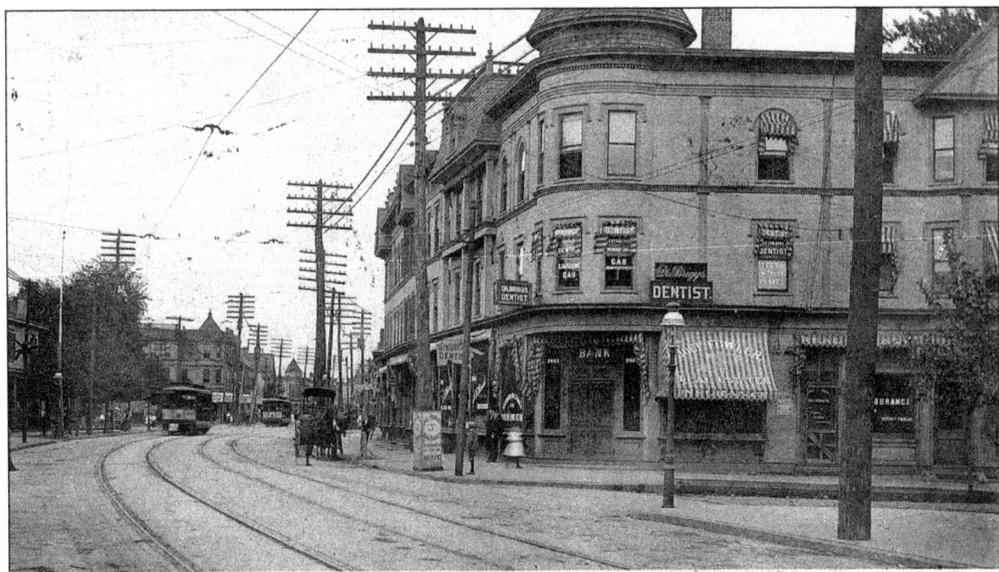

Another view of our main street, Cou

DR. BRIGGS, DENTIST. Dr. Briggs had an office at the corner of 117th Street and Jamaica Avenue, above the office of Joel Fowler. A 1904 advertisement by Dr. Briggs proclaims the expertise that had developed in dentistry for that time. "Teeth extracted painlessly with laughing gas, vitalized air of local anesthetics for 50 cents. Good guaranteed set of teeth for $10 and gold crowns from $6 to $8, and gold fillings from $1.50, according to size." (Courtesy the Lucy Ballenas Collection.)

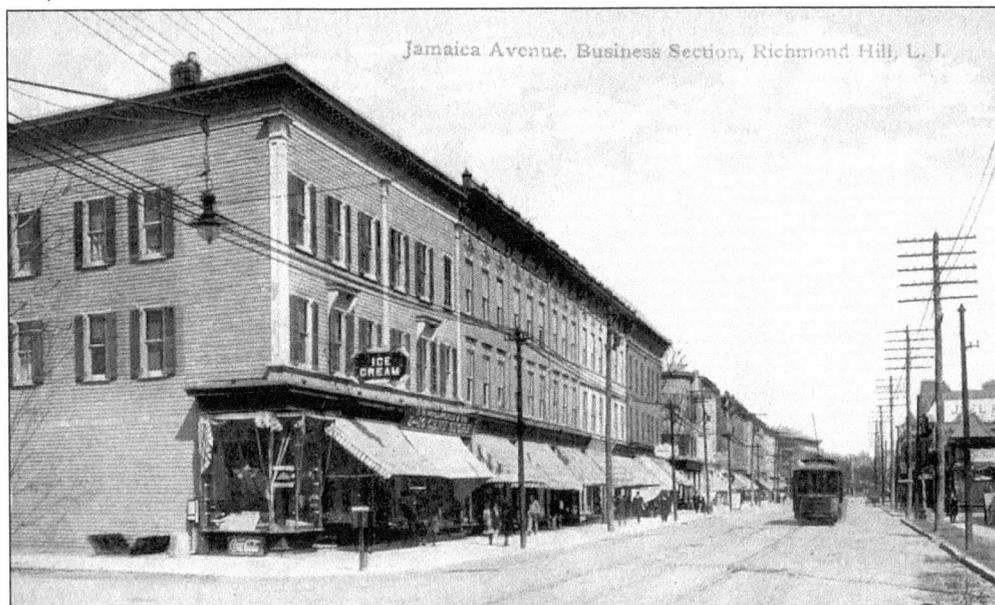

Jamaica Avenue, Business Section, Richmond Hill, L. I.

JAMAICA AVENUE WOOLWORTH & COMPANY, C. 1910. Looking east on Jamaica Avenue, this photograph shows the corner of 114th Street. Telephones, as indicated by the poles, have come a long way. "A public telephone is to be put in the Post Office [Van Wicklen's store] this week. He will connect with all the main branches, and supply a demand long needed by the residents of this locality." —*Long Island Democrat*, 1885. (Courtesy the Lucy Ballenas Collection.)

37

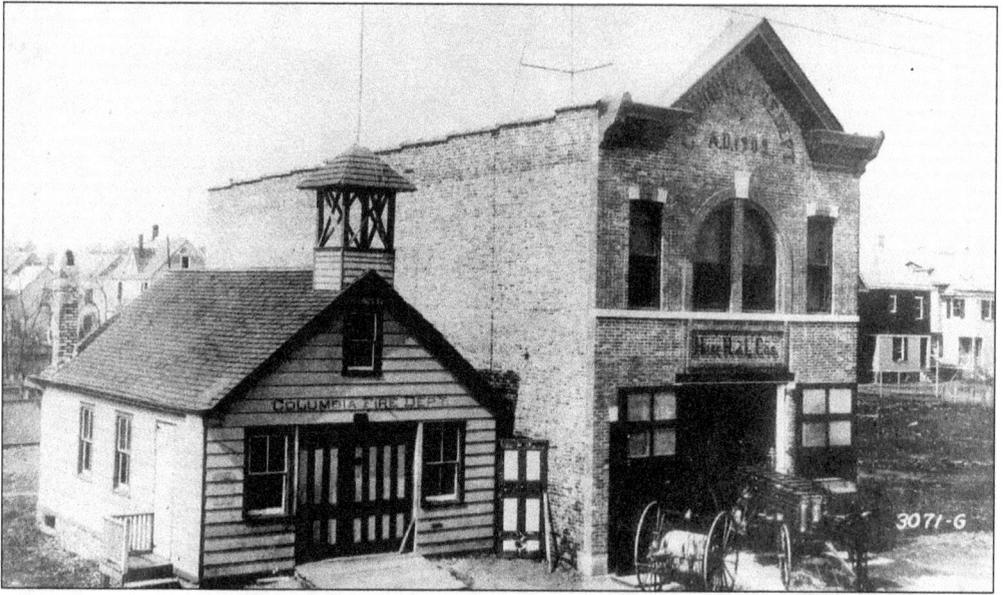

THE COLUMBIA FIRE DEPARTMENT. The Columbia Fire Department was organized in 1893. Its wooden firehouse was located on the west side of Willow (122nd) Street. High on the pole is a fireman's hat. The brick building, erected in 1902, displays a hose cart and a hook and ladder. Before telephones, a whistle would alert the volunteers. The first volunteer to arrive at the firehouse took hold of the hose cart and dragged it out. Others would hold on while the cart was driven the shortest route to the fire, through farmland and backyards, trampling over flowerbeds. "Dave Leyshon fell down and the boys pulled the hose carriage right over his prone body. He grumbled but it was all in a day's work." (Courtesy the Richmond Hill Post Office.)

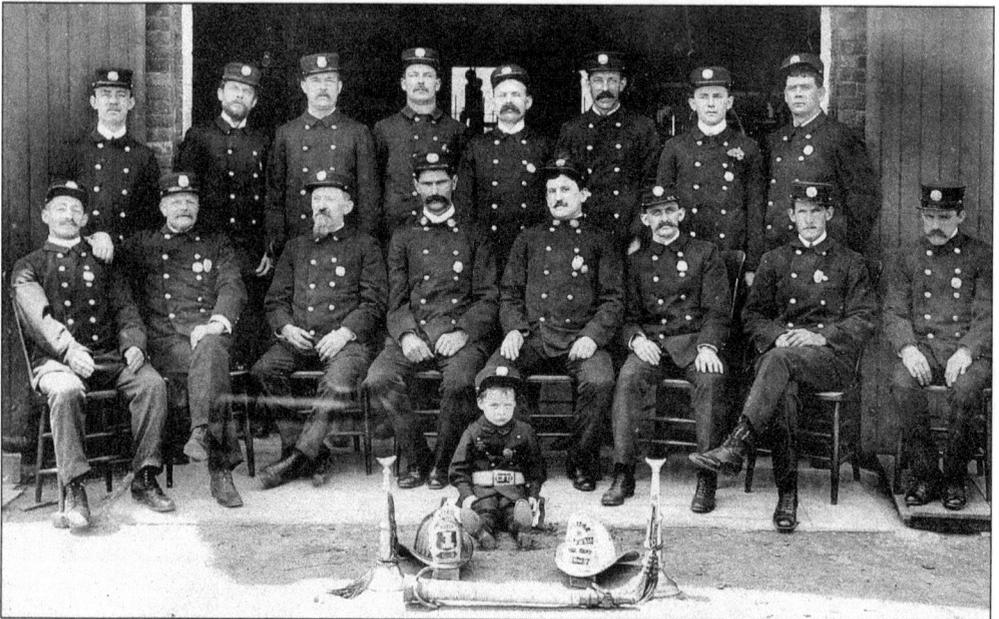

THE COLUMBIA HOSE COMPANY NO. 1. Volunteer firemen pose in the front of the 1902 building on Willow Street. Ernest Weiden is third from the right in the back row. The boy, the company mascot, is Louis D. Schroeter. (Courtesy Frederick E. Hueppe.)

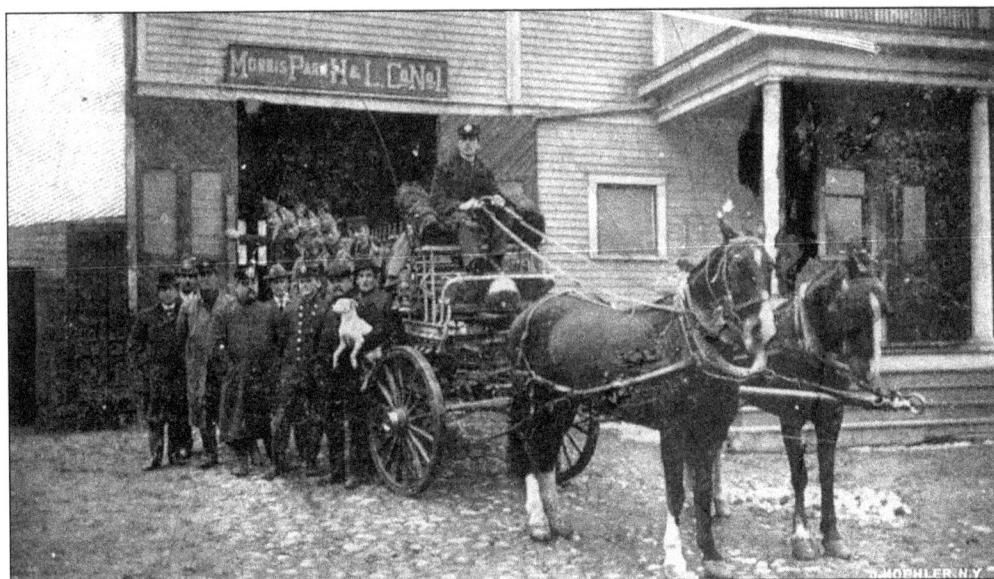

THE MORRIS PARK HOOK AND LADDER COMPANY. This company was located in the left wing of the Richmond Hill Village Hall on Johnson Avenue (118th Street). Today it is the site of the 102nd Police Precinct. This is an early-20th-century photograph of one of the five companies that served Richmond Hill between 1892 and 1907. The dog in the arms of a fireman was their mascot. A dog named Rags was often seen hanging around Richmond Hill firehouses. The horses' names were Jim and John. (Courtesy the Lucy Ballenas Collection.)

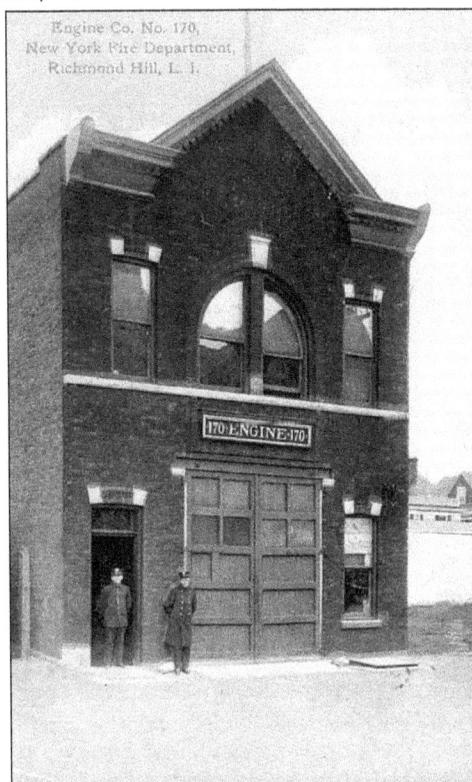

ENGINE COMPANY NO. 170. Formerly the Columbia Fire Department, this organization was manned by volunteers. The Richmond Hill Exempt Volunteer Firemen's Association was considered one of the best organizations in the county. They labored in the old village until it was consolidated with the city of New York, continuing under the city for nine years. In 1907, all companies were disbanded. During World War I, they worked in cooperation with the paid firemen until the war ended. (Courtesy Nancy Cataldi.)

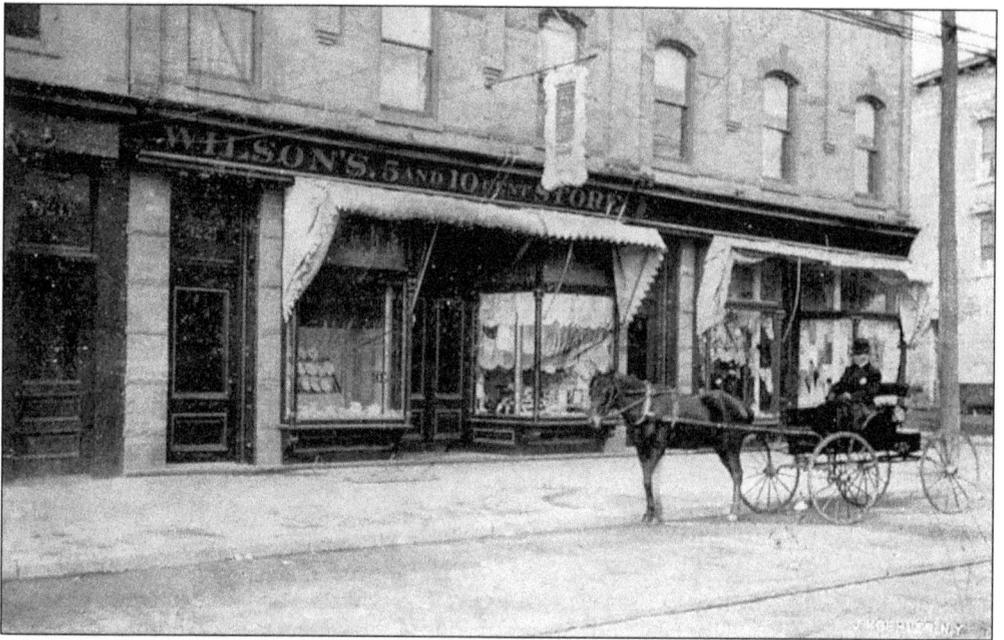

WILSON'S. On the north side of Jamaica Avenue and 116th Street was this five-and-dime store, owned by Walter A. Wilson by *c.* 1910. Wilson sold the establishment in 1919. He was a well-known and popular resident. "If we want to pave the way to an even greater future for our section let us Live Right, Stay Right and Buy Right in Richmond Hill." —Stanley Payne, president of the Richmond Hill Board of Trade, 1926. (Courtesy the Lucy Ballenas Collection.)

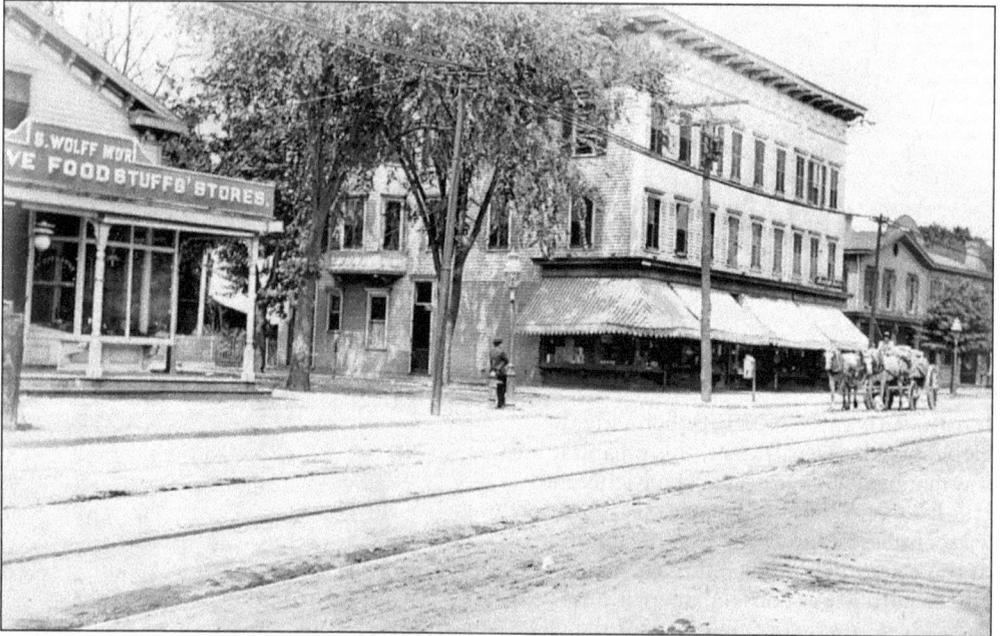

B. WOLFF'S GROCERY. The store was once located in a wooden structure that was replaced in 1910 by the first concrete-poured building in Richmond Hill, which is still standing and now called the Richmond. The grocery was located at the corner of Park Street and Jamaica Avenue. (Courtesy the Lucy Ballenas Collection.)

JEPHSON & COMPANY PLUMBERS AND GAS FITTERS. At the busy corner of Jamaica Avenue and Jefferson (116th) Street was the building that housed the Arcanum Hall, birthplace to numerous churches and Richmond Hill organizations. "To the tradesmen the success of this village is due in a great measure because without them existence would be incomplete." —Stanley Payne, president of the Richmond Hill Board of Trade, 1926. (Courtesy the Lucy Ballenas Collection.)

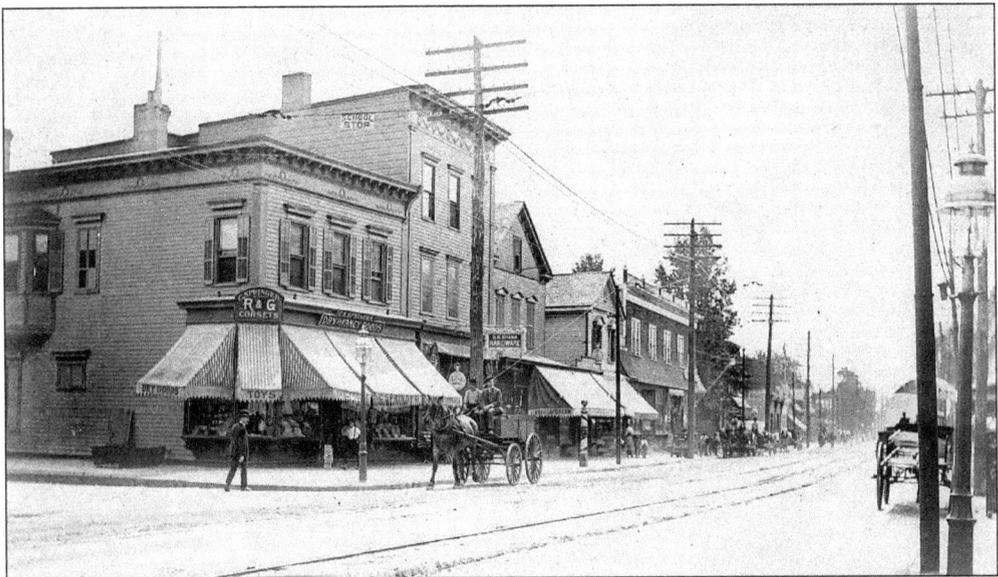

THE BUSINESS SECTION, JAMAICA AVENUE. "The business and professional men in receipt of moderate incomes find in Richmond Hill a most congenial home location and the development of the place has especially attracted families of culture and refinement, the result being the building up of a suburban community which is distinctive in its homogeneity, with a social and intellectual atmosphere, such as is found in no other New York suburb." —*Industrial Recorder*, 1905. (Courtesy the Lucy Ballenas Collection.)

41

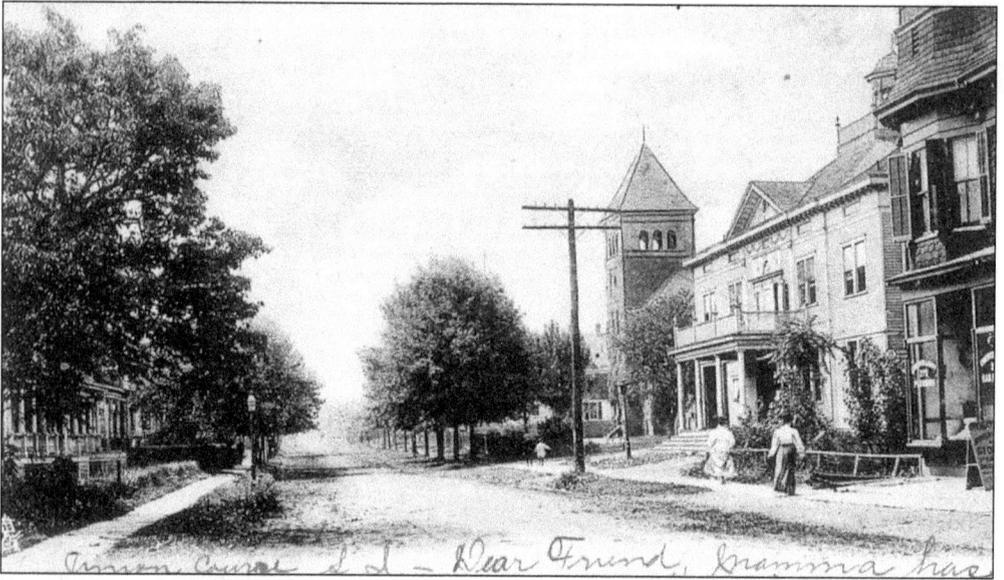

THE RICHMOND HILL VILLAGE HALL AND THE JOHNSON AVENUE SCHOOL. It was evident that the old police station needed to be replaced, as indicated by this 1909 *Richmond Hill Record* article: "Twelve hundred pounds of patrolmen saved the station from sailing away in a storm, when the torrents were raging through Richmond Hill's ravines, causing it to rock. They took a stranglehold on the trees they could reach by bending over the station porch and to their relief, bottom was touched again." (Courtesy the Lucy Ballenas Collection.)

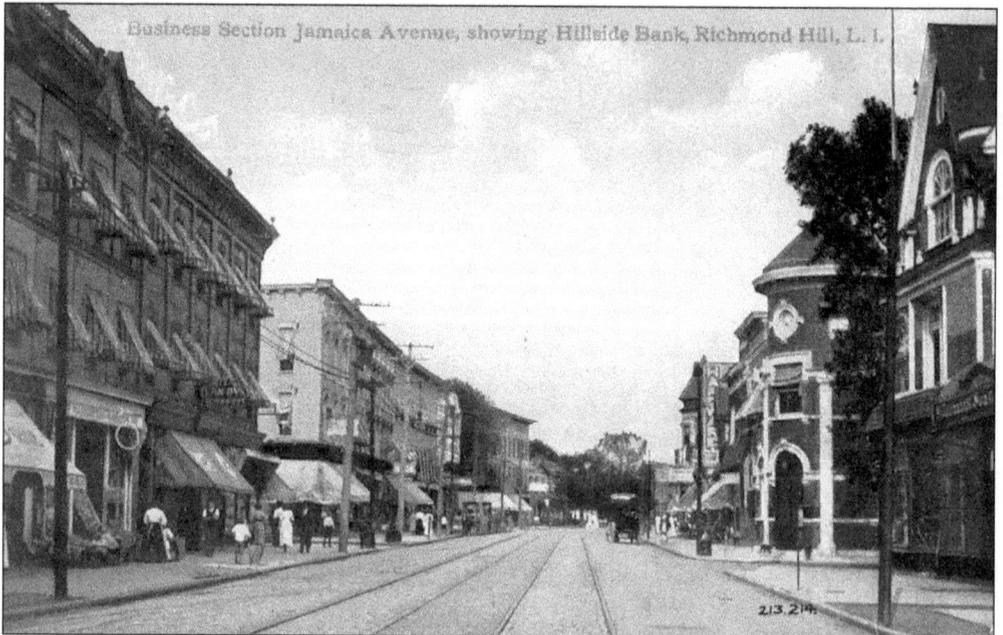

HILLSIDE BANK. The Haugaard brothers, William and Henry, had their architectural office on the second floor of the building at Jamaica Avenue and 116th Street. In 1917, a disgruntled builder entered their office and shot both brothers over a dispute of payment. William's life was saved when the bullet struck the eyeglass case in his vest pocket. His brother Henry was seriously wounded but survived. (Courtesy the Lucy Ballenas Collection.)

MAPLE GROVE CEMETERY, THE KEW GARDEN ROAD ENTRANCE. Established in 1875, Maple Grove Cemetery featured gentle rolling hills, ornamental trees, and convenient rail access from the city. To the left is stonecutter John Budion's 1901 house and workshop. He is buried in this cemetery among many of the stone monuments he had carved. Near this entrance in 1890 a gravedigger named Frule Eklund secretly dug a grave. Two days later, as he lay on his deathbed, he asked to be buried in that grave, which he said he had dug for his own body. The cemetery honored his dying wish. (Courtesy Maple Grove Cemetery.)

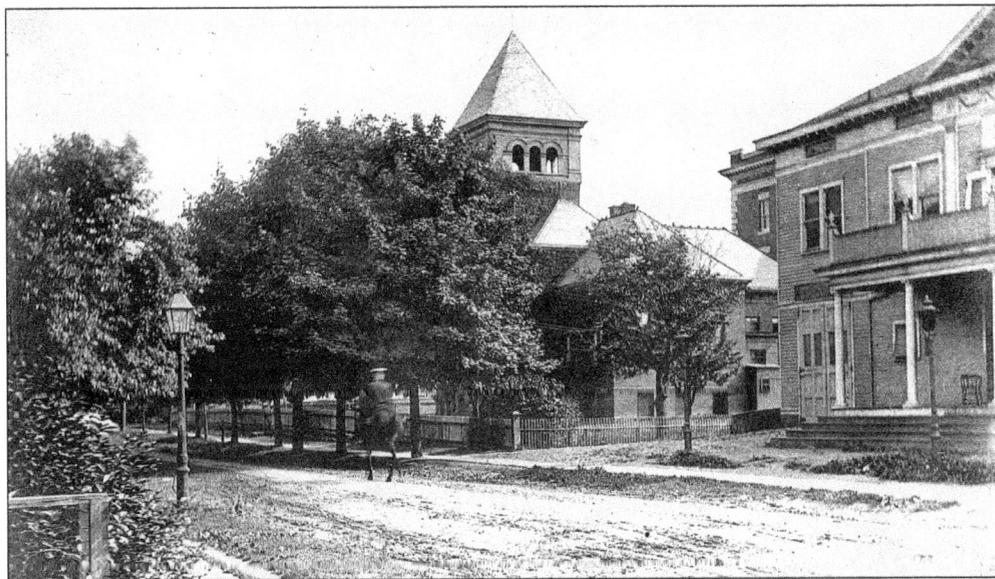

THE RICHMOND HILL VILLAGE HALL. In 1895, Clarenceville, Morris Park, and Richmond Hill merged into the Village of Richmond Hill (before that they had been a part of the Town of Jamaica). The hall was also the Village Opera House. Here, Walter Hubbell, leading a troupe of Shakespearian actors, presented *Romeo and Juliet* and *Othello*. This building also housed the village police and the headquarters of Morris Park Hook and Ladder. It was torn down in 1910 to make way for the new police precinct. (Courtesy the Lucy Ballenas Collection.)

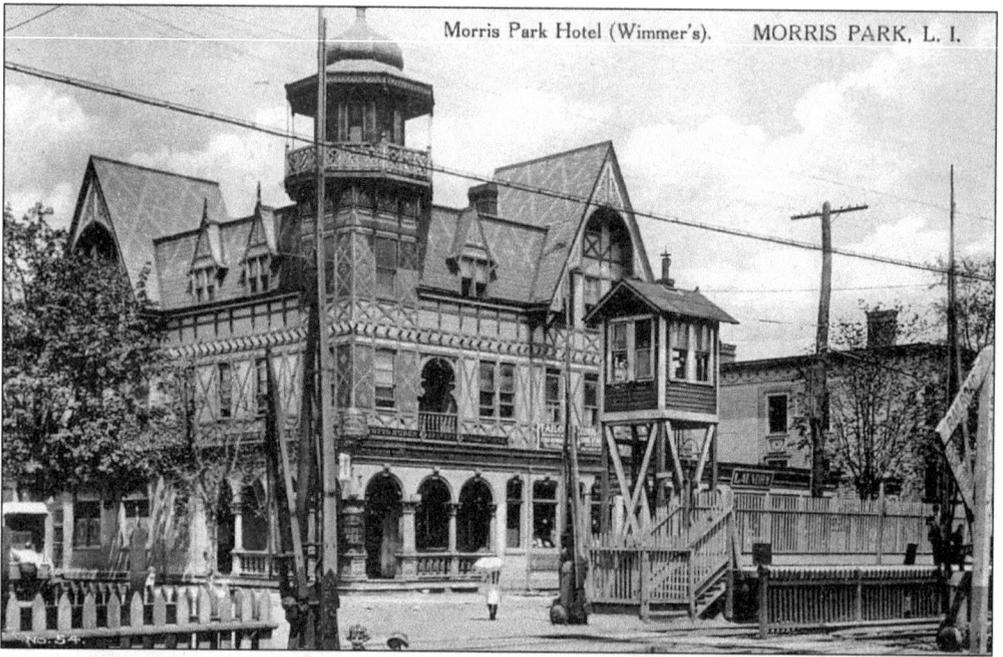

Morris Park Hotel (Wimmer's). MORRIS PARK, L. I.

THE MORRIS PARK HOTEL. No other commercial building has made more of an impact architecturally than the Morris Park Hotel. Built in the 1890s, it stood at the corner of Lefferts and Atlantic Avenues in the town of Morris Park. (Courtesy the Lucy Ballenas Collection.)

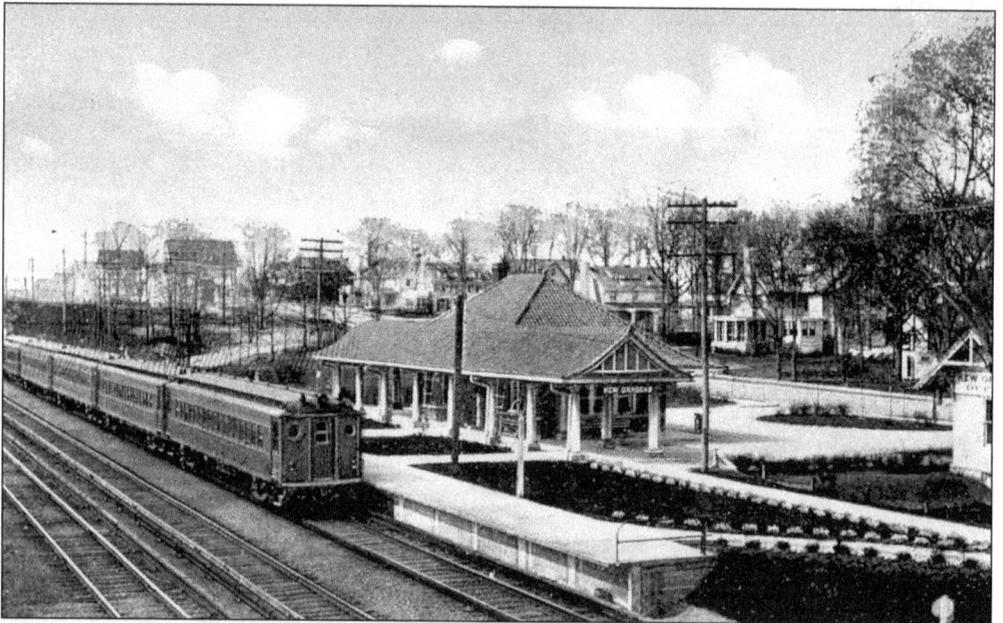

KEW STATION. In 1910, the Long Island Railroad opened its new electrified main line, which for the first time connected Long Island directly with New York City via East River tunnels. In exchange for a right-of-way through the Richmond Hill Golf Course, the railroad opened a new station called Kew. The station was Richmond Hill's fourth—the other three being Richmond Hill, Morris Park, and Clarenceville. (Courtesy the Lucy Ballenas Collection.)

Three

AN OLD-TIME PICTURE GALLERY

*They were to be seen wondering here and there expressing sentiments of love
and words of kindness, as they thought on the past and the future. How sweet
the voice of sympathy, let it be heard dripping from the lips of those we love, of those
who have been endeared to us by long years of friendship and intimacy, or from those
we know not, and it is ever the same. To be conscious that other hearts are beating with
joy, when we, too, are filled with hope and gladness, is wont to increase our pleasures.*

—Long Island Democrat, 1867

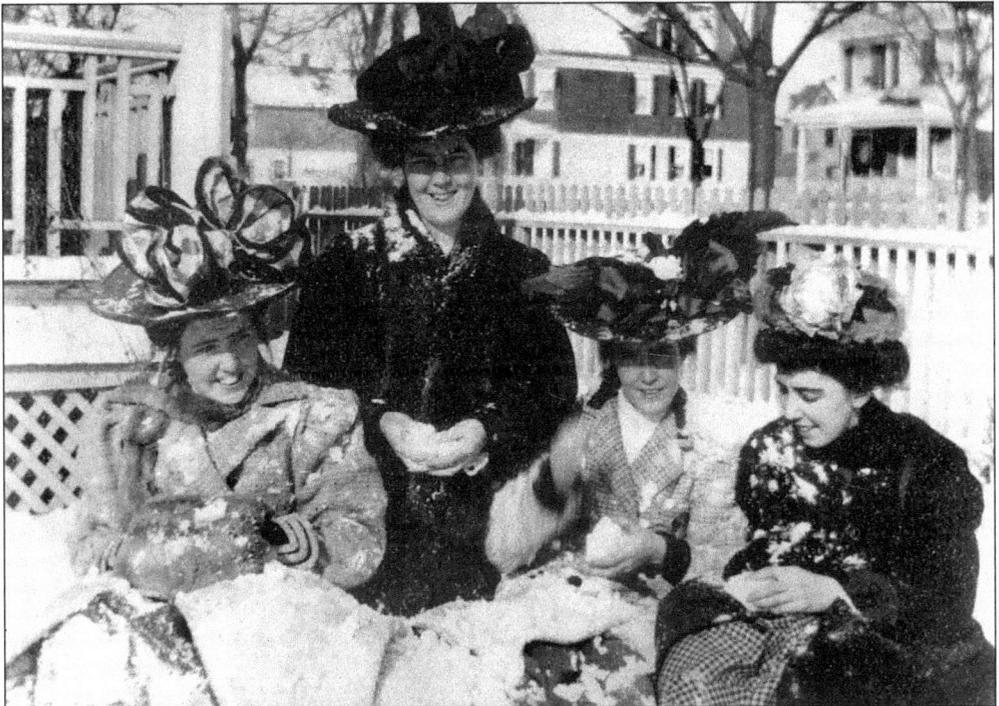

THE DEEHAN SISTERS IN THE SNOW. Wearing elaborately decorated hats, the sisters play with snow in the yard of their farmhouse on 111th Street. (Courtesy St. Benedict Joseph Church, Margaret Lally.)

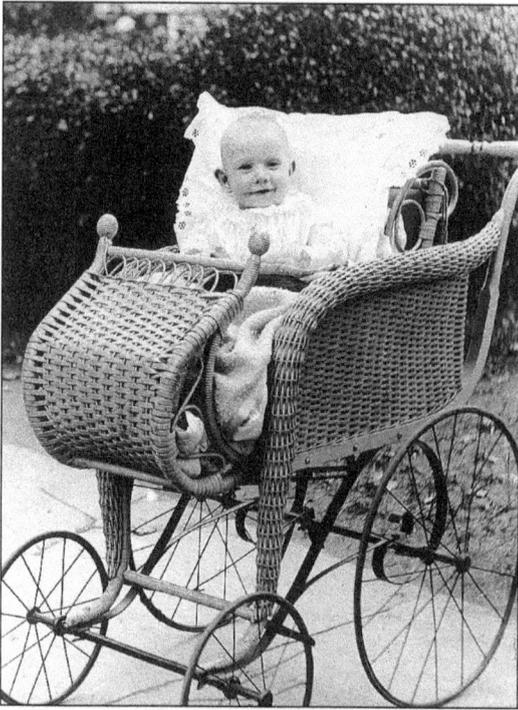

A BABY IN A CARRIAGE. Robert Reginald Waltien is shown in 1909 at the age of six months. He lived on North Jefferson Avenue. (Courtesy the Richmond Hill Historical Society.)

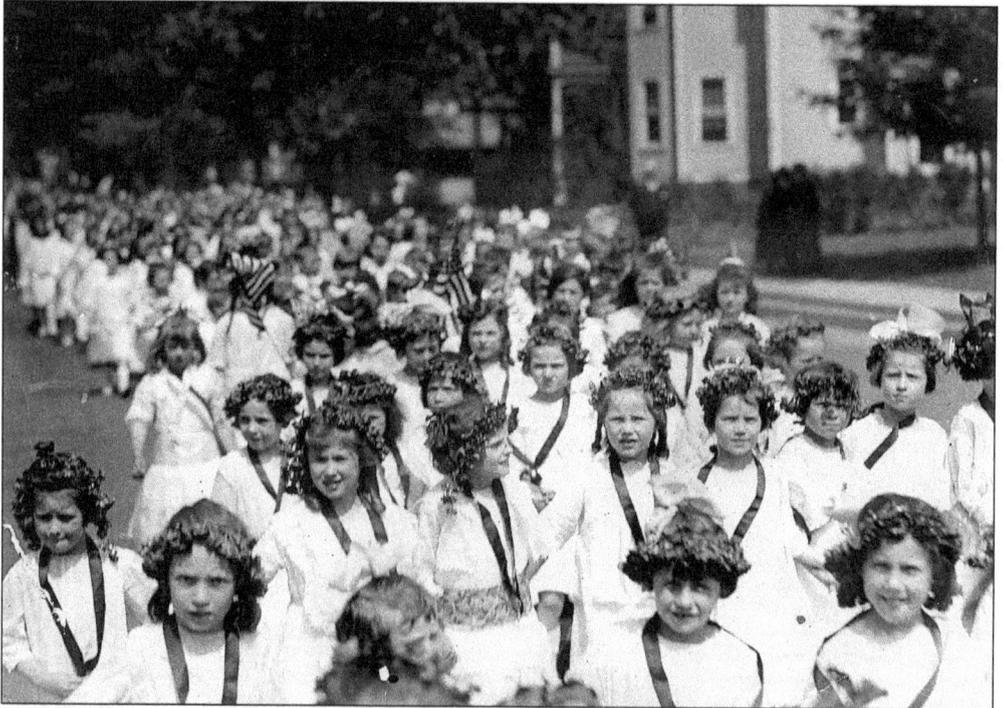

SODALITY DAY. Dressed all in white with floral wreaths in their hair, young Catholic girls parade down 86th Avenue. The Sodality of the Children of Mary is an organization for both boys and girls. They learn to pray, sacrifice, and practice modesty. (Courtesy Rita Werner, Holy Child Jesus Church.)

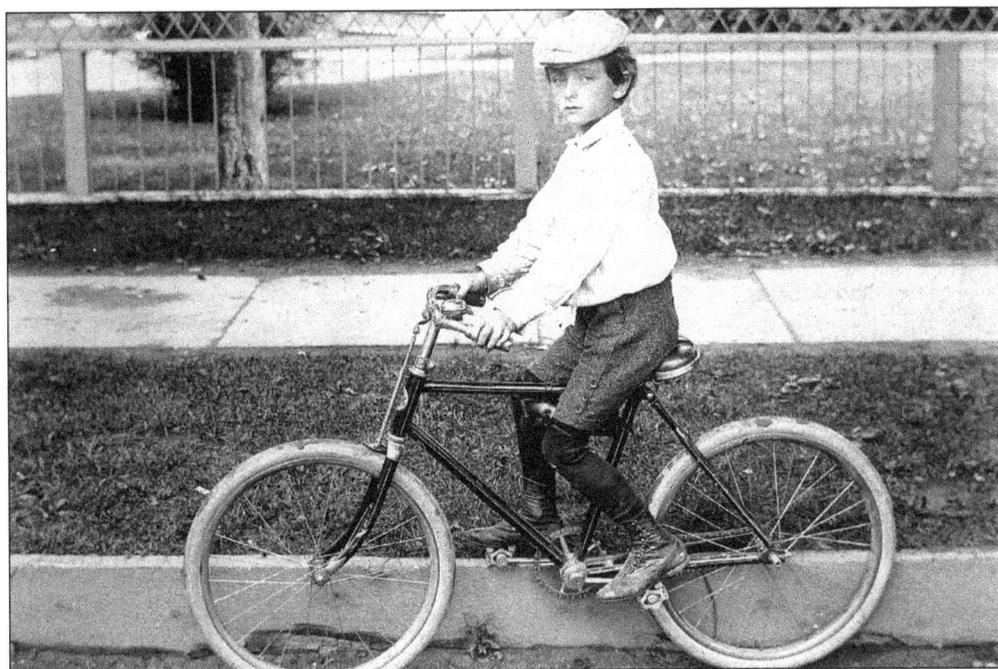

A BICYCLE RIDE. Norman A. Quortrup is shown at the beginning of the 20th century. The Queens County Wheelmen Club was organized in 1891, and its clubhouse was located on Lefferts near Jamaica Avenue. The bicycle craze at the end of the 1800s led to clubs being started across the country. Almost every young person had at least one bicycle for Sunday whirls over the country roads. Henry Willett Sr. (the former president of Richmond Hill), Harold Quortrup, and Jacob Riis were counted among its members. (Courtesy Helen A. Harrison, Quortrup Family Archives.)

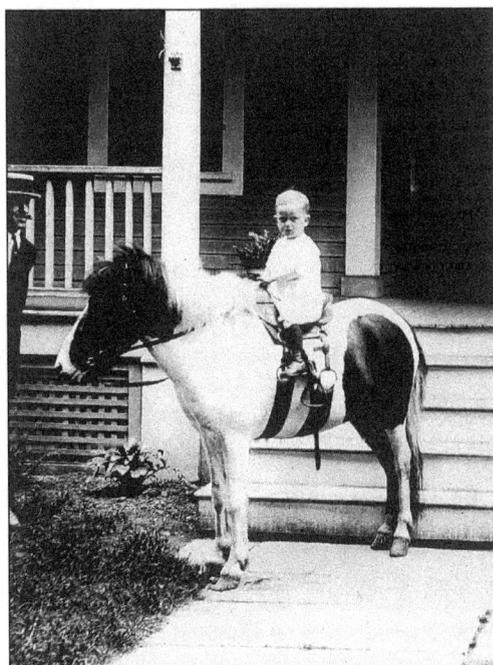

A PONY RIDE. A young Robert Parylak rides a pony in front of his aunt Margueritte Stratton's house on 118th Street c. the 1920s. (Courtesy Robert Parylak.)

HOLY CHILD JESUS GIRLS' BASKETBALL TEAM, 1946. Coach Mike Gamberdella sits in the driver's seat as his team playfully poses for a picture. (Courtesy Rita Werner.)

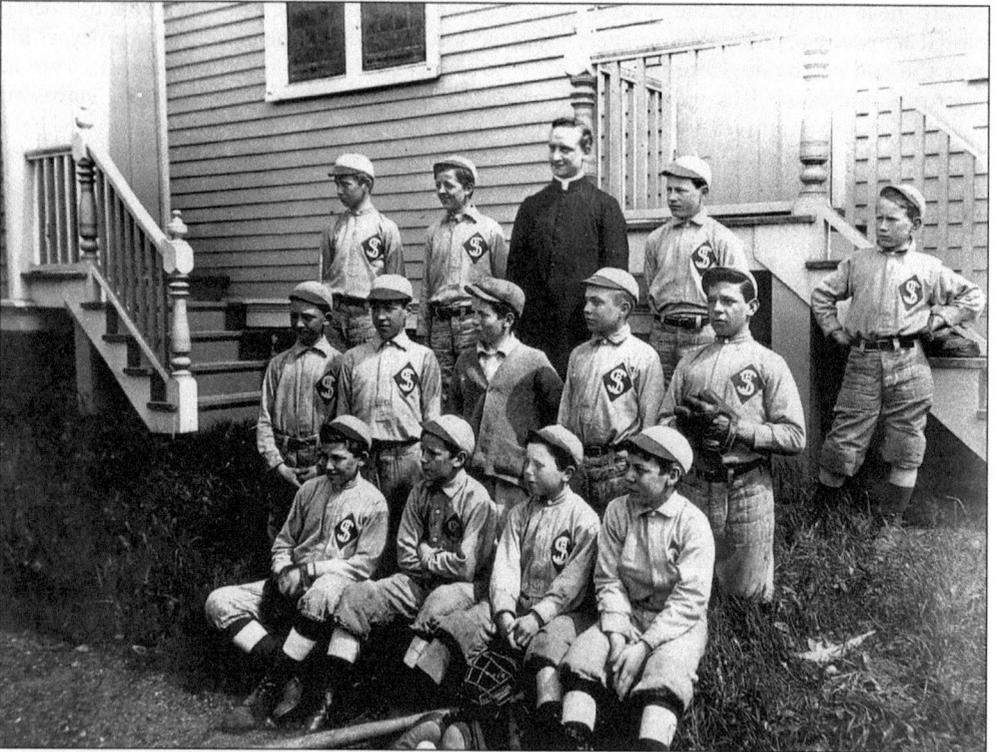

ST. BENEDICT JOSEPH BASEBALL TEAM, 1910. A parish curate stands by the side of the church with the parish baseball team. (Courtesy the Lucy Ballenas Collection.)

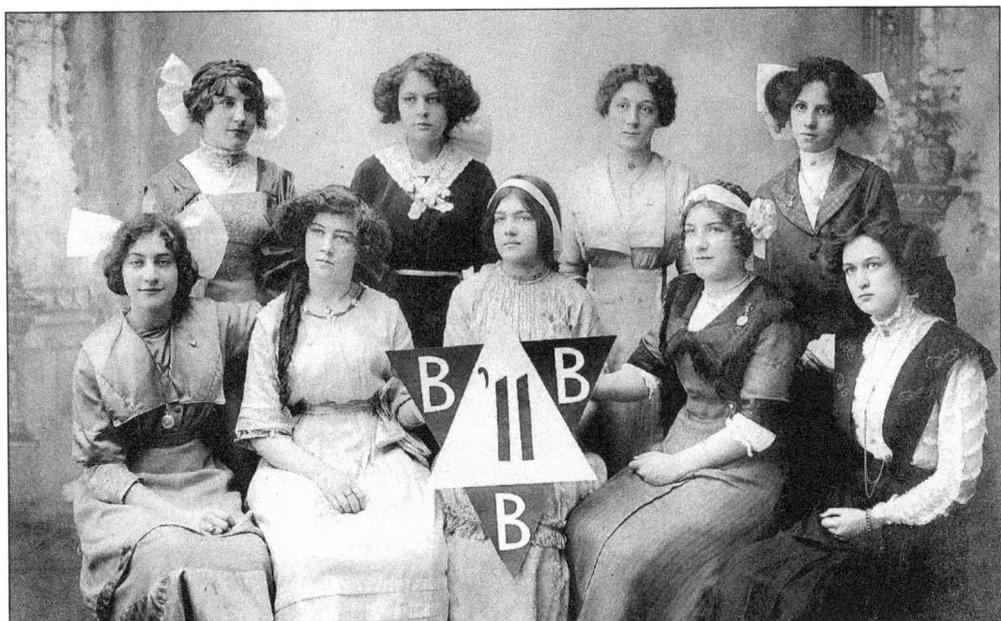

THE TURVERINE GROUP, 1911. This ladies' group was formed for the German citizens of Richmond Hill. On the far right in the front row is Matilda Mayer Beyer. (Courtesy Robert Parylak.)

TAKING A RIDE. Marie German stands on the running board of a late-model car in 1920. Another young woman had made headlines years before. "Mrs. Cuneo, of Church Street, having the reputation of being the most expert woman motorist in America, was arrested for speeding in Coney Island. She was charged for driving 25 miles an hour. Policeman Culbertson pursued the automobile before overhauling it, arresting her. At the Flatbush Avenue court Mrs. Cuneo waived examination and was held in the sum of $200." —*Richmond Hill Record*, 1909. (Courtesy Rita Gambardella.)

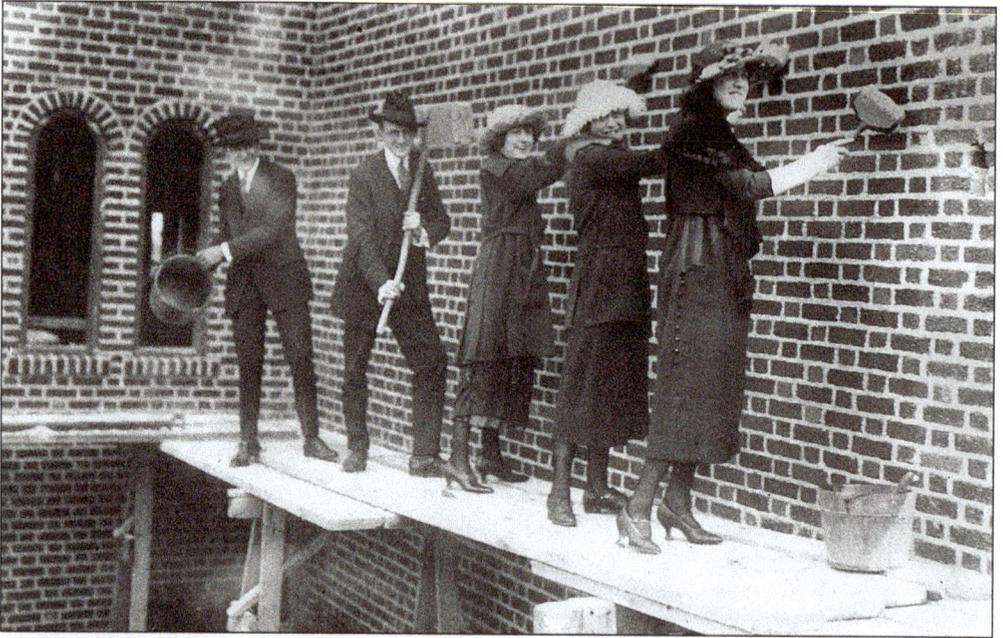

A CONSTRUCTION CREW. Parishioners of St. Benedict Joseph Church drum up support for their building fund to help construct their new church in 1918. Mary Daly White, a student in the first graduating class of St. Benedict Joseph School in 1916, recalls, "We would sell bricks, 5 cents a brick. They were listed on a paper or a card and you would sell them. All the neighborhood families owned a brick in St. Benedict Joseph's." (Courtesy Nancy Cataldi.)

LOVE AND BLOOM, 1940. "I am a great admirer of the fair ladies-whose words are like dewdrops to thirsty flowers, or as the sweet perfume of the honey suckle. They were out in full force, and made the woods ring loud and clear with their musical tones, as they tripped arm-in-arm over the grassy sward. The passing breeze played about their marble-white temples, gently lifting the luxuriant tresses of long dark hair, and dropped them in rich profusion upon their gracefully molded necks and shoulders." —*Long Island Democrat,* 1867. (Courtesy the Richmond Hill Historical Society.)

MOTHER AND DAUGHTER. Anna Theresa Beyer and her daughter Matilda sit in their garden at 89-21 118th Street in 1907. "I love spring. Especially do I love spring in Richmond Hill. And how Mother Nature must love our town. Every tree, plant or bulb we choose to put in the soil seems to be a favorite child of hers. To be sure, the good dame insists on our hearty cooperation, as any mother would." —*Richmond Hill Record*, 1912. (Courtesy Robert Parylak.)

SISTERS. Agnes and Anna Kliorikaitis pose in a studio setting in the 1920s. Anna emigrated from Lithuania in 1913, entering the country through Ellis Island. (Courtesy Diane Freel.)

51

BUDDIES ON BEECH STREET. Arthur Cummings (left) and Dick Anderson are on Beech (120th) Street in 1925. In the background, the cupola of the old Bronson House is visible. (Courtesy Helen A. Harrison, Quortrup Family Archives.)

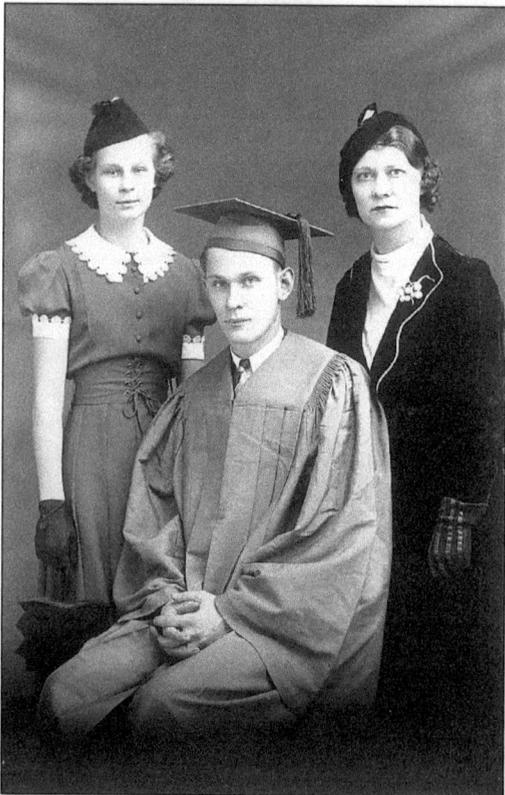

A RICHMOND HILL HIGH SCHOOL GRADUATE. Leonard Banaitis poses with his sister Helen and mother, Agnes, in 1937. Leonard's quote in the yearbook read, "Little things affect little minds." Some rules in the 1900 annuals of the Richmond Hill High School included "1) The pupils are requested to talk loudly in the halls to amuse the teachers. 2) Will the pupils please bring a dose of yeast to school. Perhaps this will make them rise. 3) Stir the pollywogs in the lecture-room, they need exercise. 4) Please put your feet in the aisles, as the track team needs the practice." (Courtesy Diane Freel.)

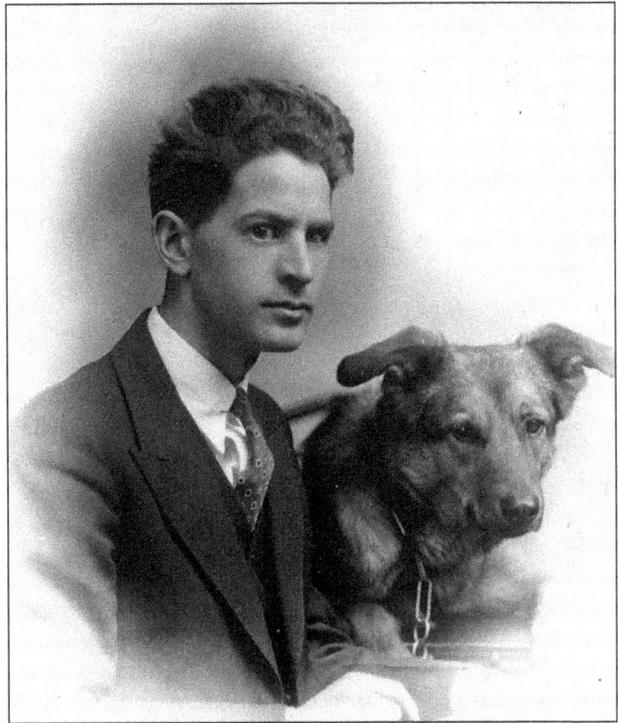

A MAN AND HIS DOG. Thomas Gilmartin, who lived on 118th Street, is shown with his Seeing Eye dog, Rascal. His father ran the Gilmartin Pharmacy on Atlantic Avenue. For many years, Thomas was the director of the lighthouse in Queens. (Courtesy Robert Parylak.)

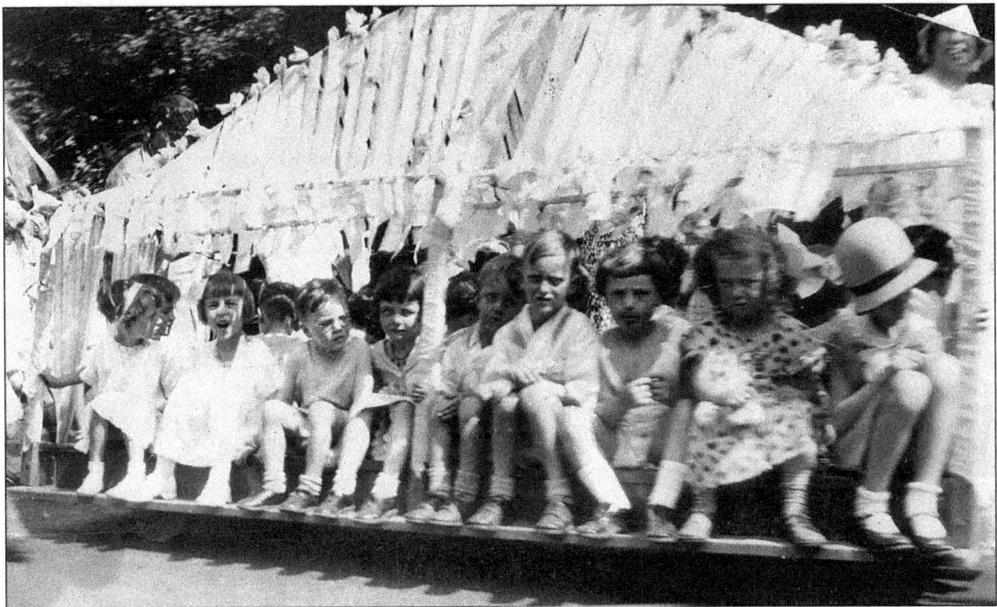

ANNIVERSARY DAY. In June 1929, a young Robert Parylak and his sister ride a Church of the Resurrection float. "The party assembled and marched through neighboring streets to the music stand in Forest Park. The sun shone down on a constantly changing mass of color. Beautiful children in gorgeous costumes and floats, dazzling with gilt and jewels, made a picture well nigh indescribable. There, were seven floats, many of them the work of proud and fond fathers." —*Richmond Hill Record*, 1916. (Courtesy Robert Parylak.)

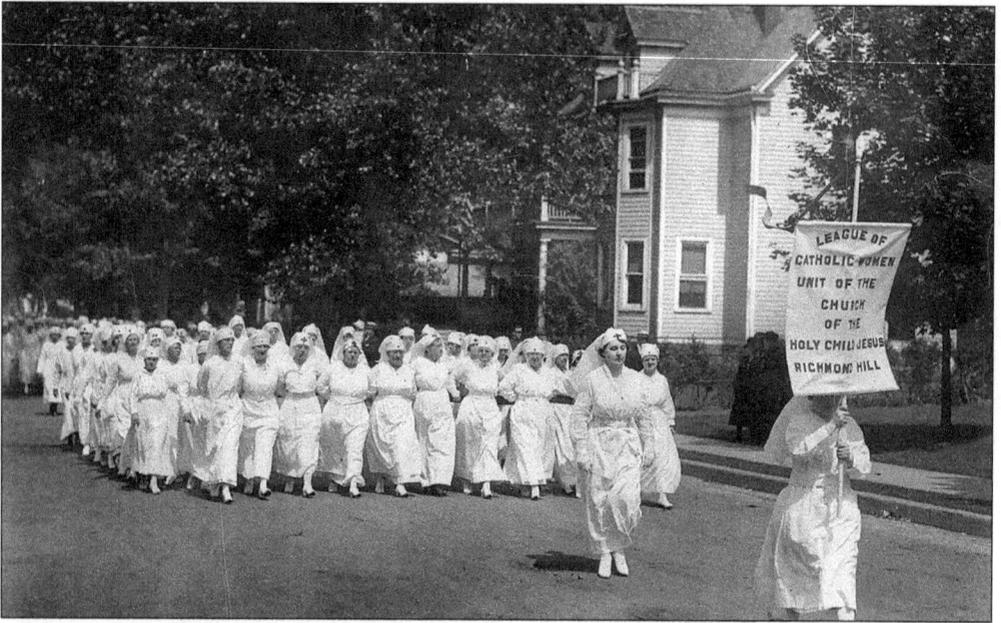

THE LEAGUE OF CATHOLIC WOMEN. A unit of the church Holy Child Jesus marches in a parade on 86th Avenue in 1917. This organization was founded in 1911 and was involved with programs such as war-relief work, boys and girls group homes, and health and educational programs. (Courtesy Rita Werner, Holy Child Jesus Church.)

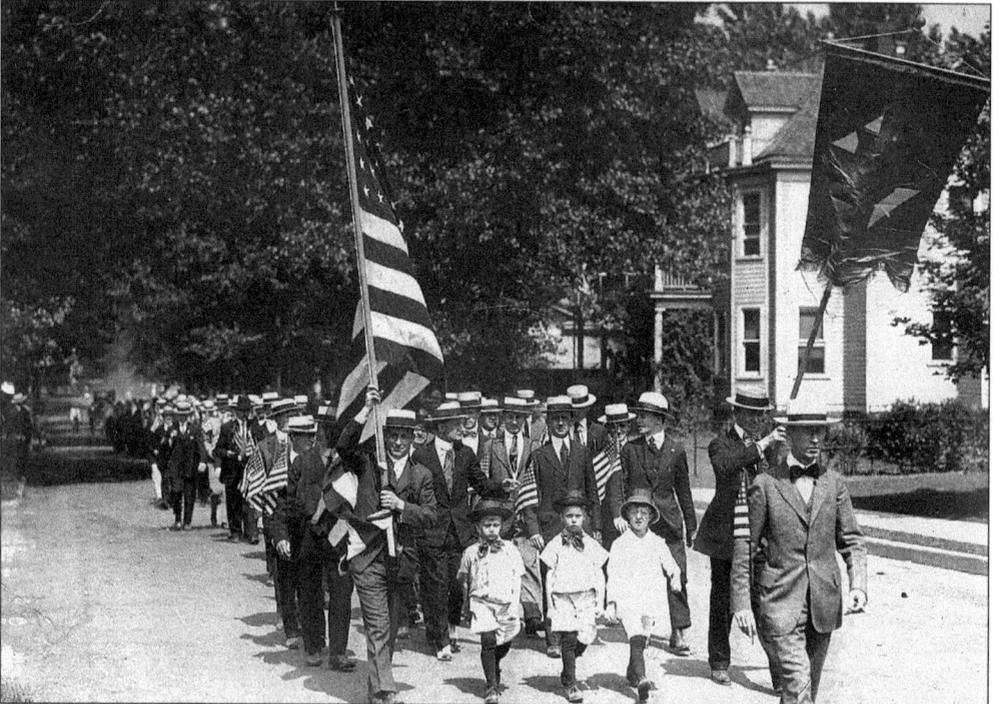

THE KNIGHTS OF COLUMBUS. This parade was held on 86th Avenue in 1917. The Knights of Columbus was founded in 1882 in New Haven, Connecticut, to aid those in need and encourage civic involvement and Catholic education. (Courtesy Rita Werner, Holy Child Jesus Church.)

MECHANICAL WONDERS. William Keller and Leonard Banaitis admire a new car in front of William's house on 86th Road in 1936. Another mechanical wonder had been dreamt of years before. "An aeronaut in the village, Paul Greshe of the Triangle Hotel, is working on his flying machine, built along lines which have never been attempted by flying machines manufacturers. Its inventor is not sure how it will work, hoping for the best. When the machine is ready, his friends will assemble to witness the trial trip." —*Richmond Hill Record*, 1908. (Courtesy Diane Freel.)

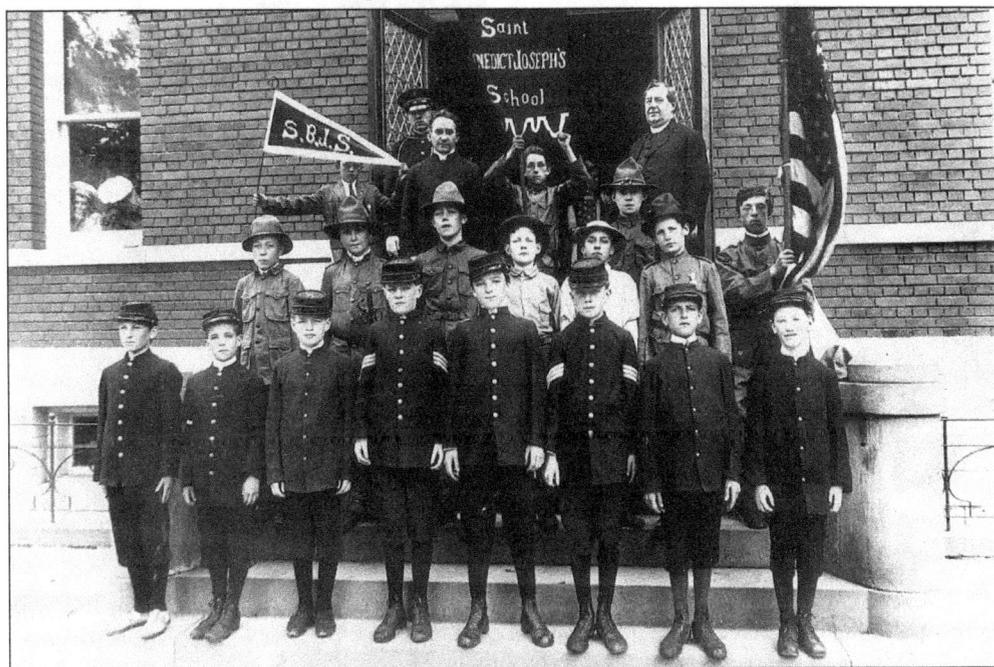

DECORATION DAY AT ST. BENEDICT JOSEPH SCHOOL, 1916. Fr. Patrick Fahey and a curate stand on the steps of the school with many of the students. They are dressed in Civil War and World War I uniforms. Now called Memorial Day, this holiday originated in the 1860s when widows and children decorated the graves of the Civil War dead. (Courtesy St. Benedict Joseph Church.)

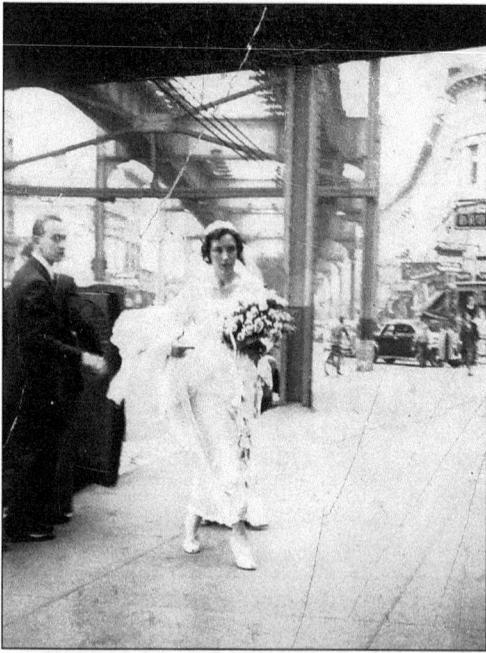

A Wedding Reception at the Triangle Hofbrau. In 1937, bride Evelyn Purnhagan rushes from her limousine to her wedding reception. Her husband, William Purnhagan, was later killed in Pearl Harbor. (Courtesy Regina Santoro.)

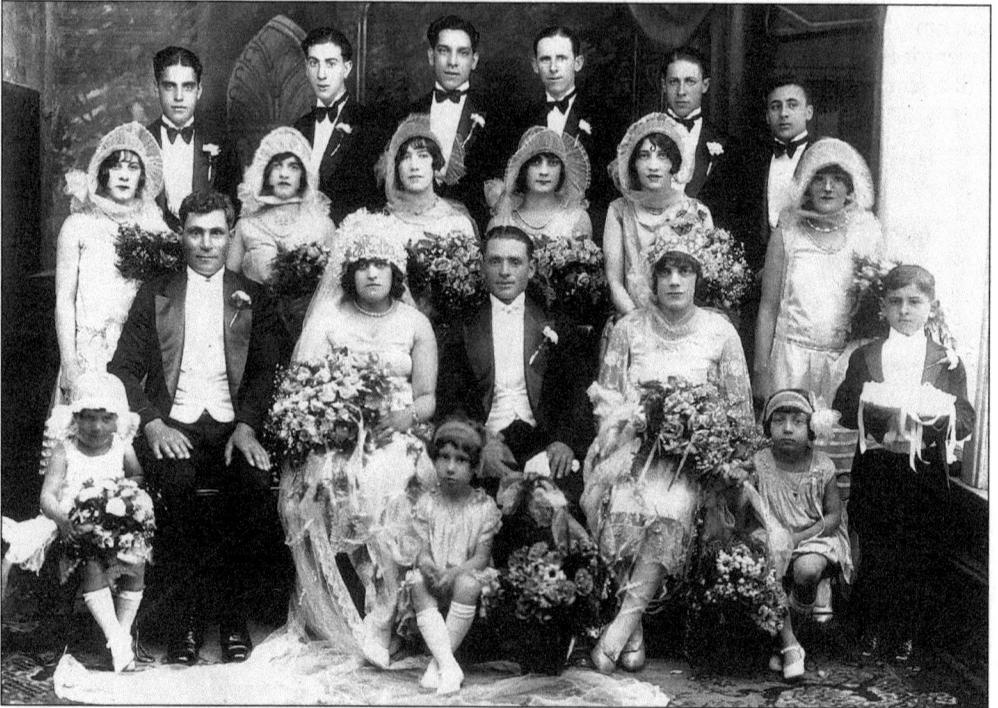

A Wedding Group. The Spagnolo family, who lived on 129th Street, is shown in the early 1920s. Many weddings have taken place in Richmond Hill with many unique reception rituals. "A reception was held at the residence of the bride's parents. In the bride's cake, a gold ring had been placed, and pieces were passed to everyone present. The person who was fortunate enough to get the ring was one of the ushers, who is to be married next month, and intends to put the same ring in the cake at his wedding." —*Long Island Democrat*, 1885. (Courtesy Ann Mancaruso.)

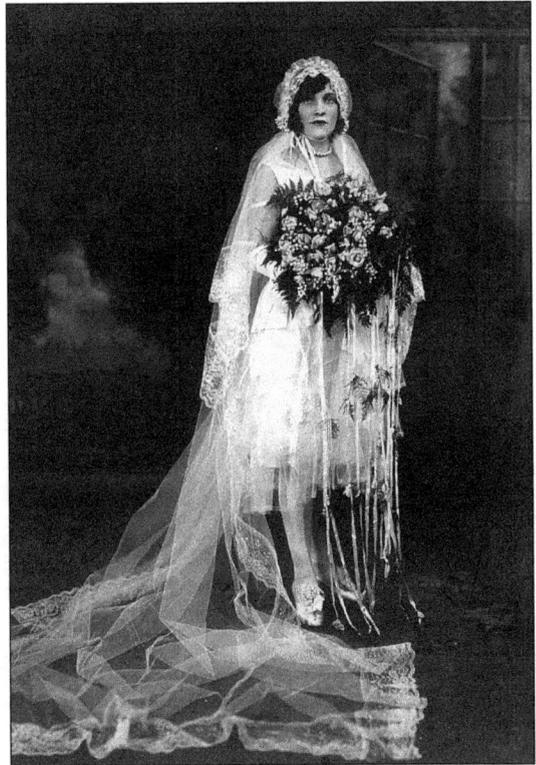

A WEDDING PORTRAIT. Bride Anna Kliorikaitis poses in a studio on November 25, 1928, becoming Mrs. George Freel. (Courtesy Diane Freel.)

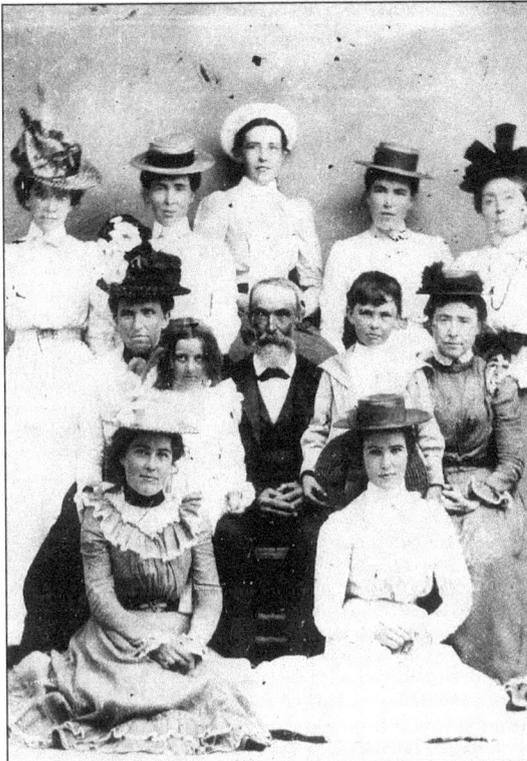

A DEEHAN FAMILY PORTRAIT. At the beginning of the 20th century, the Deehan family poses for a photograph. The patriarch of the family, Timothy Deehan, a gentleman farmer, sits in the center. Born in Ireland, he lived in Richmond Hill for 56 years. He was a founding member of St. Benedict Joseph Church. He raised six daughters and two sons. His son Joseph stands to his left in the picture. His other son James became a well-known civil engineer and surveyor in Queens. (Courtesy St. Benedict Joseph Church.)

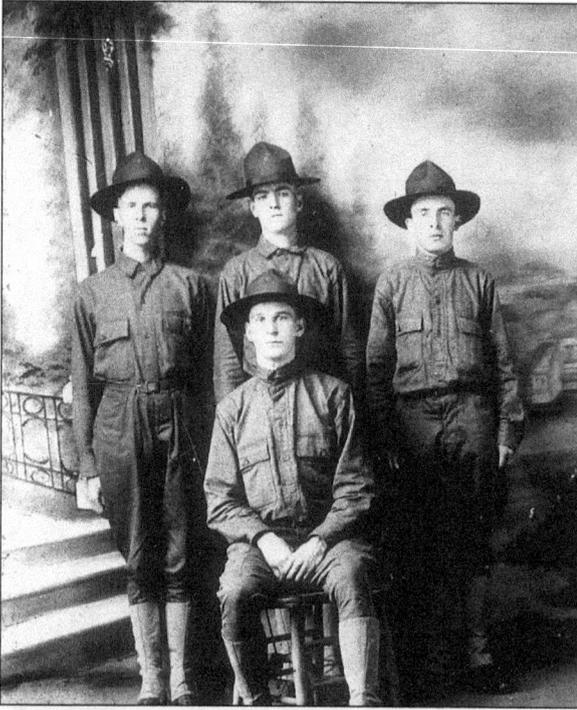

WORLD WAR I DOUGHBOYS.
Edward Murphy, on the right, lied
about his age and at 16 fought in
World War I. Another soldier,
Courtney Tolley of Company D,
306th Machine Gun Battalion,
worked at Rex Shoe Store. He was
in the "Lost Battalion," which,
for five days, was surrounded
by Germans and isolated in the
Argonne Forest in France. He
recalls, "I will never forget that
experience. Seems like a dream
now. Had to lie low every minute,
and I had no coat or blanket and I
guess that helped put my feet out
for the ground isn't warm or dry,
nor are the nights warm." (Courtesy
Hugh and Rita Maguire.)

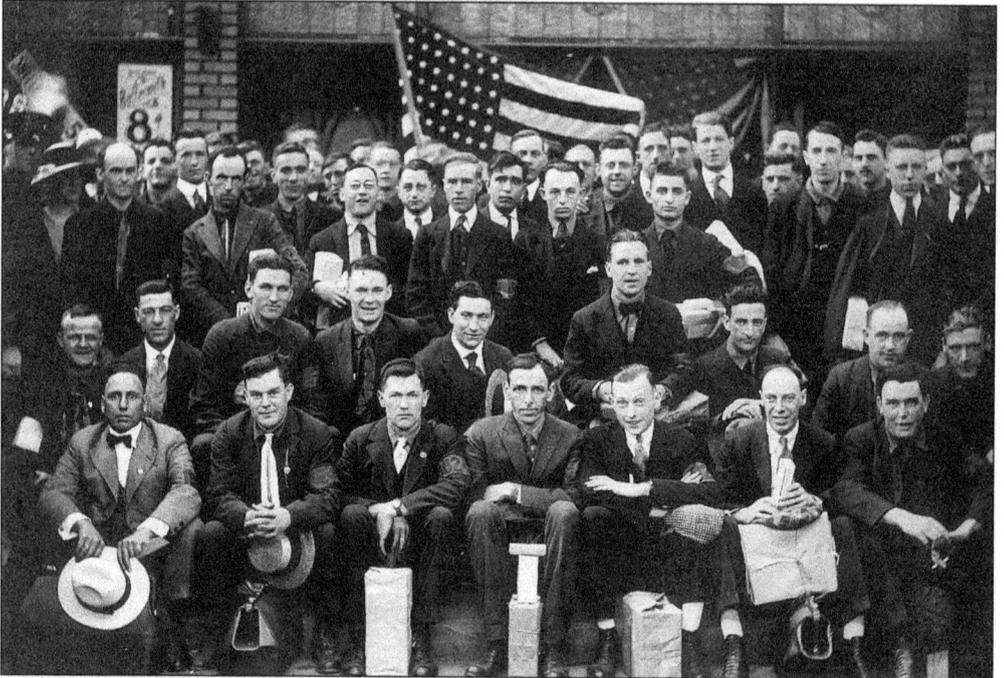

FAREWELL TO THE SOLDIERS, 1917. As young men prepared to leave for the war, the send-off
of soldiers began at 7:30 a.m., with roll call of those called to federal service. A committee of
Richmond Hill and Morris Park clergymen would grasp the hand of each boy called to colors
at the high school, followed by a parade on Jamaica Avenue to Library Square, Final Roll, and
farewell at Richmond Hill Station at 10:15. (Courtesy the Lucy Ballenas Collection.)

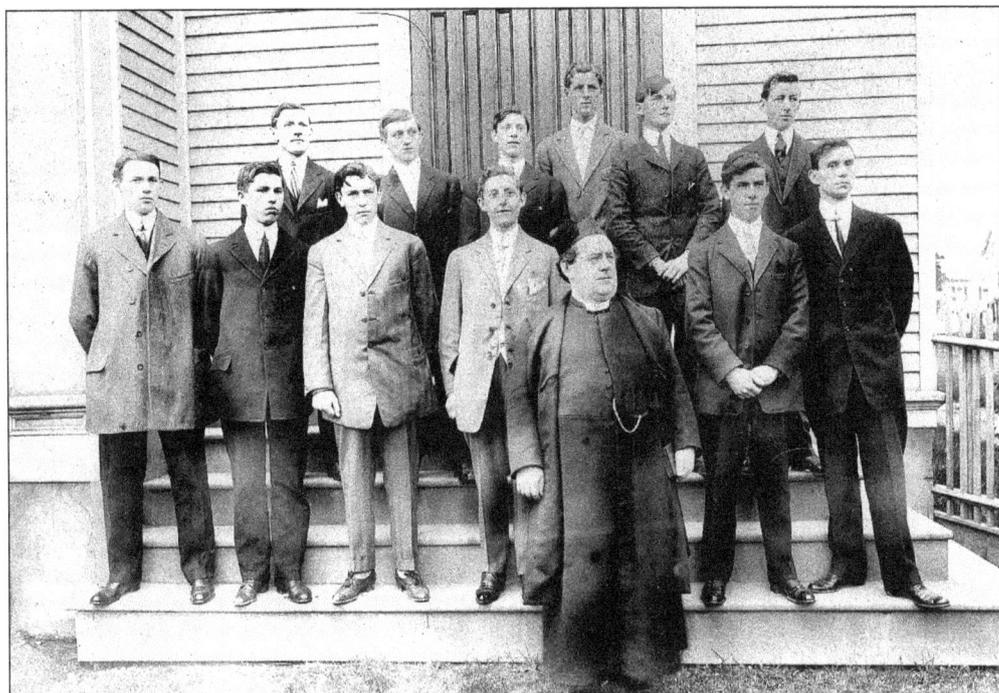

THE ST. BENEDICT JOSEPH CATHOLIC MEN'S CLUB, 1910. Fr. Patrick Fahey and a group of young men stand on the steps of the church. The group performed plays and held many athletic activities during its time. (Courtesy St. Benedict Joseph Church.)

LEAVING FOR CAMP, WORLD WAR I. George German prepares to leave Richmond Hill to fight in World War I. He poses with his mother, Jane German, in 1918. When the United States joined World War I, many Richmond Hill men were inducted. The first group consisted of 12 young men who left on September 5, 1917. A send-off committee was established so the boys would have the proper farewell. Many more groups would follow as the war continued. (Courtesy Rita Gambardella.)

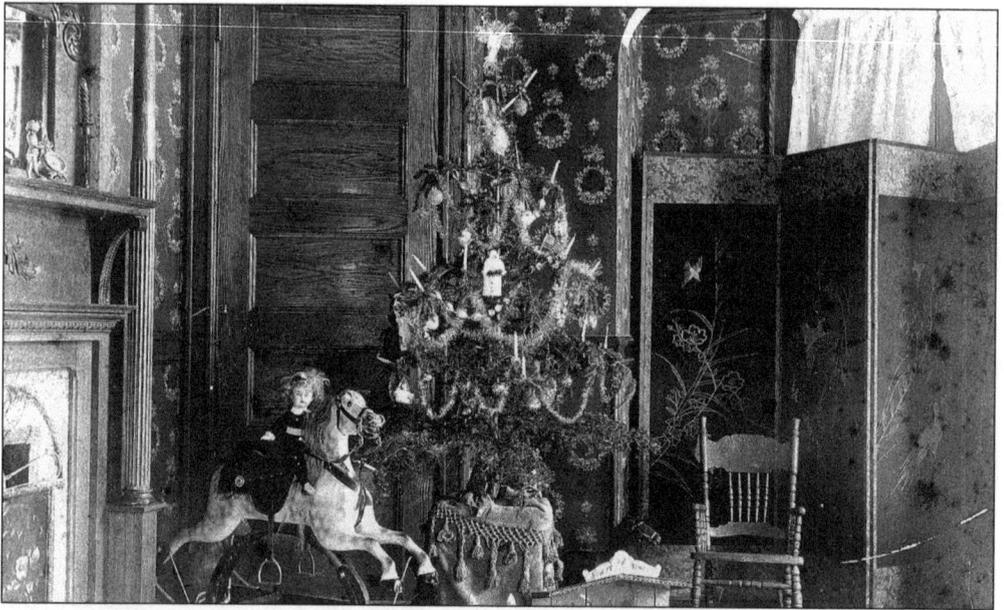

A Victorian Christmas in Richmond Hill, 1907. "Christmas Eve 1913—Ole has been playing 'Holy Night' and some other lovely hymns on the phonograph. Tonight Mr. and Mrs. Jacob Riis are spending the night at the Man's house and are to take Christmas there, and are to go around with the 'Christmas Carolers.'" —*Diary of Miss Ella J. Flanders*. Jacob Riis pioneered the use of Christmas seals in America, the tradition of outdoor Christmas tree lighting, and caroling door-to-door. (Courtesy Ann Mancaruso.)

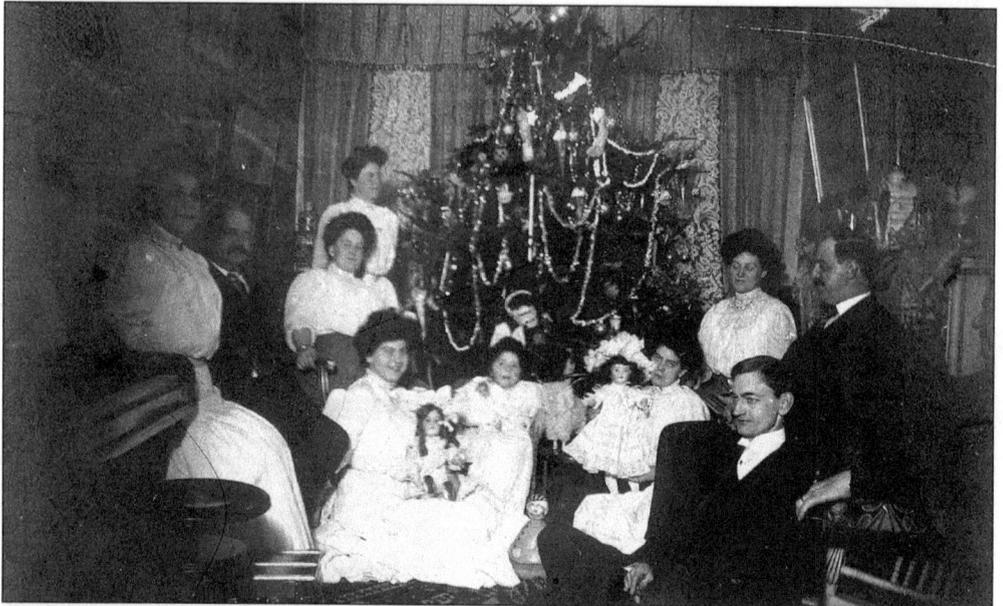

The Scanlan Christmas, 1906. The Scanlan family poses with five-year-old Gertrude and her dolls. An earlier Christmas was recorded in an old newspaper article: "The Hall was beautifully decorated with evergreen wreaths and mottoes, and the Christmas tree was brilliant with colored lights and was rich in gifts for the children." —*Long Island Democrat*, 1872. (Courtesy Rita Gambardella.)

Four

ON THE STREET
WHERE WE LIVE

*A real and lasting foundation had been laid on which to build up a town
of fine houses and public buildings, wide streets with beautiful trees giving
them shade and coolness, and, last but not least, a community of real homes where
the tired city worker can find the rest he needs, and where his wife and children
can live in peace and quiet, enjoying the fresh air and pleasant surroundings.*

—*Richmond Hill Record,* 1913

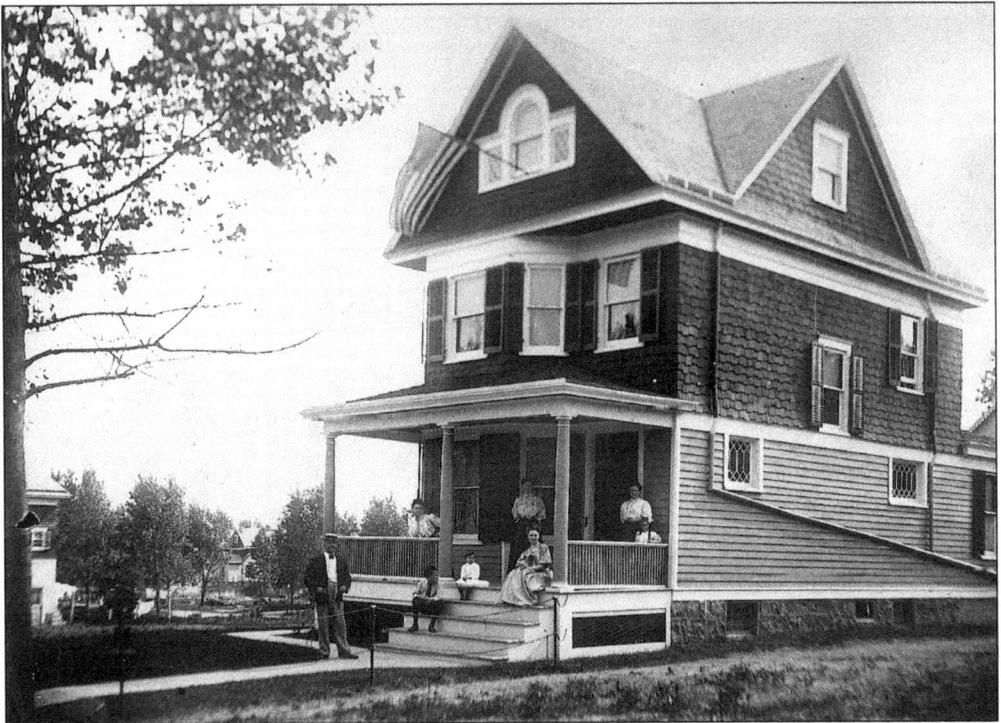

THE OLNEY HOUSE. This home was built c. 1893 and shows how far apart houses were at that time. The house is on 108th Street near Park Lane South and still stands today. (Courtesy Rita Smith.)

HOUSES FOR SALE, GARFIELD AVENUE (106TH STREET). A 1913 real estate advertisement pitches this house well: "Buy this home for $4,350. If you are paying $23 or more for rent, then you can afford to own this swell detached house. Has seven delightful rooms and tiled bath, arranged for absolute comfort. Has parquet floors, furnace heat, dining room with plate shelf and panels, costly chandeliers, duplex shades and abundance of closet room. Convenient to the trolleys and all other forms of transit. Only $500 cash down!" (Courtesy Marianne Veidt.)

WRAPAROUND PORCH. Located south of Jamaica Avenue around 120th Street, these types of houses had wraparound porches on which residents could catch a summer breeze. In houses that had second-floor porches, people actually slept there when the heat was unbearable. (Courtesy Ann Mancaruso.)

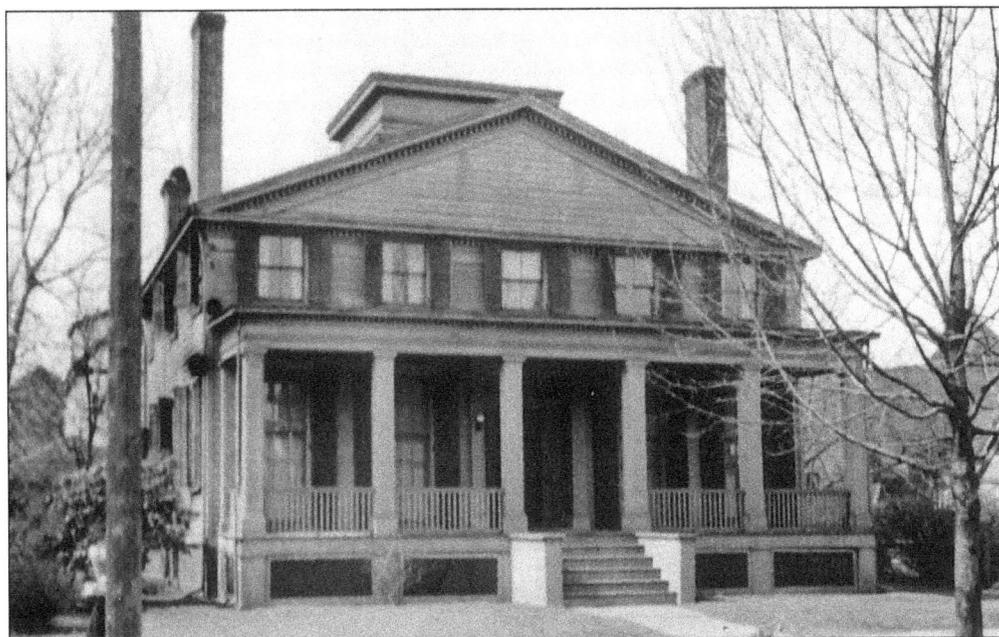

THE BRIGGS FARMHOUSE. "We today announce the death of one of our oldest and most respectable citizens, Captain Jeremiah Briggs. He was warm-hearted, kind and generous with a pleasant word and a smile for all, he attracted friends wherever he went and to the poor and unfortunate he gave a word of sympathy and a helping hand. His life was an active and careful one and he leaves behind a name upon which no blot remains." —*Long Island Democrat*, 1876. (Courtesy Tamm and Ivan Idrobo.)

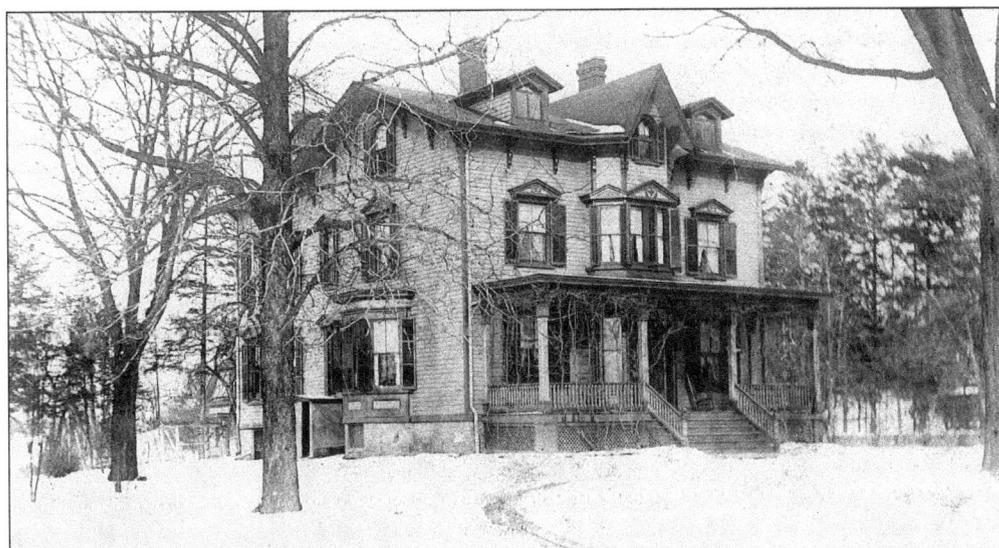

THE MAGNIFICENT MANSION. An early-20th-century mansion stands in the snow on 120th Street. "The residences in and around Richmond Hill are designed and constructed to meet the requirements of people of good taste, appreciative of aesthetic beauty, and combine with pleasing architectural design, artistic interior finish and those up-to-date conveniences which add so much to the comfort of the modern home." —*Industrial Recorder*, 1905. (Courtesy Ann Mancaruso.)

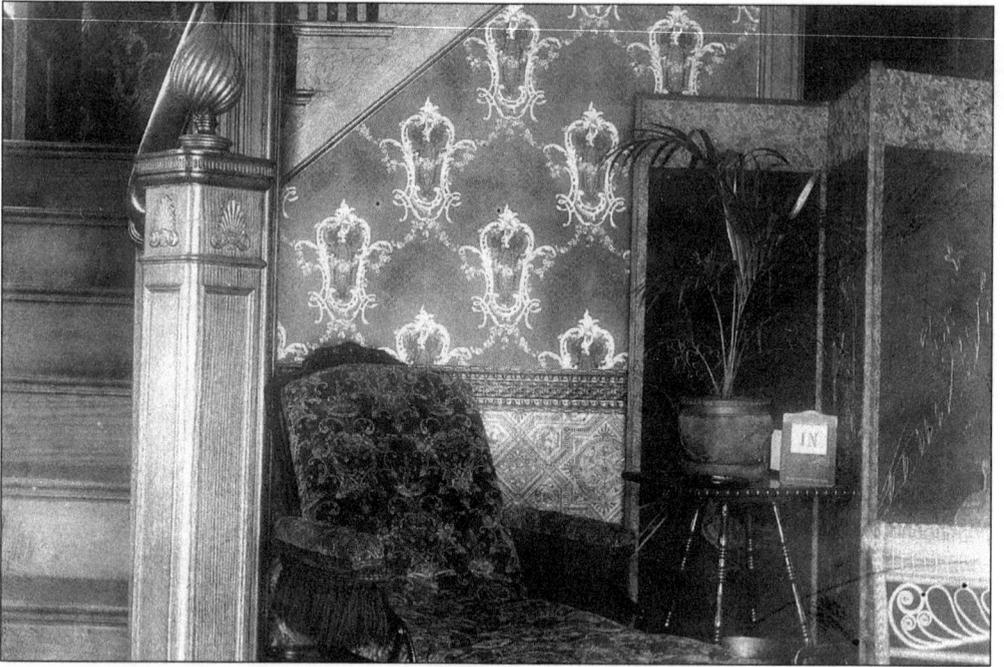

THE INTERIOR OF THE MAGNIFICENT MANSION. This wonderful early-20th-century Victorian featured ornate woodwork with intricate designs on the fabrics. The entrance portico was very attractive for the times. (Courtesy Ann Mancaruso.)

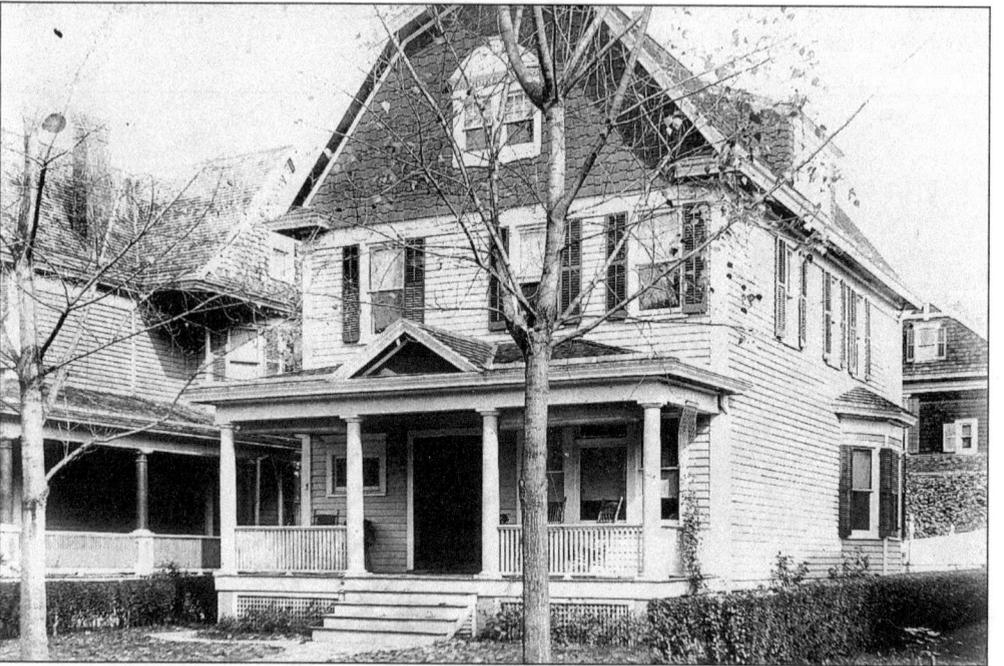

A HOUSE ON JEFFERSON STREET. This house is located at 89-35 116th Street. This area of Richmond Hill South consisted of similar houses built on small plots of land. The mass production of this style took place in the 1920s, and many grown children of European immigrants living in Brooklyn eagerly purchased these new houses. (Courtesy Ron Layer.)

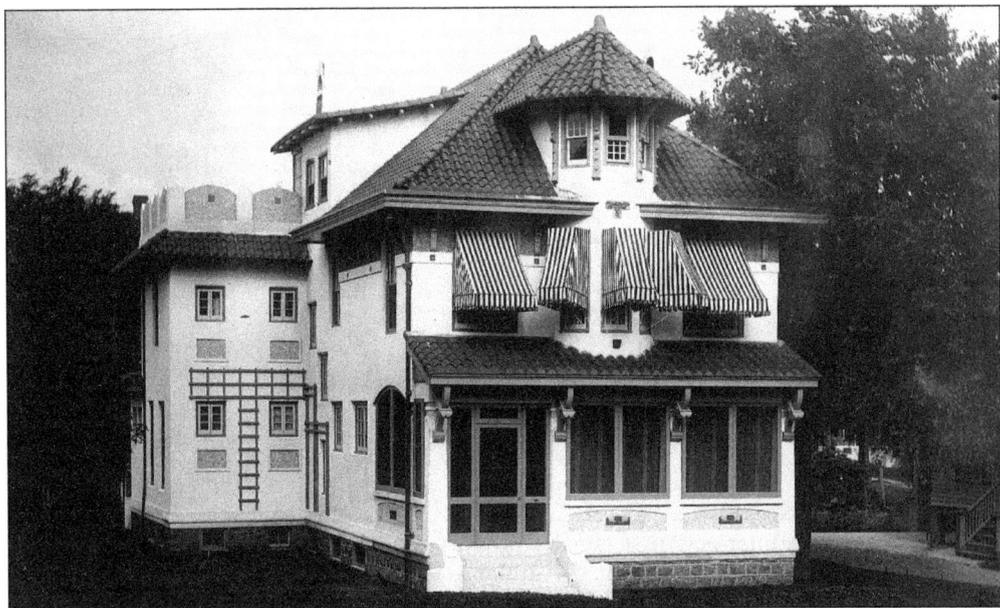

THE SPANISH TILE ROOF. Built on Richmond Hill Drive (117th Street), which is now part of Kew Gardens, this house boasted an enclosed front porch, canvas awnings, and a terra-cotta roof. It was demolished a few years ago and replaced with a nine-story assisted-living apartment building. (Courtesy the Richmond Hill Historical Society.)

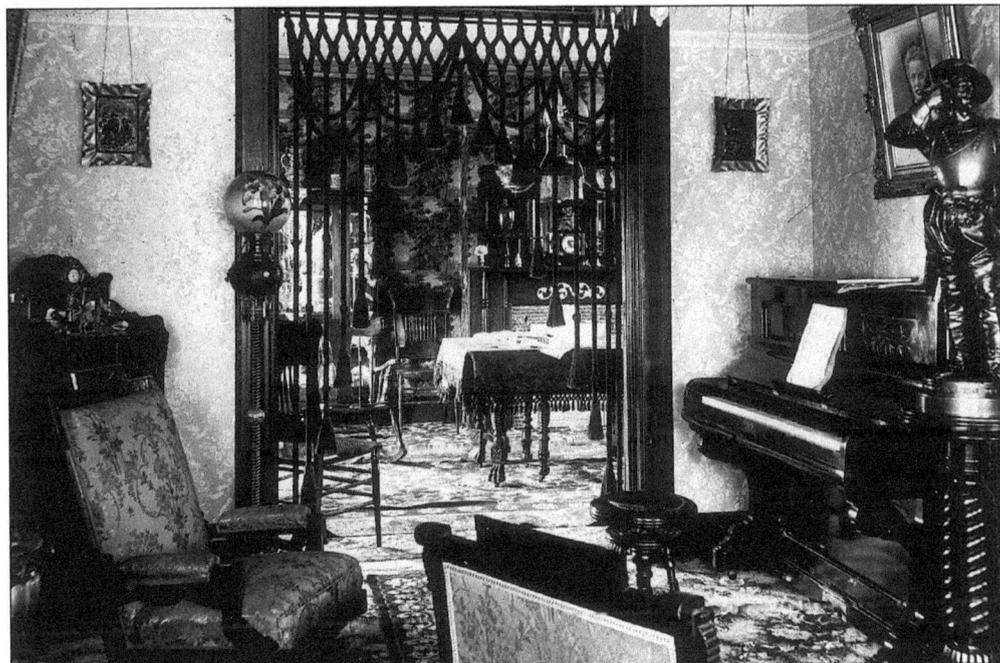

THE INTERIOR OF THE OLNEY HOUSE. Note the lovely Victorian furnishings, upholstered chairs, tasseled hangings, pocket doors, and patterned rugs and wallpaper. Almost every home had a piano at that time. "Richmond Hill offers everything for the creature comfort of its residents." —Stanley Payne, president of the Richmond Hill Board of Trade, 1926. (Courtesy Rita Smith.)

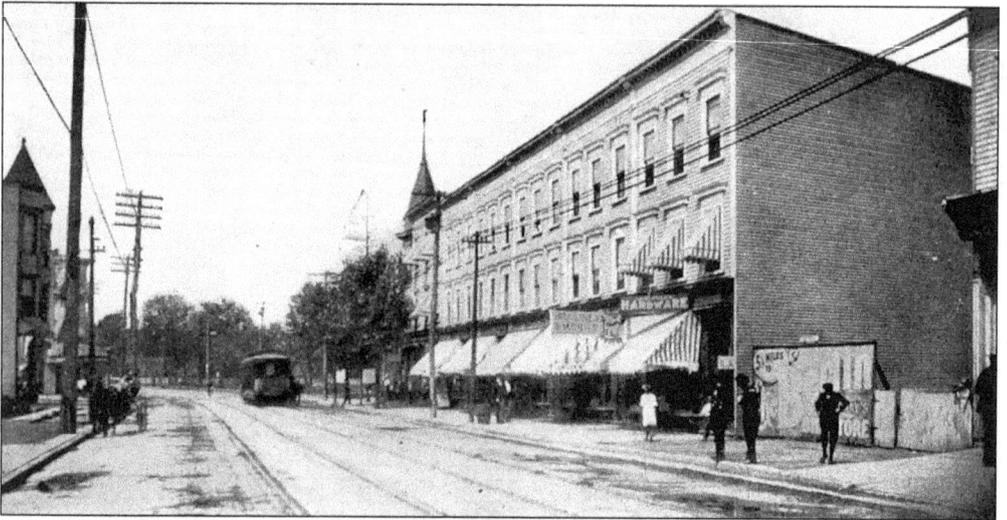

UNION PLACE. This intersection at Jamaica Avenue is now 102nd Street. Different kinds of accidents occurred years ago. "Mounted Patrolman Charles Dannhauser stopped a runaway horse on Jamaica Avenue, the main street of Richmond Hill. The horse took fright at a passing automobile and started to run. Dannhauser was soon in hot pursuit. After a hard chase of several blocks, the officer overtook the fleeing animal and bought it to a halt." —*Richmond Hill Record*, 1909. (Courtesy Nancy Cataldi.)

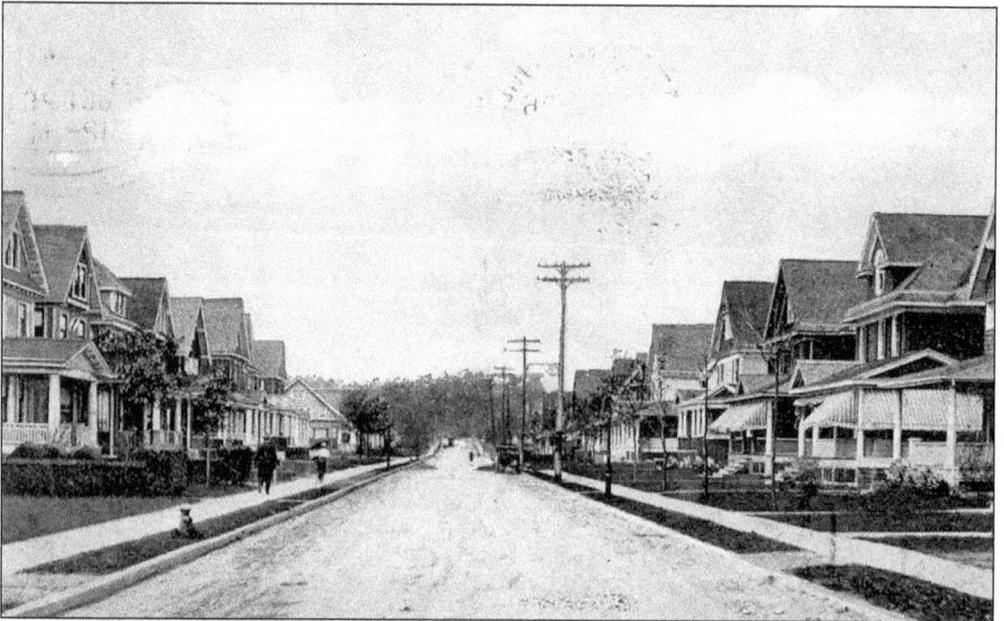

OXFORD AVENUE. When the names of streets were changed using the new number system in 1915, Oxford Avenue became 104th Street. "All the improvements are new and elegant; the broad streets are lined with choice shade trees." —*Long Island and Where to Go*, 1877. (Courtesy Helen Day.)

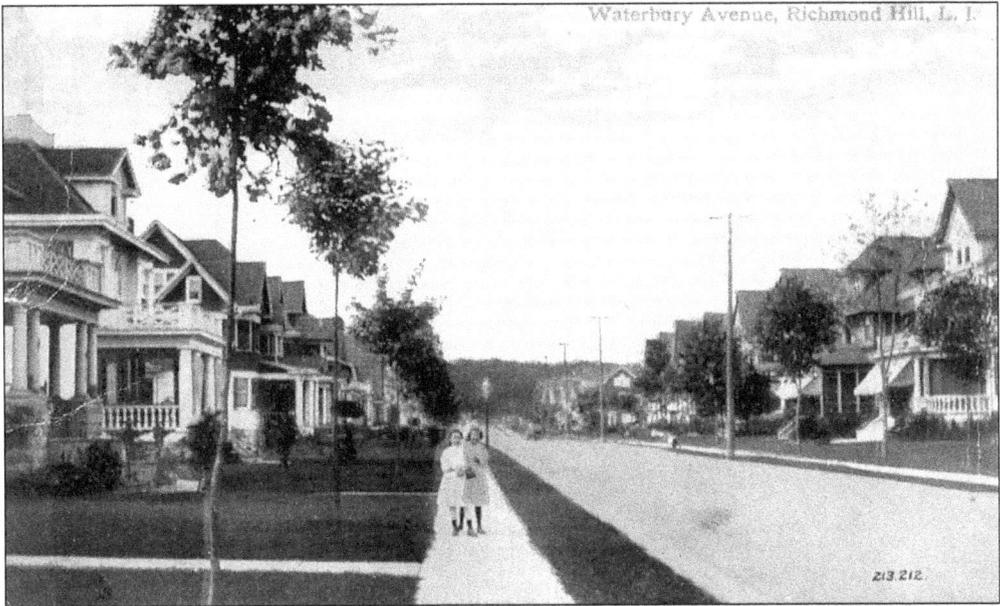

WATERBURY AVENUE, "DOCTOR'S ROW." This street, with its many doctors' offices, became 105th Street. In 1928, the *Richmond Hill Record* wrote about the early rounds of Richmond Hill's first doctor. "Dr. William T. Scovil was relied on in times of sickness. More than once, the wheels of his buggy sank many feet into the mud." It is still one of the most beautiful streets. It was named for Noah Waterbury, who owned the land here. Henry E. Haugaard, the noted Richmond Hill architect, lived on this block. (Courtesy Nancy Cataldi.)

HERALD AVENUE. Also known as Grant Avenue, its name was changed to 107th Street. In the 1920s, the City of New York asked the homeowners on this street for permission to raise their houses to allow for sewer pipes to flow beneath. Every homeowner on the block consented except one. Most of the houses have 13-foot-high basements, except for a lone house that sits in a gully. (Courtesy Regina Santora.)

67

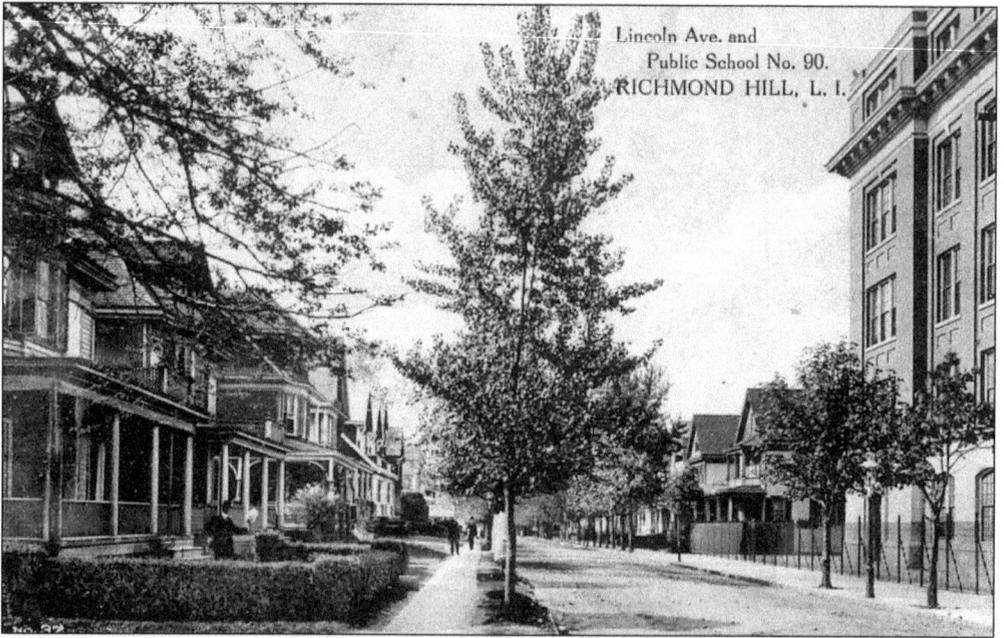

Lincoln Ave. and
Public School No. 90.
RICHMOND HILL, L. I.

LINCOLN AVENUE. This street had been known as Guion Street and is now 108th Street. Public School No. 90 once boasted of being the largest school in Queens and had entrances at Lincoln and Washington Avenues. It can be seen in the right corner of the photograph. (Courtesy the Lucy Ballenas Collection.)

NAPIER AVENUE. This street's name was changed to Washington Avenue and is now 109th Street. Andrew Napier originally had a farm in this section, which ran from Jamaica Avenue south to Atlantic Avenue. John T. Haugaard, the third Haugaard brother, and his wife, Margaret C., lived on this street. (Courtesy the Lucy Ballenas Collection.)

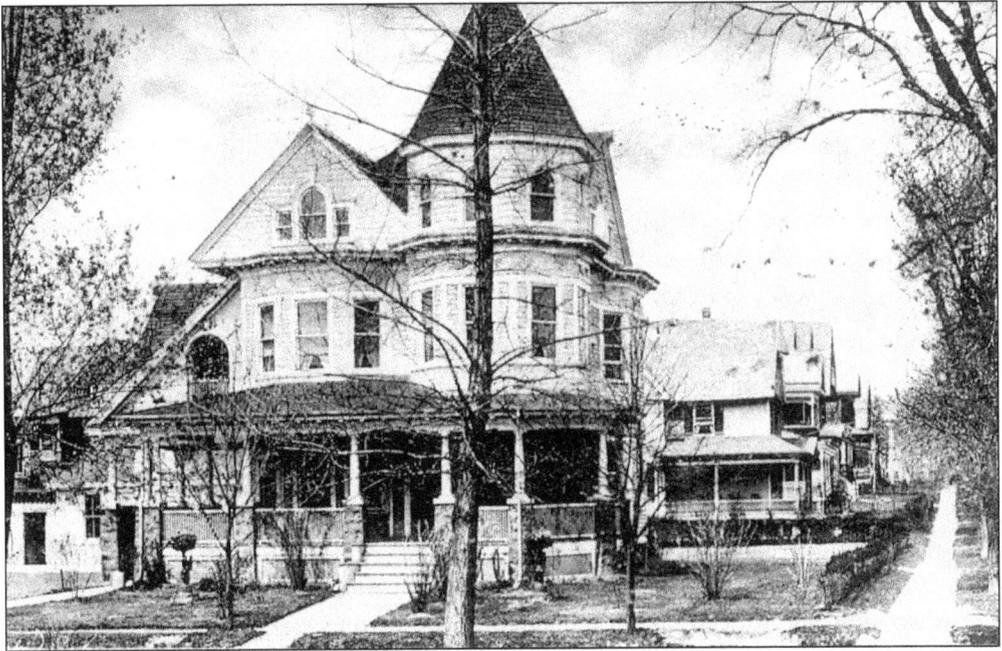

WELLING STREET, LOOKING NORTH. On the corner of Orchard Avenue, this house is typical of corner houses, usually turreted and grandiose. In 1902, James Hays owned this house. An exact copy of this house with its porte-cochere sits on the opposite corner on 109th Street. (Courtesy Nancy Cataldi.)

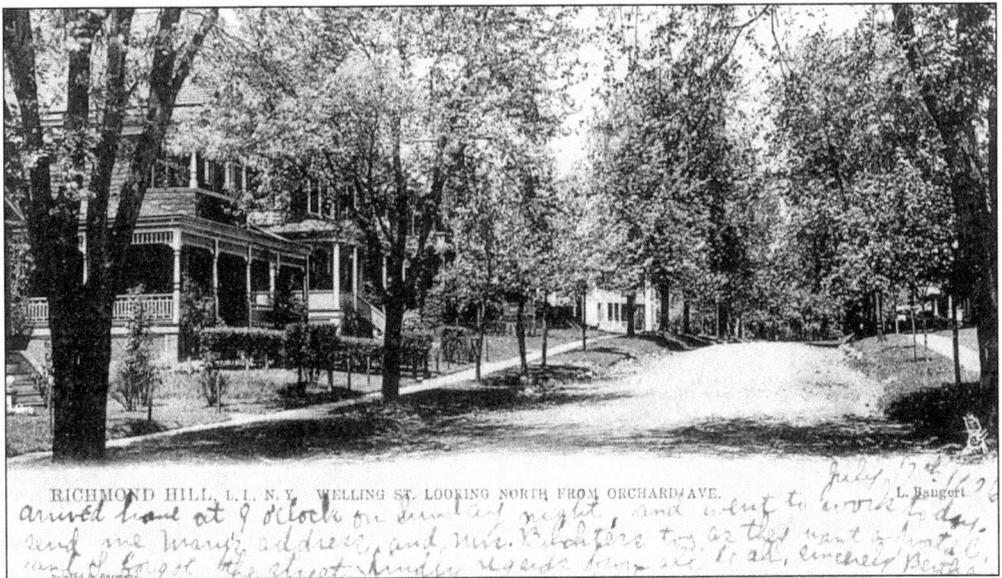

WELLING STREET. Also known as Bedford Street, it became 110th Street. Thomas Welling was a prominent citizen of the early village; his estate was on the north side of Jamaica Avenue between 109th and 110th Streets. The Welling farmhouse, believed to have been built in 1751, was torn down in 1917. The gingerbread-trimmed house on the left was the home of noted novelist Amelia Edith Barr. She died at her 445 Bedford Avenue home in 1919. (Courtesy Nancy Cataldi.)

GREENWOOD AVENUE. This street, formerly called Cherry Street, is now 111th. Edward Richmond was called the "godfather" of Richmond Hill and, with Albon Man, purchased the land in 1868 to develop the town. For over a year, he nurtured this land into a village. By July 1870, an advertisement appeared describing the advantages of Richmond Hill, but by that September he had died, never witnessing the full development of his community. In 1869, he arranged an outing for the children to visit a fair, paying for their tickets and food. The newspaper praised his kindness: "Like a star at midnight, so shines a good deed in a naughty world." (Courtesy the Lucy Ballenas Collection.)

CHESTNUT STREET. Chestnut Street later became 112th Street. "The part of Richmond Hill North is unique in being restricted perpetually as a whole against everything objectionable. Here a man may freely spend as much as he likes on his home with no fear that it will be cheapened or his comfort invaded by factories or nuisances." —Richmond Hill: The Centre of Greater New York, 1907. (Courtesy Nancy Cataldi.)

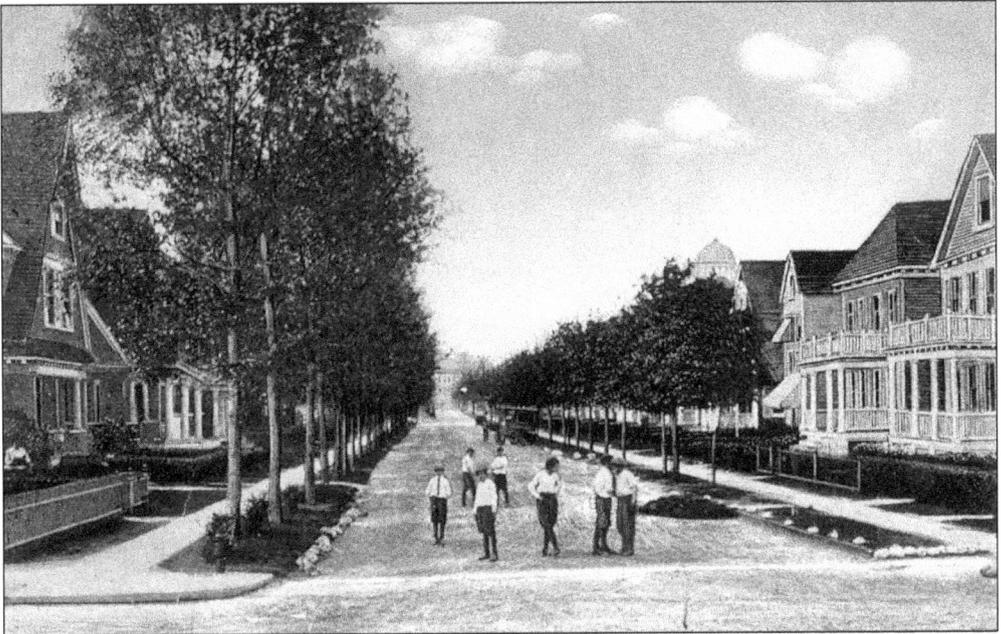

CEDAR AVENUE. Cedar Avenue became Maple and was later changed to 113th Street. Richmond Hill had gained prominence because of its spreading elm, oak, and cedar trees, and many streets carried these names. (Courtesy Nancy Cataldi.)

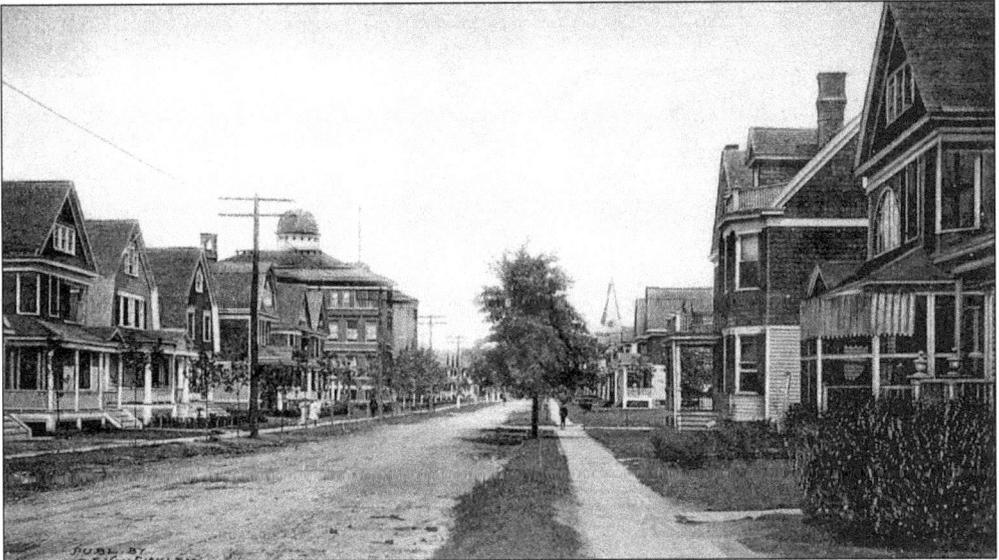

ELM STREET. It was previously called Stoothoff Avenue and is now known as 114th Street. J.C. Stoothoff was a gentleman farmer. His farm reached from 114th east to 117th Street, and from Jamaica Avenue south to Atlantic Avenue. The dome to the left is the observatory of Richmond Hill High School. (Courtesy the Lucy Ballenas Collection.)

OAK STREET. This view looks south onto Oak Street, which is now called 115th Street. Union Congregational Church is seen in the distance. "Rich in sylvan wealth and with a peculiar charm which is especially attractive to families of culture and refinement, Richmond Hill is at once one of the most beautiful and convenient suburban sections of the metropolis." —*Industrial Recorder*, 1905. (Courtesy the Lucy Ballenas Collection.)

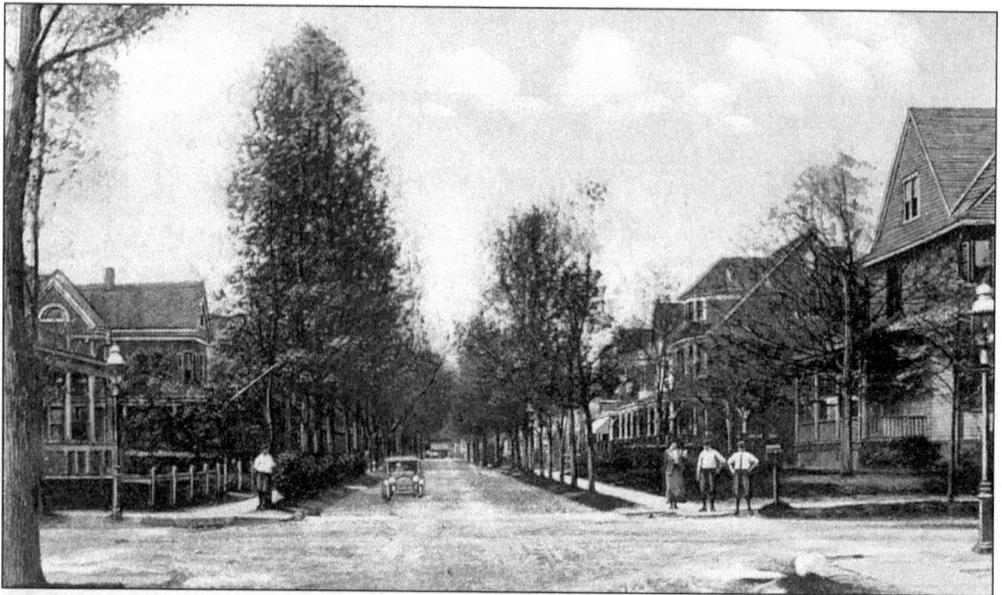

WALNUT STREET. Walnut Street has also been known as Jefferson and is now known as 116th Street. "In a few days Richmond Hill will hardly know itself. Mr. Godley, engineer of lighting in Queens, has a gang of men at work changing the open flame gas lamp to the Welsbach burner. There are over 400 lamps here. The present lamps are 20 candlepower; the new ones 60 candlepower, so Richmond Hill will be three times as light as at present." —*Richmond Hill Record*, 1906. (Courtesy Patrick Polisciano.)

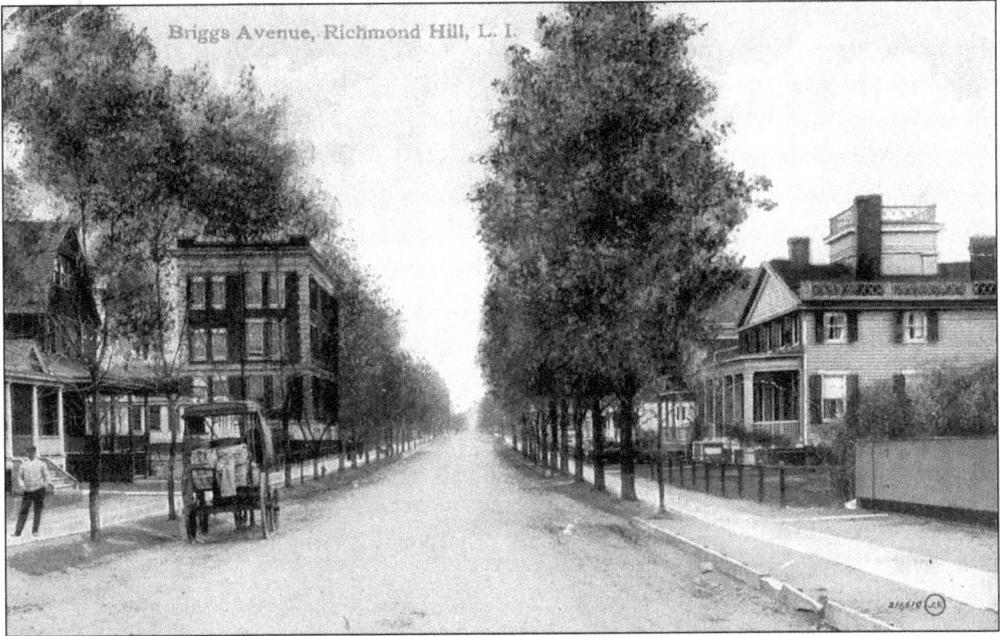

BRIGGS AVENUE. Originally named for Capt. Jeremiah Briggs, who lived in the house on the right, Briggs Avenue is now called 117th Street. "Richmond Hill today is a most desirable locality in which to live." —Stanley Payne, president of the Richmond Hill Board of Trade, 1926. (Courtesy Nancy Cataldi.)

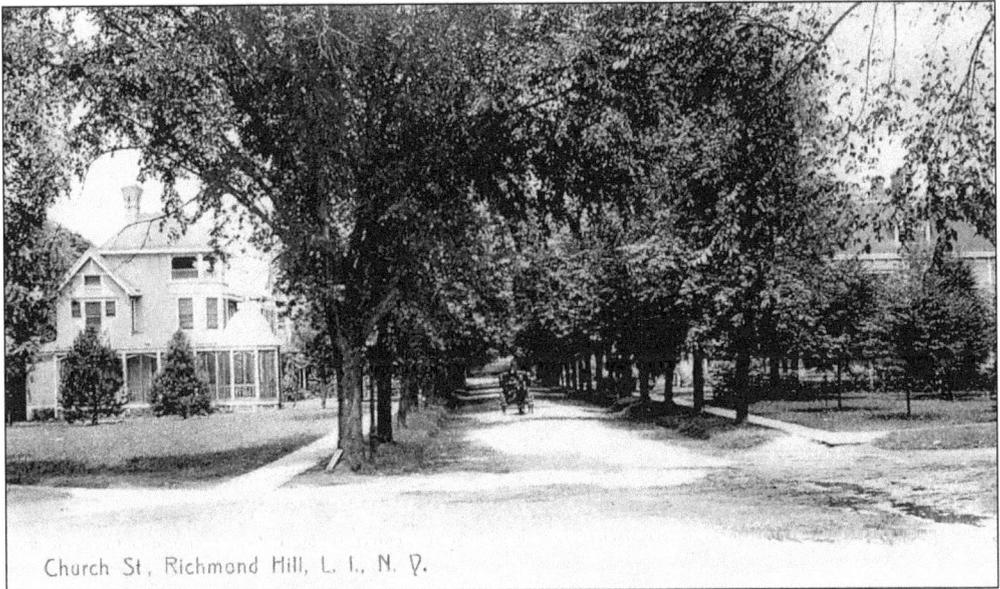

CHURCH STREET, LOOKING NORTH FROM HILLSIDE AVENUE. "When asked as we often are, what are the particular advantages of living in Richmond Hill, we point to our churches, our schools, our excellent public library, our fine golf links and the many spots within easy reaching distance from home, where the boys can play ball and skate to their hearts content." —*Richmond Hill Record,* 1903. (Courtesy the Lucy Ballenas Collection.)

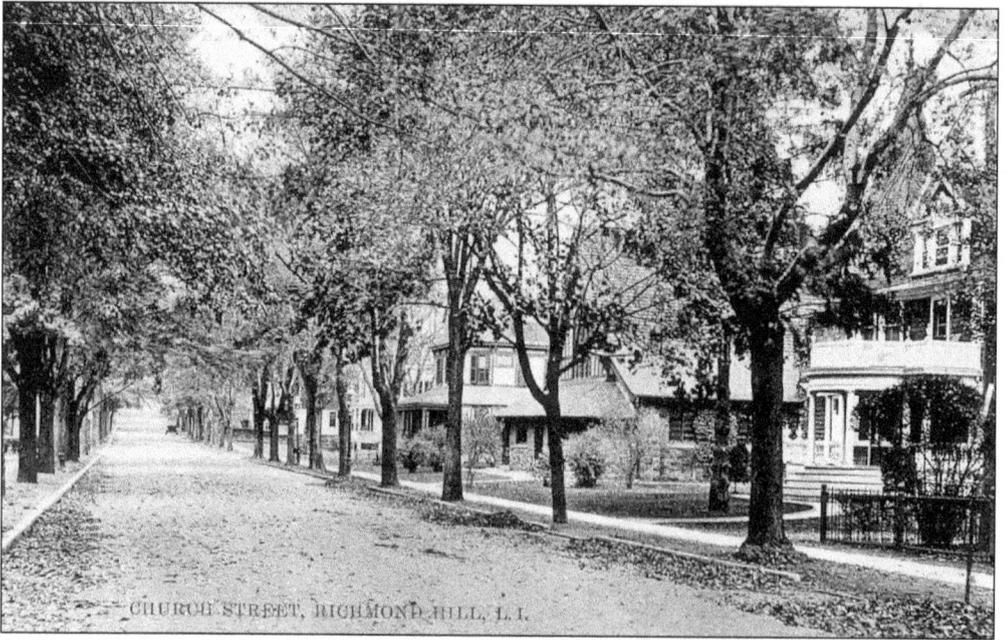

CHURCH STREET. When first laid out in 1869, Church Street was called Market Street; presumably the market referred to Van Wicklen's country grocery store, the only such store at that time. The name was changed when the Church of the Resurrection, seen to the right, was built in 1874. Today it is known as 118th Street. (Courtesy Nancy Cataldi.)

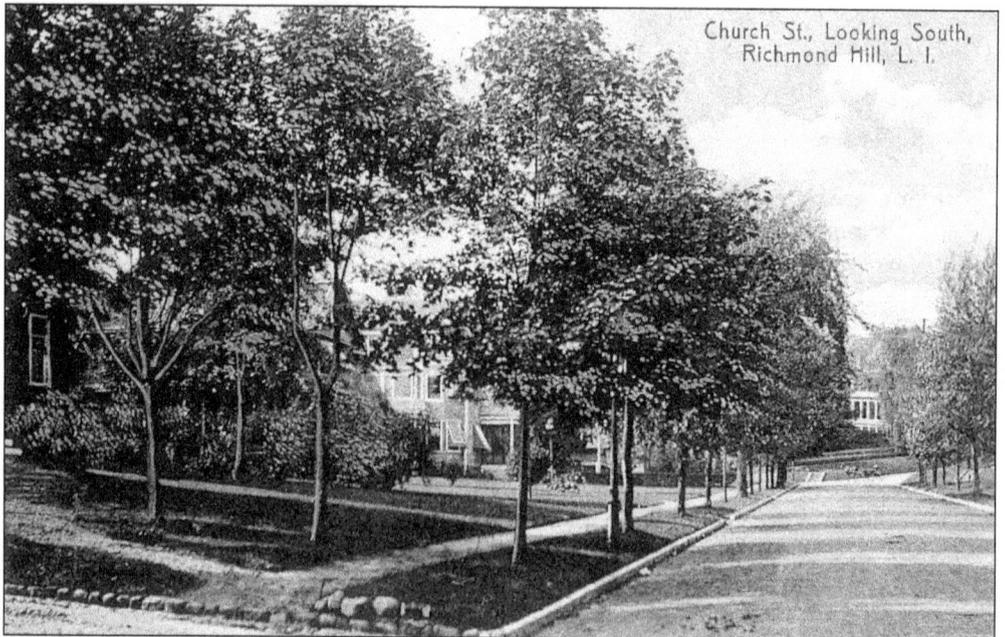

CHURCH STREET, LOOKING NORTH TO METROPOLITAN AVENUE. This postcard was mislabeled "south" but actually looks north. "On the higher ground are many fine residences which command a view of the ocean, distance about nine miles. The broad and well-kept lawns and tree embowered streets and avenues give a beautiful park-like effect and the section around is rich in sylvan scenery." —*Industrial Recorder*, 1905. (Courtesy Nancy Cataldi.)

74

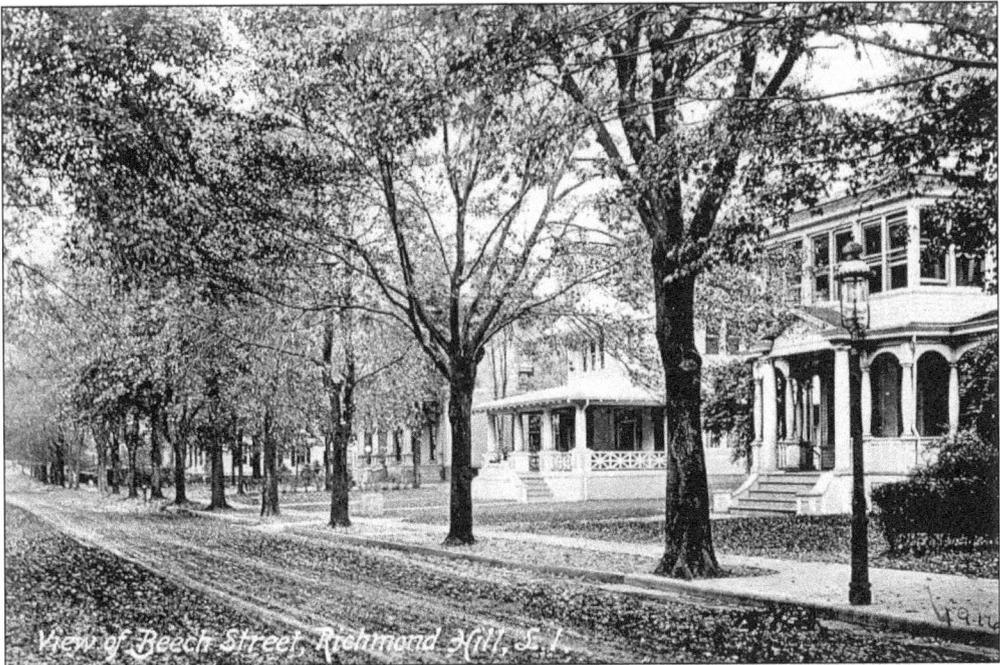

A VIEW OF BEECH STREET. The street upon which Jacob Riis built his home, now 120th Street, once had gaslights, like many streets in Richmond Hill. "The citizens of this enterprising locality have erected 15 street lamps to be lighted with oil until gas is introduced." —*Long Island Democrat,* 1873. (Courtesy the Lucy Ballenas Collection.)

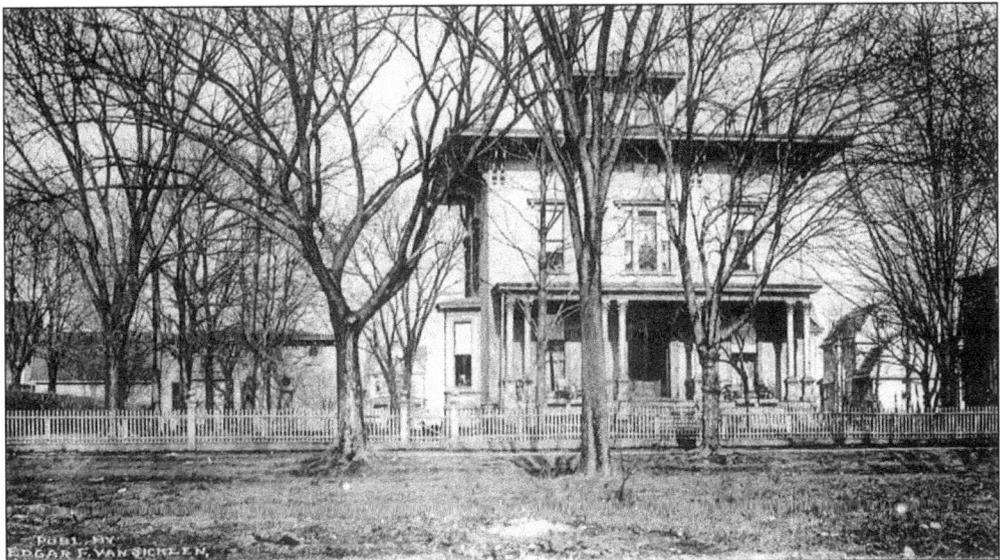

THE RESIDENCE OF MRS. HAMBLEN. Situated on Beech (120th) Street, this home was owned by the Bronson family in the 1880s. "The Bronsons became the leaders of the social life of the community. Many can recall the many gay parties and social functions which eventually made them famous in Richmond Hill." —*Richmond Hill Record,* 1928. (Courtesy the Lucy Ballenas Collection.)

SPRUCE STREET. Spruce Street was a dirt road at the time this photograph was taken of what is now 121st Street. "Richmond Hill is fast becoming one of the prettiest and most attractive villages on the Island, and many of our village people, in taking their afternoon drives, make it a part of the journey." —*Long Island Democrat,* 1884. (Courtesy Nancy Cataldi.)

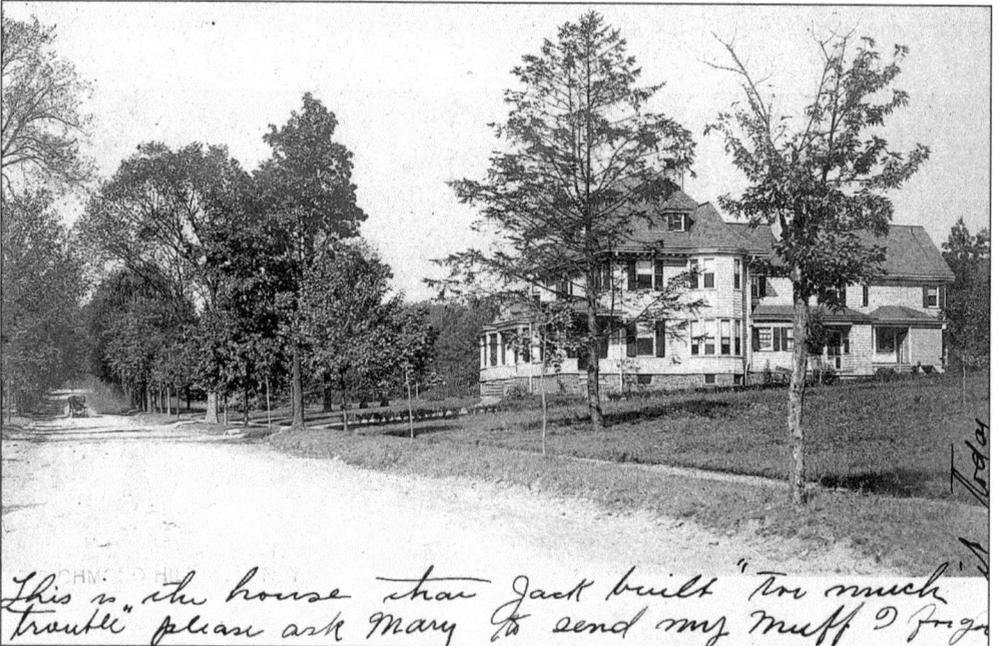

This is "the house that Jack built" "too much trouble" please ask Mary to send my muff I forgot

WILLOW STREET AND METROPOLITAN AVENUE. A lone dwelling stands on what is now 122nd Street. "Carpenters are now demanding $2.75 and $3 per day for their daily toil. Even at such wages there are none out of employment, and people are compelled to go to the city for help. There are now four houses being erected in Richmond Hill. —*Long Island Democrat,* 1884. (Courtesy Patrick Polisciano.)

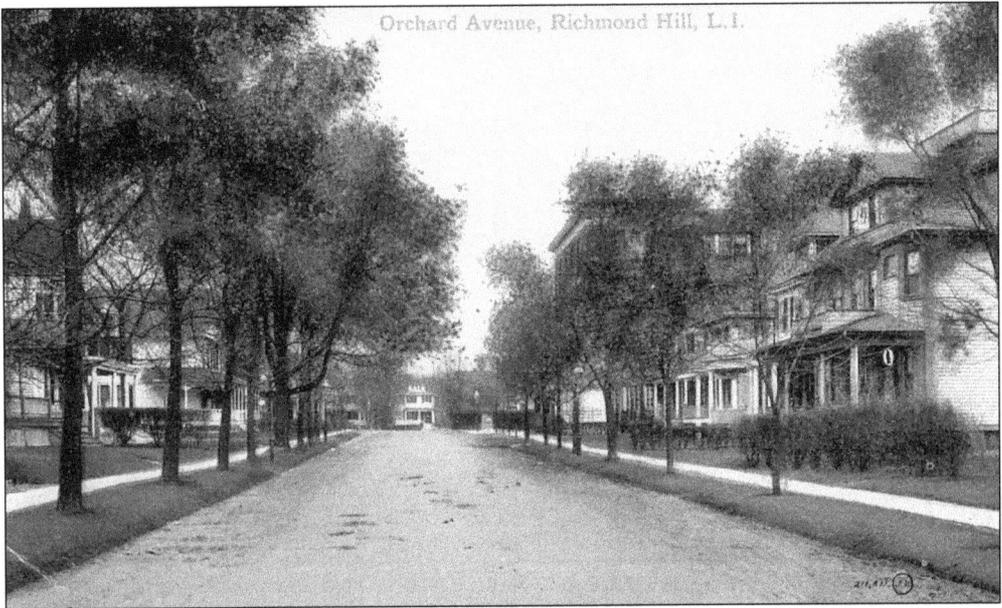

ORCHARD AVENUE, LOOKING EAST. Once known as Brandon Avenue, Orchard Avenue is now called 86th Avenue. The brick version of Public School No. 56 can be seen on the right. "Richmond Hill has not grown on account of big, flaring advertisements in the large daily and Sunday papers; but has had a steady, natural, healthy growth, caused by the people gradually becoming educated to the advantages of this beautiful suburban point." —*Richmond Hill Record,* 1906. (Courtesy the Lucy Ballenas Collection.)

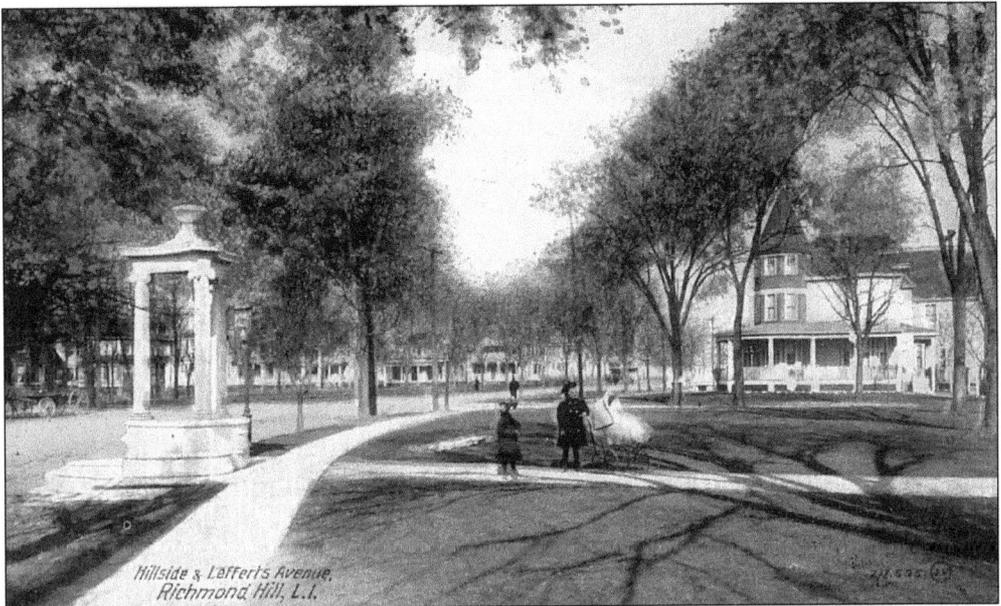

HILLSIDE AND LEFFERTS AVENUES. The little girls stroll along the path that leads to the library with their baby carriage. They are in front of the fountain that was donated by the Twentieth Century Club in 1907. "The dweller on any part of Richmond Hill has full benefit of the ocean breezes, cooler in summer and milder in winter than the winds of the interior, and which are always healthful." —*Long Island Democrat,* 1870. (Courtesy Nancy Cataldi.)

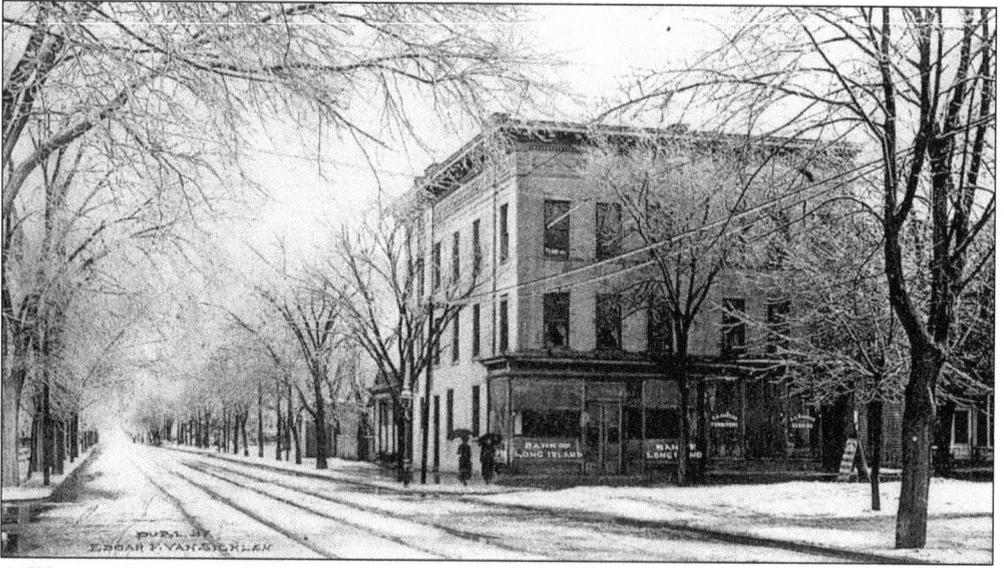

A Winter Scene at Myrtle Avenue and Park Street. This downtown business area forms a triangular hub that was the center of activity. The hand-lettered glass windows indicate that the corner building housed the Bank of Long Island, and next door was the C.A. Havens Furniture Store. "No one in Richmond Hill makes his mark as often as Thomas Paine, the popular painter who almost exclusively puts the gilt signs on windows, handsomely displayed through out this section." —*Richmond Hill Record*, 1906. (Courtesy the Lucy Ballenas Collection.)

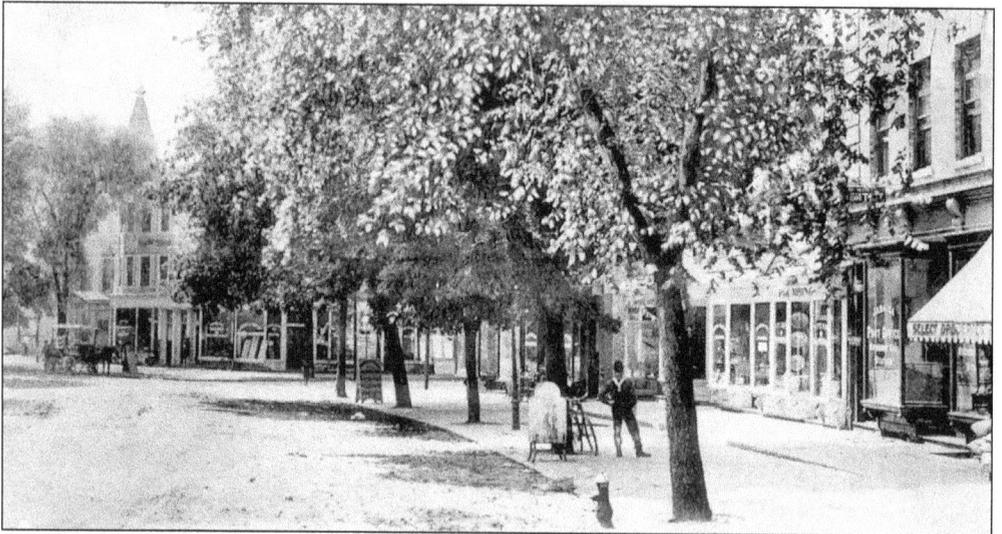

Park Street, Looking South. Here we have another view of the downtown business area, looking south to Jamaica Avenue. A row of shops including the fourth post office is shown. The steeple in the background was originally built as a hall by Albon Man but was leased to the Union Congregational Church. When the church vacated, the building was used as the library until the Carnegie Library was in built in 1905. (Courtesy the Lucy Ballenas Collection.)

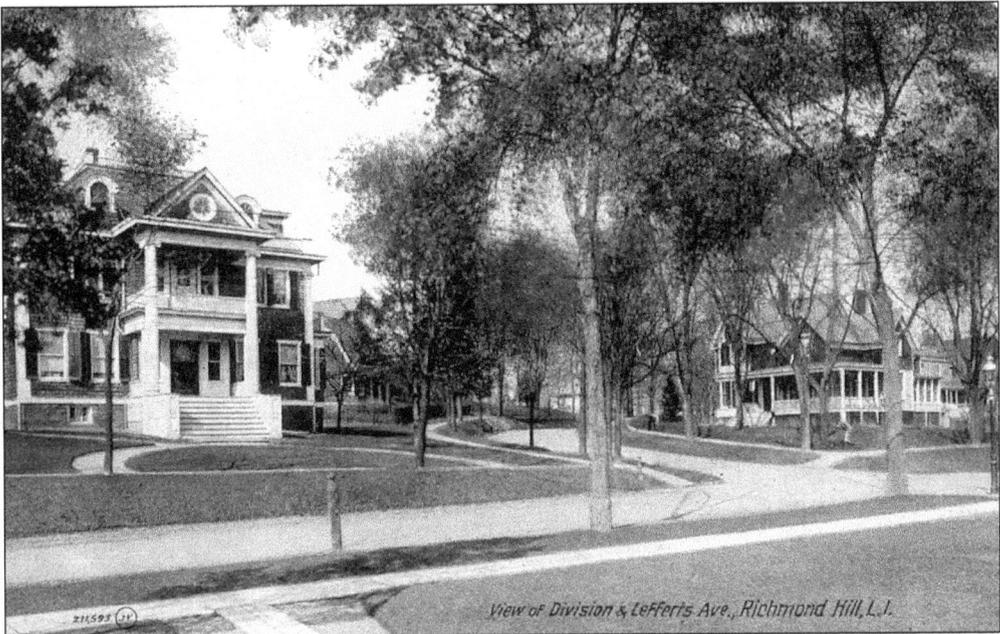

DIVISION AND LEFFERTS AVENUES. "Richmond Hill contains about 250 acres of land, lying at an elevated grade, well drained and perfectly healthy, restricted against nuisances and easily accessible by various roads." —*Long Island Democrat,* 1870. (Courtesy the Lucy Ballenas Collection.)

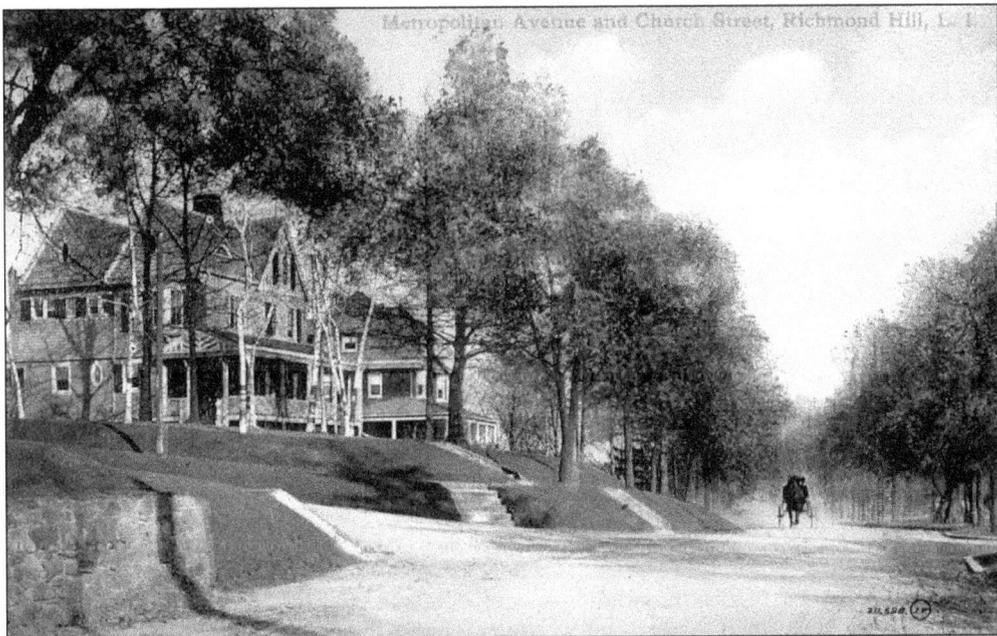

METROPOLITAN AVENUE AND CHURCH STREET. "A number of dogs have been poisoned during the past week, and the owners of the animals now fear that a raid will be shortly made upon their residences by burglars. Get your gun ready!" —*Long Island Democrat,* 1884. (Courtesy Nancy Cataldi.)

WILLIAMSBURG ROAD. Looking east along what has become known as Metropolitan Avenue, this photograph shows a once tree-lined winding road now bordered with numerous apartment buildings. (Courtesy Nancy Cataldi.)

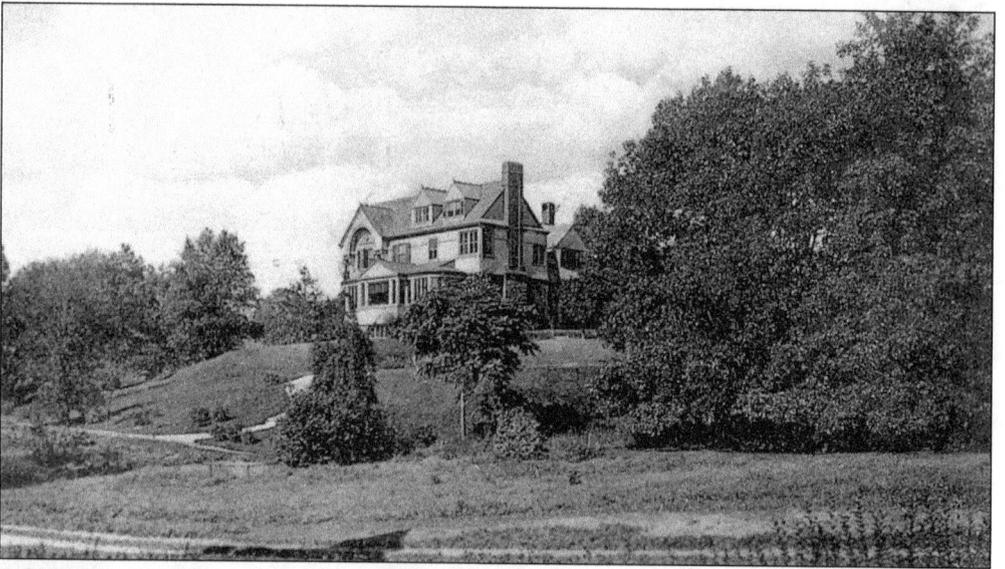

A VIEW ON THE HILL. Once the grand home of Lieutenant Cowles, this property is now home to hundreds of apartment dwellers and is situated between 116th and 118th Streets, above Curzon Road. On October 10, 1891, Cowles was at the helm of the presidential yacht the *Despatch*, a wooden schooner-rigged steamship, which had been the official yacht of presidents Hayes, Garfield, Arthur, Cleveland, and Harrison, when it ran into a storm and sank. Everyone aboard at that time survived the accident. (Courtesy Nancy Cataldi.)

Five

SIMPLE PLEASURES

Richmond Hill today is a most desirable locality in which to live and play,
it offers everything for the creature comfort of its residents. Its social activities
furnish a goal for the human desires of its men, women and the younger generation.

—*Richmond Hill Record, 1926*

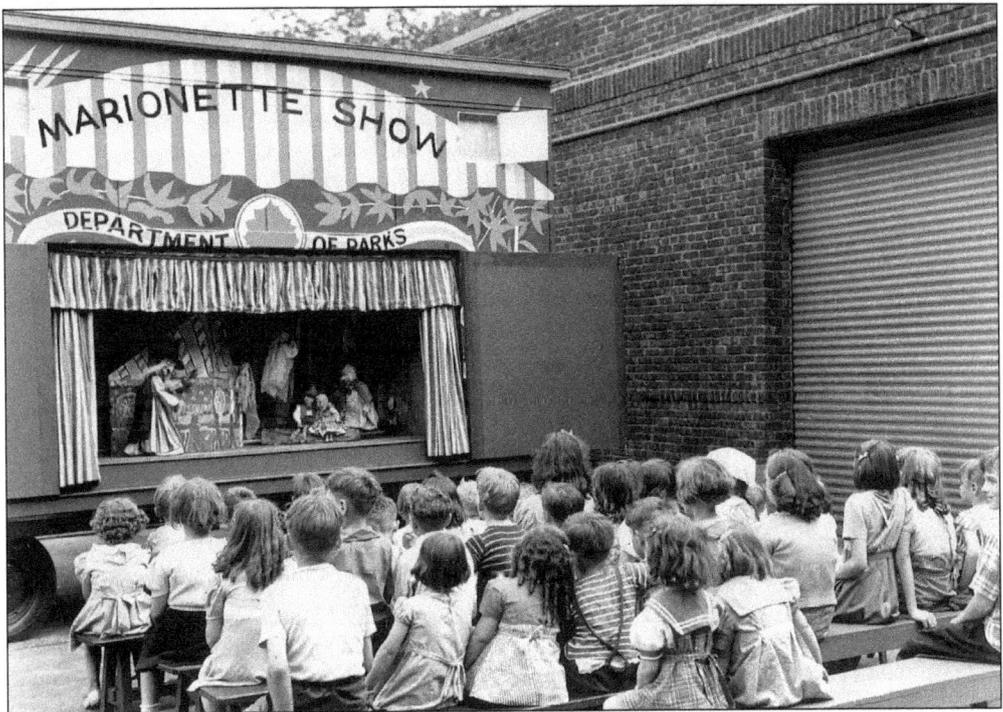

A MARIONETTE SHOW. Spellbound children watch the fairytale story of Hansel and Gretel at the Forest Park Marionette Show in the 1950s. (Courtesy the Forest Park Trust.)

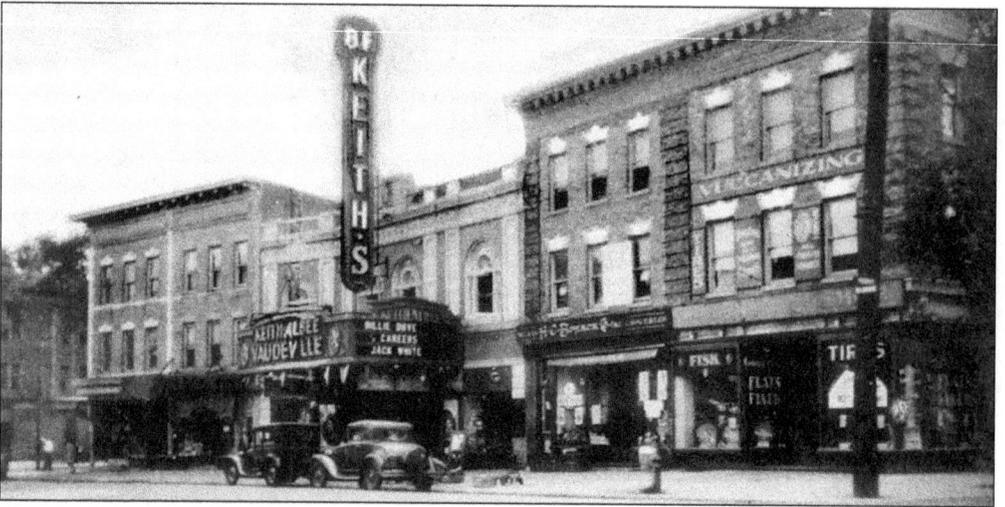

KEITH'S ALBEE. In February 1926, it was announced that Richmond Hill would have a new theater. It was to be called the American Theatre and built facing Hillside between Myrtle and Railroad Avenues. It would be one of the largest, most up-to-date theaters on Long Island, providing seating for 3,000 for the showing of moving pictures of the better kind and first-class vaudeville. Still unfinished by December 1926, the theater changed hands and was acquired by the Keith-Albee Syndicate. (Courtesy the Lucy Ballenas Collection.)

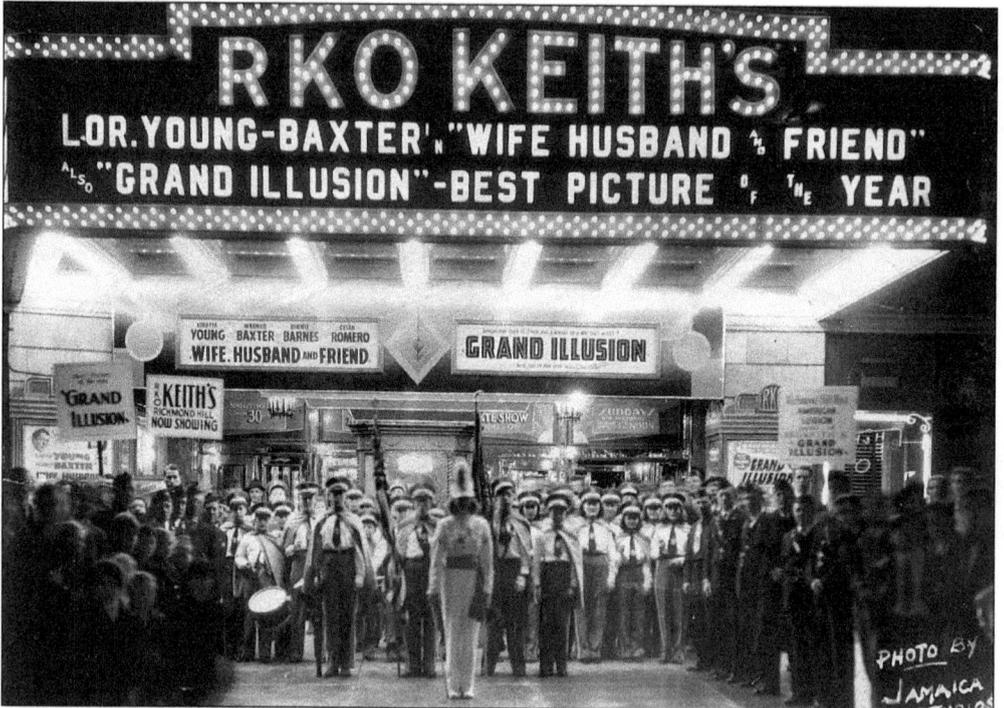

RKO KEITH'S. Started in 1926, the theater finally opened its doors on March 22, 1929. Delays were caused by the slow arrival of the machines for the new talking pictures. It stopped its movie run in 1963. This scene depicts the grand opening of a motion picture with the Richmond Hill Post American League Band providing the music. On Saturdays, one could sing along with Uncle Bob West as he played on the organ. (Courtesy the Richmond Hill Historical Society.)

82

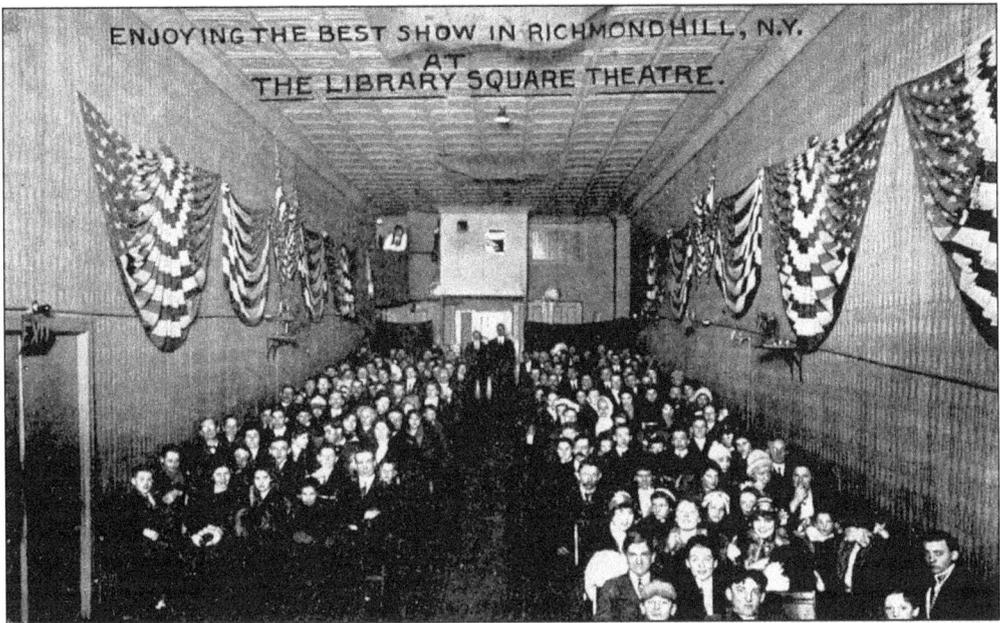

THE LIBRARY SQUARE THEATER. In 1910, George Schwenger erected the Library Square Palace on Lefferts just north of Jamaica Avenue. It opened in April, seated 250 persons, and featured the finest pictures and songs sung by real talent. One of the earliest pictures shown was of Pres. Theodore Roosevelt's hunting trip to Africa. By 1911, it changed hands and was renamed the Library Square Theater, offering five-reel pictures and music by Prof. J.D. Quinn. The fee was 10¢ for adults and 5¢ for children. (Courtesy Nancy Cataldi.)

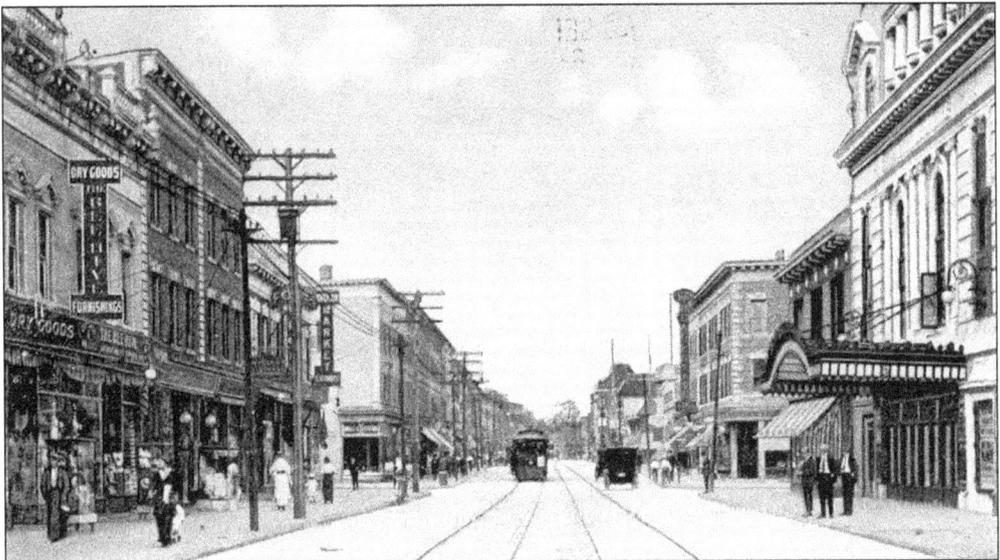

THE GARDEN THEATRE. In 1910, a theater was to be erected on Jamaica Avenue east of Elm (114th) Street. It was to be 54 by 130 feet and seat 1,000. This high-class, vaudeville house finally opened in 1914 and was also a photoplay house. In 1915, the roof garden opened. "The opportunity of witnessing the pictures while seated in the open air is appreciated." Gone forever, the vacant lot serves as a parking area for a laundromat. (Courtesy the Lucy Ballenas Collection.)

83

THE FIRST FREE CIRCULATING LIBRARY OF RICHMOND HILL. In a small room under Arcanum Hall, the Twentieth Century Club formed the first Free Circulating Library. The idea of creating this library was initiated by Ella J. Flanders. Harriet Easby took charge on February 1, 1899, and the library was opened on April 8, 1899. More than 1,000 books were donated, and on that first day, 158 books were circulated. On January 1, 1901, it was ceded to the Queens Borough Public Library, with Easby remaining as librarian. She was the first public librarian in Queens. (Courtesy the Richmond Hill Post Office.)

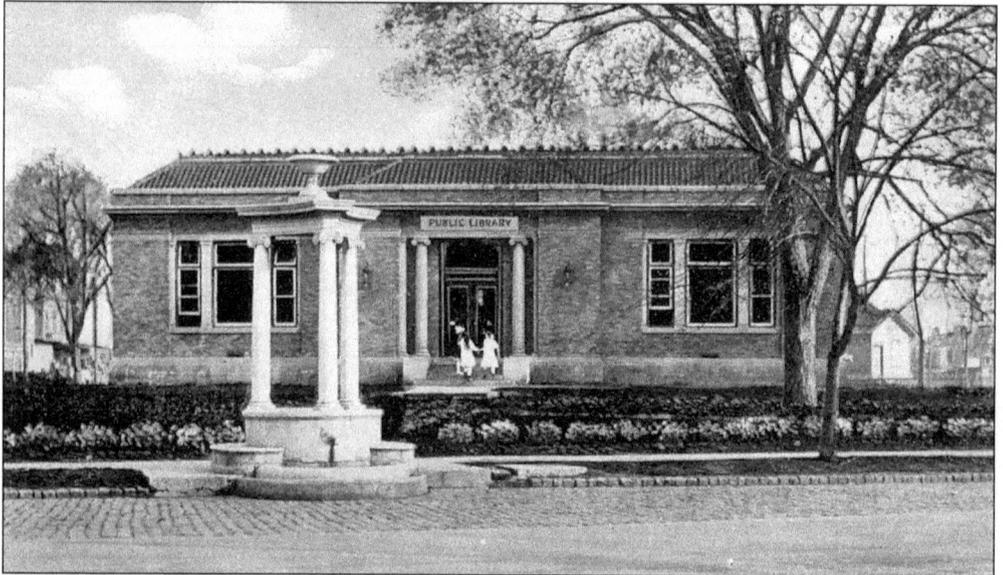

THE RICHMOND HILL CARNEGIE PUBLIC LIBRARY. In 1902, the library leased the old Congregational church building on Park Street (Hillside Avenue) as the library building. On July 1, 1905, a new, $35,000 brick building, erected through the generosity of Andrew Carnegie on land donated by the Man family, was opened. The architectural firm was Tuthill & Higgins. The area around the new structure became known as Library Square. In 1929, a $25,000 addition was added to the rear and was used as a children's room. (Courtesy Nancy Cataldi.)

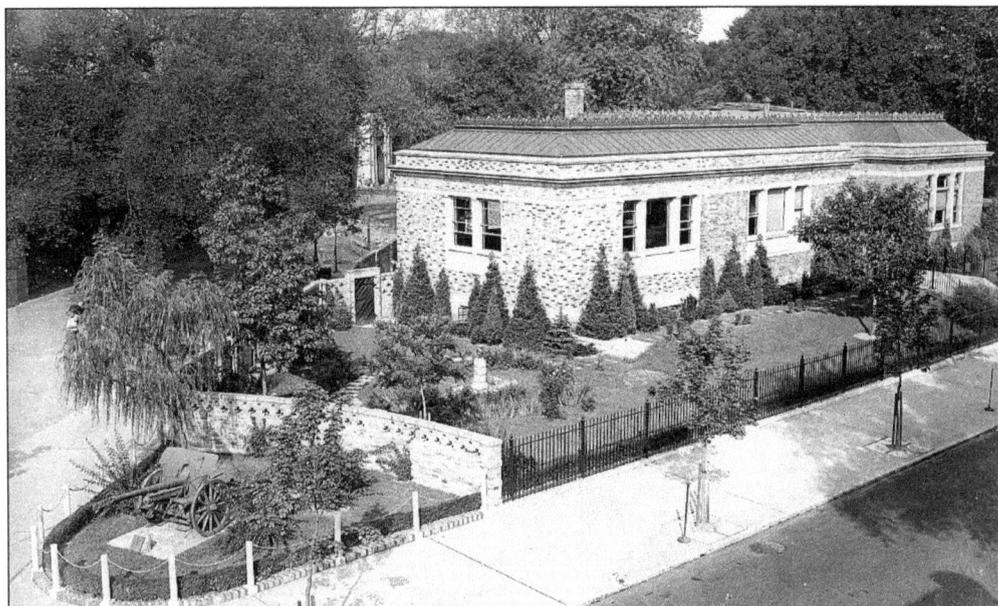

THE RICHMOND HILL LIBRARY, 1936. At the apex, a captured German gun from World War I was placed on display. Removed during World War II, it was melted down for scrap. "Have you been to the library within the last few weeks? Have you seen the newly laid cement walk? Do you realize that you can walk all around the triangle on a stormy day without wading through puddles of water, because the entire walk has been raised?" —*Richmond Hill Record*, 1910. (Courtesy QBPL, LID, the Library Collection.)

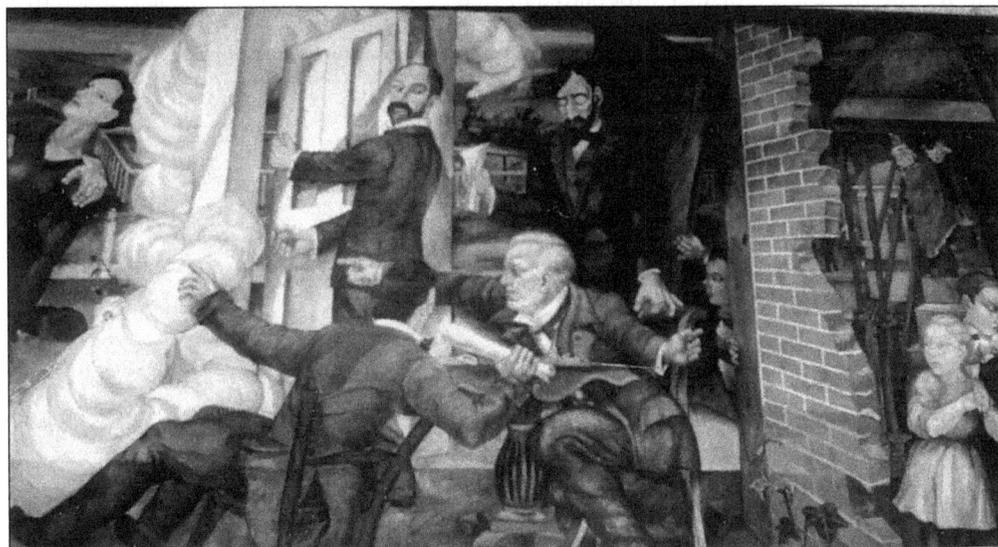

THE STORY OF RICHMOND HILL. Such is the title of a 160-square-foot mural painted in 1938 by Phillip Evergood at the library. It is divided into two sections—one side reserved for the dingy, congested city and the other for a vision of an ideal rural community. Separating them, in the center, are four men: Albon Platt Man, the founder of Richmond Hill; his son Alrick H. Man, the developer; Oliver Fowler, the proprietor; and, with his back to the viewer, Edward Richmond, the landscape architect. (Courtesy Collection of the City of New York, QBPL, Richmond Hill Library; photograph by Nancy Cataldi.)

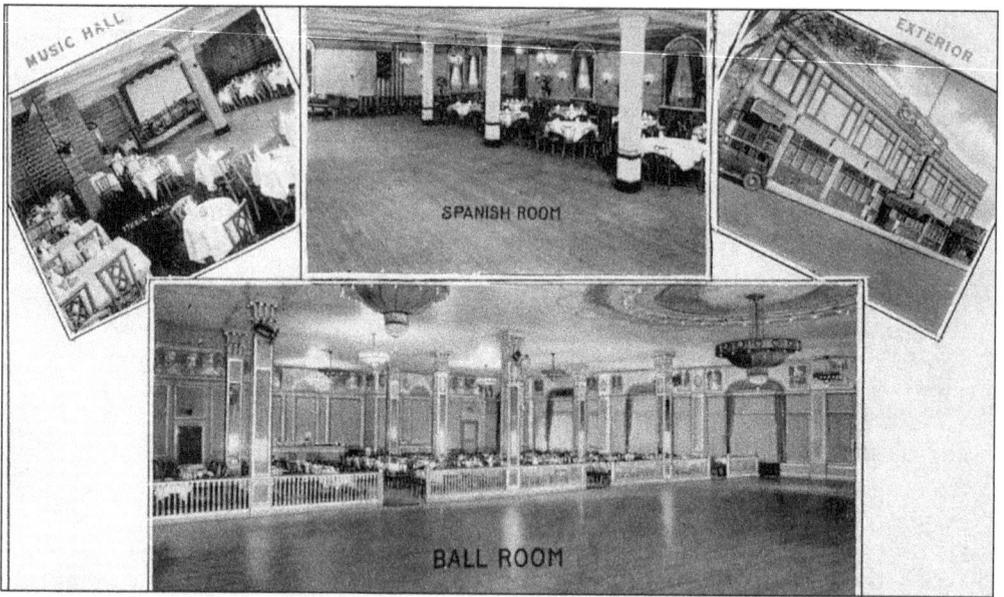

MUSIC HALL

SPANISH ROOM

EXTERIOR

BALL ROOM

THE RICHMOND HILL PALACE. The Richmond Hill Palace opened as the Triangle Ball Room on September 26, 1925. Across from the Triangle Hofbrau on Myrtle Avenue, it was billed as "Richmond Hill's new quarter of a million dollar pleasure palace." James Kendis's Blowing Bubbles Orchestra provided the music. Kendis composed the song "I'm Forever Bubbling Bubbles." A noted guest that opening year was Helen Keller. "Miss Keller stepped upon the waxed floor with Miss Polly Thomson, her secretary, as her dancing partner and seemingly enjoyed the music of a tuneful foxtrot played by Kendis' Orchestra, and enjoyed it so much that she danced frequently during the evening." (Courtesy Patrick Polisciano.)

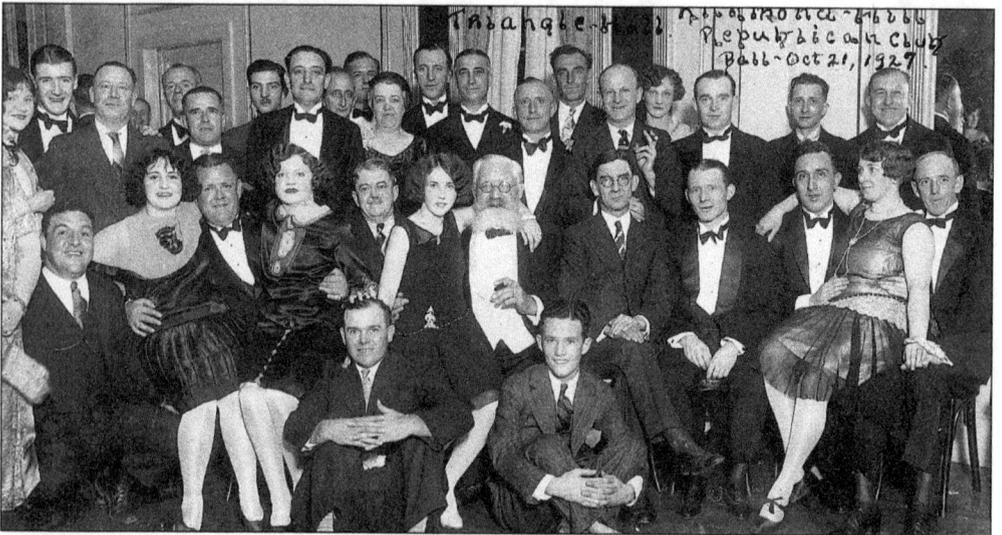

A REPUBLICAN CLUB BALL, 1927. At the Triangle Hall, a group of Republicans and flappers gather for a fun picture. According to Theodore Wilsnack, first president of the Republican Club, he discussed the early days in a lecture in 1926: "Liquor was never permitted in the clubhouse. It was a clubhouse that could be entered by any man with his son, and the wife and mother knew that her men folk were having clean enjoyment at our club." (Courtesy the Richmond Hill Historical Society.)

THE RICHMOND HILL CLUB. This club had been the original schoolhouse, built in 1872. When the new Johnson Avenue School was built, the club was sold and moved from Lefferts Avenue to Hillside Avenue. There it was renovated and made into the Richmond Hill Club, featuring bowling alleys and game rooms. The Vetter house is seen to the right. (Courtesy the Lucy Ballenas Collection.)

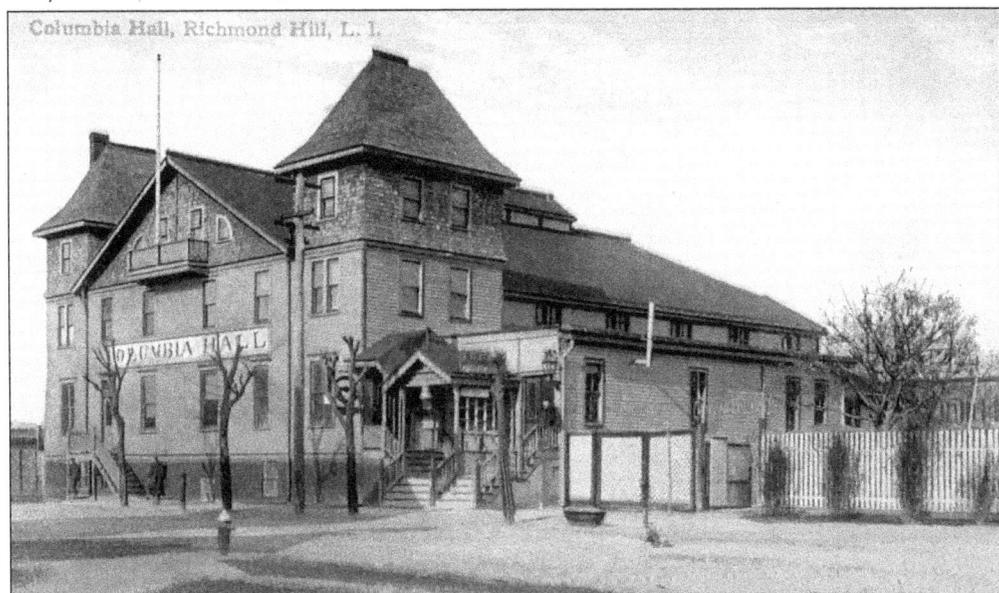

COLUMBIA HALL. Previously the Richmond Hill Hotel, with a beer garden and picnic area in the back, this building was renamed Columbia Hall in 1892. From 1894 to 1911, Ernest Weiden was its proprietor, making it the biggest place of its kind in Queens. Big political meetings were held there, and it was in great demand for balls in the winter, while in the summer its picnic grounds were used by organizations. It was located behind the present-day post office at 122nd Street but was destroyed by fire in 1948. (Courtesy the Lucy Ballenas Collection.)

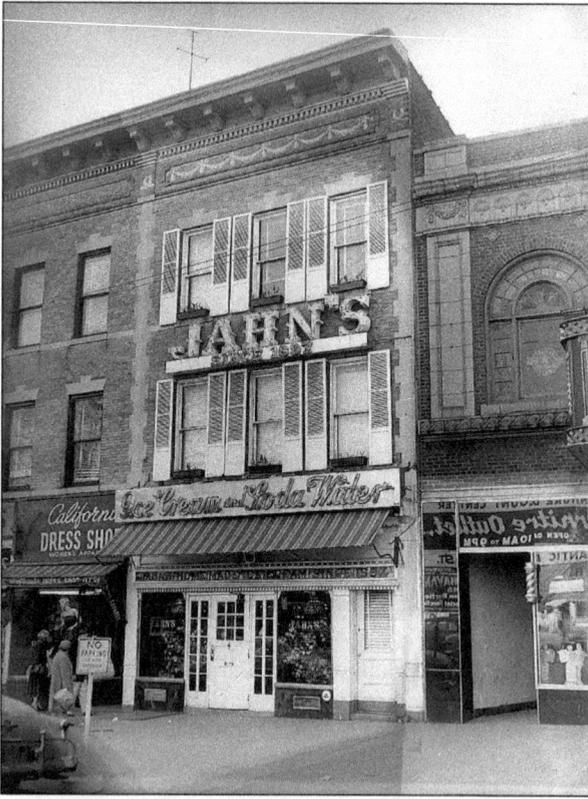

JAHN'S ICE-CREAM PARLOR. Started in 1926 next to the RKO Keith's Movie Theatre, Jahn's has old-fashioned interiors and a nickelodeon. The establishment offers such ice-cream treats as the Kitchen Sink, which could feed up to 12 people. In its heyday, many a date ended with a soda at Papa Jahn's. (Courtesy the Richmond Hill Historical Society.)

THE RICHMOND HILL GOLF CLUB. In 1895, a nine-hole golf course was designed on the hilly lands of north Richmond Hill, because of the areas rough terrain and deep hollows. Its beautiful landscape was suited for the exclusive Kew Gardens residential development, which was constructed in 1910 after the golf course closed. The old golf clubhouse was moved to Audley Street, where it has remained a private residence. (Courtesy Helen Day.)

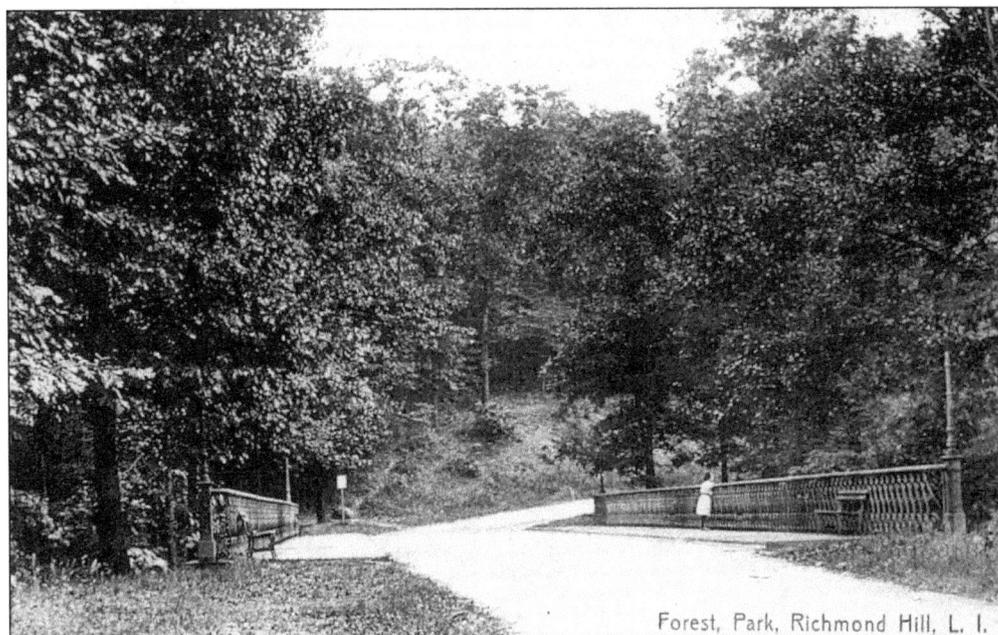

Forest, Park, Richmond Hill, L. I.

FOREST PARK. This park sits on an ancient glacial ridge. The third largest park in Queens, it covers 538 acres, 411 of them wooded, and dates back to 1895. Frederick Law Olmstead, the architect of Central Park, designed Forest Park's main drive. Its magnificent headquarters is located in a colonial gambrel called Oak Ridge. Victory Field boasts a running track, ball fields, and handball courts. It also features the Seuffert Band Shell, which has seasonal concerts. (Courtesy the Lucy Ballenas Collection.)

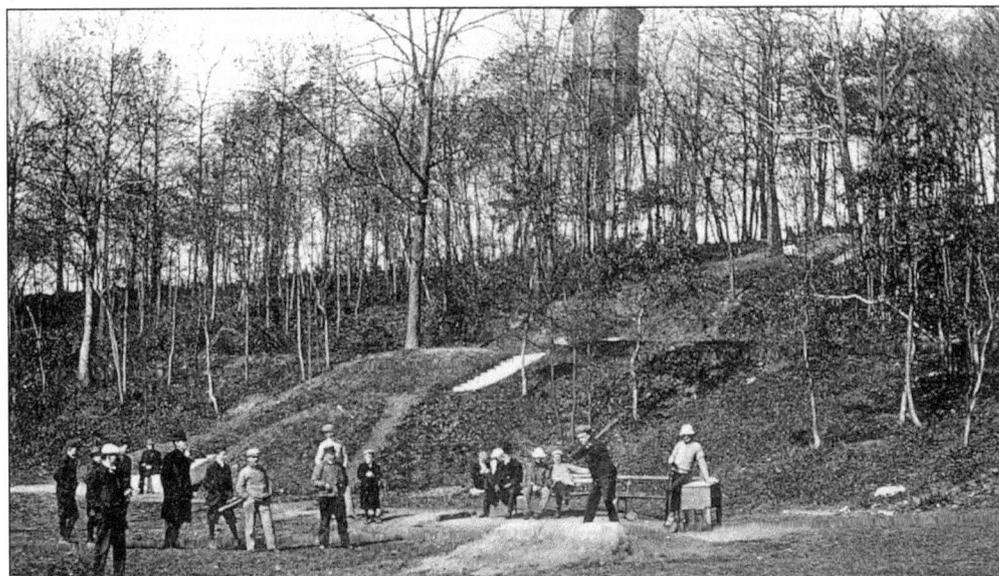

FOREST PARK GOLF CLUB LINKS. "Early use of the park was mainly limited to walking and this mostly on weekends, though a nine hole golf course was created early in 1905. The western section of the park was developed with a golf course and clubhouse on top of a hill where the Rockaways, Jamaica Bay and parts of Brooklyn could be seen on a clear day." —Naturalist Mary T. Fletcher. (Courtesy the Lucy Ballenas Collection.)

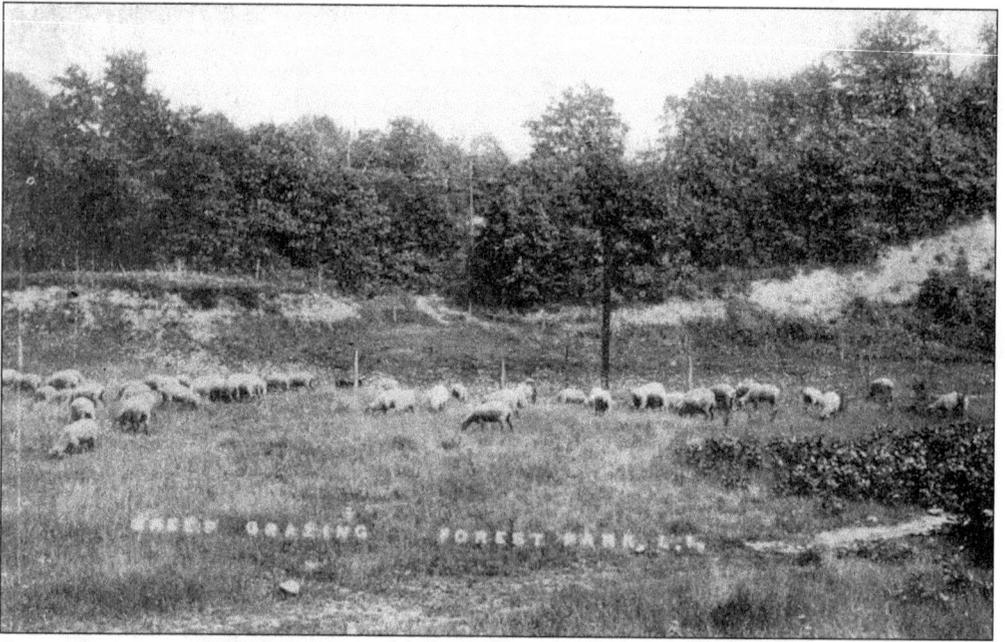

SHEEP GRAZING IN FOREST PARK. The Richmond Hill Zoo was created in 1914 at the corner of Myrtle Avenue and Washington Avenue (109th Street). A puma named Teddy, captured in Brazil by the son of Theodore Roosevelt, Colonel Roosevelt, was given as a gift. The zoo was stocked with elk, deer, sheep, and goats. An artificial pond was dug for the use of the animals. Shelters were built for them and their keepers. (Courtesy the Lucy Ballenas Collection.)

RELAXING IN FOREST PARK. On a grassy slope, three men enjoy a breath of fresh spring air in the park. "A walk to, or in, Forest Park was also a one-day-a-week feature of the girl's health education classes of Richmond Hill High School in fine spring or fall weather." —Naturalist Mary T. Fletcher. (Courtesy the Forest Park Trust.)

A DAY IN THE PARK WITH GEORGE. Young George German and his family spend a day in Forest Park in 1910. In the summer of 1903, Jacob Riis brought 89 children from Manhattan to Forest Park. "Some of the children said to their hostess, 'We have spent a delightful afternoon.' Perhaps we should have it put down to good breeding as to appreciation; but when one of the little waifs says, 'Say, we've had a bully time. Can't we come again next summer?,' we feel that the enjoyment has been real indeed." (Courtesy Rita Gambardella.)

JACKSON POND, FOREST PARK. Hearing in 1922 that this pond would be filled in and a playground built, a letter sent to the *Richmond Hill Record* in 1922 by a boy named Wallace Fox saved the pond. "From my point of view the pond is the most attractive spot in Forest Park. Jackson's Pond is the only pond in Richmond Hill where we boys and girls, and very often grown-ups, too, can go skating in the winter. . . . A lot of us who got skates for Christmas would have no more fun with the skates. . . . Why not leave it as is?" It was filled in years later but was recently renovated. (Courtesy the Forest Park Trust.)

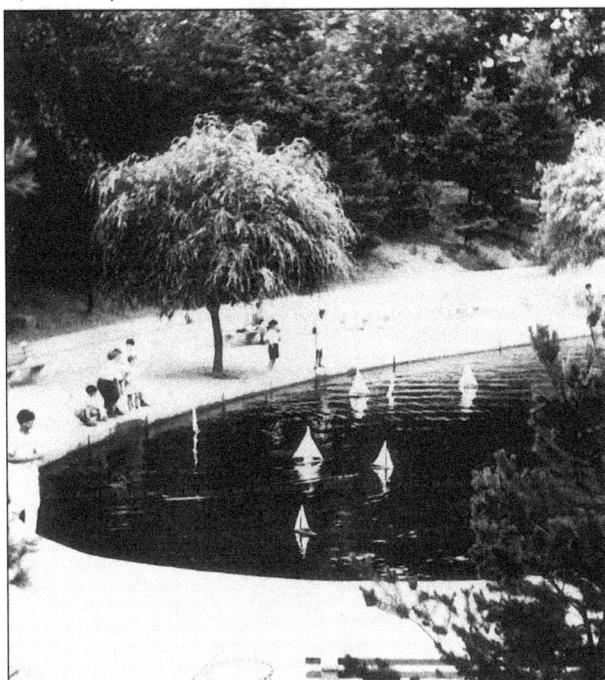

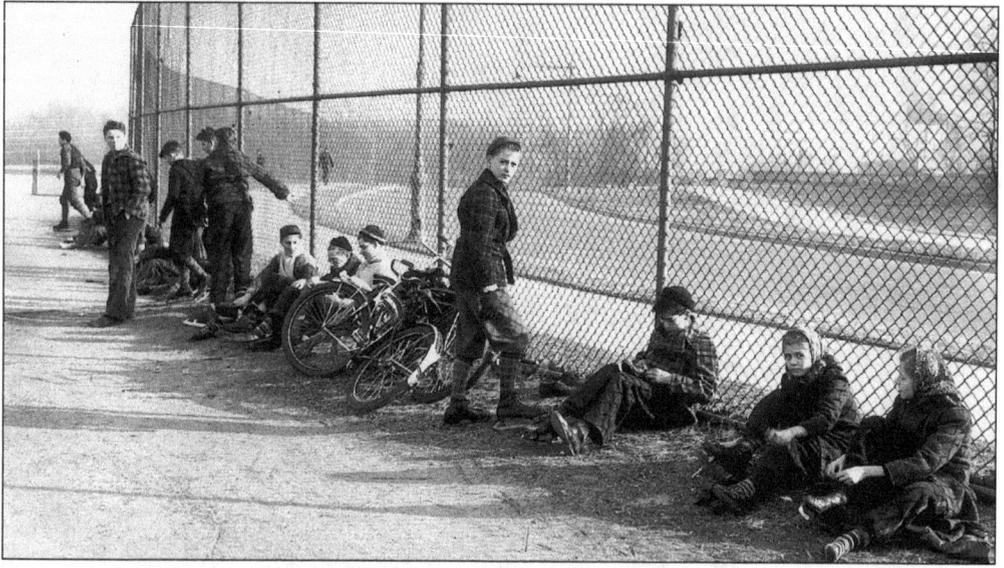

Children at Victory Field. Roller-skating has always been a pastime in Forest Park, and here in 1939, children line up to lace their skates and take a twirl around the park. "Park Commissioner Benninger has decided to name the new $100,000 athletic field, at Forest Park, Victory Field, in honor of the Unknown Soldier of the World War." —*Richmond Hill Record*, 1925. (Courtesy the Forest Park Trust.)

The Hillside Rollerdome. The Hillside Rollerdome was once located on Metropolitan Avenue near 129th Street. After the Great Depression, Metz, an automotive dealer across the street, made the people of Richmond Hill happy by opening this skating rink. Children were skating in the streets in anticipation of its grand opening. On platforms encased in glass facing each other were two organists playing all the latest tunes. (Drawing by Ann Mancaruso.)

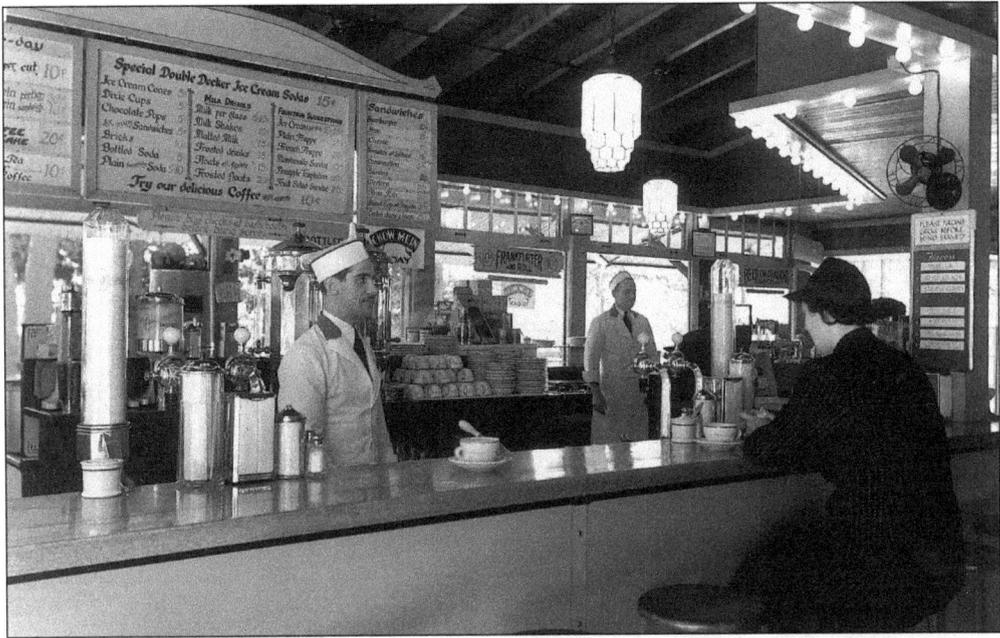

THE FOREST PARK SNACK BAR. Here, many patrons could enjoy a treat after a ride on the carousel, a concert at the band shell, or any of the other park activities. This photograph is dated *c.* 1940. The carousel is the only remaining one produced by master carver Daniel C. Muller and was designed in 1903. It was restored a few years ago to its original splendor and is situated in the Woodhaven section of Forest Park. (Courtesy the Forest Park Trust.)

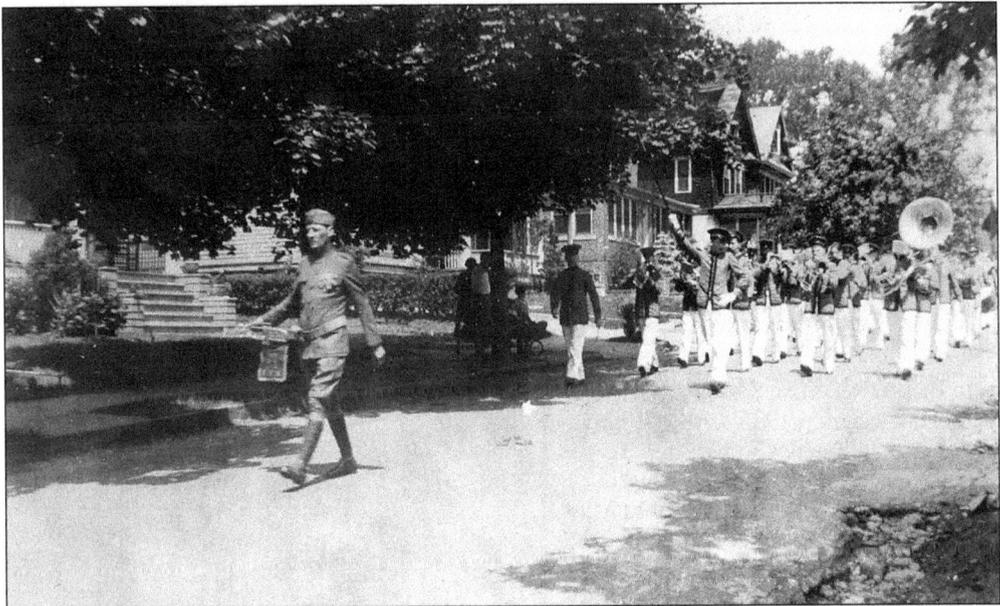

A MEMORIAL DAY PARADE, 1933. A veteran leads the band marching down 108th Street. Richmond Hill held many tributes to those in military service. "What was undoubtedly the most impressive celebration was held last Sunday. For months the residents of the community had been arranging to make the service flag and honor roll celebration a fitting testimonial to the boys in service." —*Richmond Hill Record*, 1918. (Courtesy Rita Gambardella.)

MEMORIAL DRIVE, FOREST PARK. George German sits on a park bench in the early 1940s. Previously, in 1923, the entrance to Forest Park had been chosen as a site for a memorial to honor those from Richmond Hill who had died in World War I. The main drive was renamed Memorial Drive. On November 11, 1923, 71 memorial trees were planted on either side of the drive. (Courtesy Rita Gambardella.)

THE BUDDY MONUMENT. This bronze statue, dedicated in 1925 to the 71 brave Richmond Hill men who perished in World War I, was designed by sculptor Joseph Pollia (1893–1954). Entitled *My Buddy*, it depicts an American soldier, rifle and helmet over his arm, after a search of the battlefield, looking down at a small mound of earth surmounted by a fallen cross at the grave of his fallen comrade. William Van Alen, architect of the Chrysler Building, designed the granite base. (Photograph by Nancy Cataldi.)

94

Six

A COMMON FAITH AND
TEMPLES OF EDUCATION

*Religion did indeed play its part in the growth of Richmond Hill. The first religious
services were held in the newly built depot in 1869 and today here and in nearby communities
there are more than 30 places of worship, including Protestant, Jewish and Roman Catholic.*

—*Richmond Hill Record*, 1928

THE FIRST GRADUATING CLASS OF ST. BENEDICT JOSEPH SCHOOL, 1916. A proud Fr. Patrick
Fahey stands with his young scholars with their diplomas in hand. Each girl was required to make
her own dress for graduation. (Courtesy St. Benedict Joseph Church, Mary Daly White.)

THE CHURCH OF THE RESURRECTION. "The cornerstone of the Church of the Resurrection was laid on Sunday afternoon last, a procession was formed at the depot, headed by the Sunday school children, the clergy in surplices and the vestry of the church, followed by a large congregation. The processional hymn being the 322 rd from the Hymnal 'Onward Christian Soldier.'" —*Long Island Democrat*, 1874. (Courtesy Nancy Cataldi.)

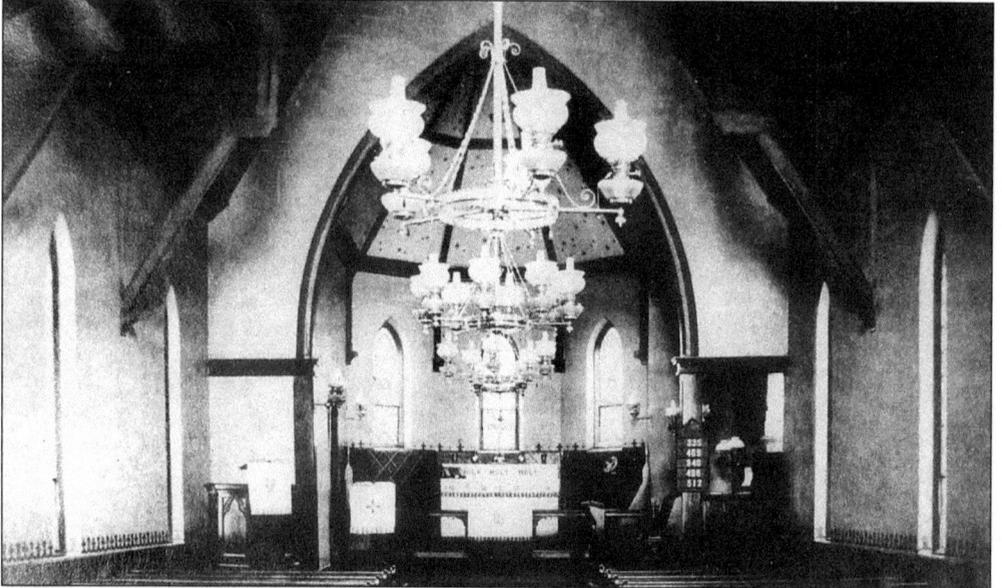

THE INTERIOR OF THE CHURCH OF THE RESURRECTION. In 1886, after the last evening service ended, the sexton began to extinguish the lights. The chandelier contained 42 kerosene lamps, and as he worked, the chandelier fell. He rang the bell calling the parishioners back. Richmond Hill had enough water but no fire apparatus, not even a hose, to respond to the blaze. Water was carried in buckets from the nearby Fisher home. Men and women acted as firemen, and their brave and heroic acts saved their little church from destruction. (Courtesy the Lucy Ballenas Collection.)

REV. JOSHUA KIMBER. The founding pastor of the Church of the Resurrection welcomed Pres. Theodore Roosevelt in 1903 on his whistle-stop tour. He said, "Mr. President, we have gathered here to give you a cordial welcome. You are the first president who has honored us by your presence. You also honor us by your affection for our fellow townsman, Jacob Riis, as well as by your public service as chief magistrate, and I take great pleasure in calling for three cheers for the President of the United States." (Courtesy the Lucy Ballenas Collection.)

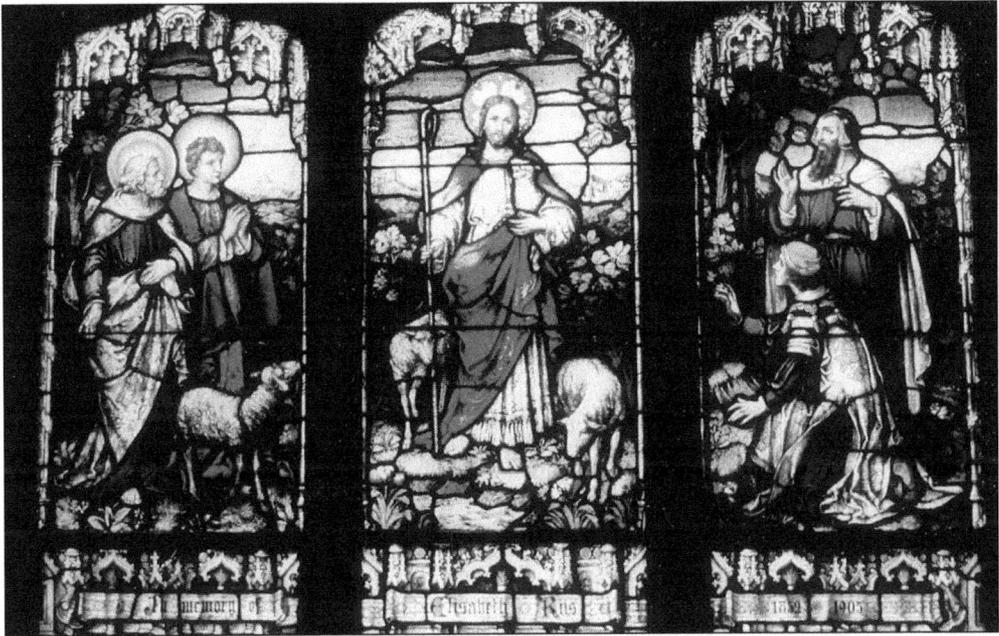

THE RIIS MEMORIAL WINDOW, THE CHURCH OF THE RESURRECTION. In the north aisle is the stained-glass window donated by noted photojournalist Jacob Riis. It represents Jesus, as described in the gospel of St. John, and was given as a tribute to Riis's wife, Elisabeth, who died in 1905. Riis affectionately called Elisabeth his "Little Lamb." The theme follows through to Maple Grove Cemetery, where a small statue of a reclining lamb rests upon Elisabeth's grave. She is buried along with four infant children and the ashes of a son, George Riis, who died at the age of 51 in 1927. (Photograph by Nancy Cataldi.)

REV. WILLIAM AGUR MATSON. Born in 1819, Rev. William Agur Matson came to Richmond Hill in 1877 and served as pastor of the Church of the Resurrection until 1886. He lived on Division Avenue until his death in 1904. An 1886 incident made news. "On Saturday night robbers attempted to enter the home of Rev. Matson. The cool-headed clergyman was on the alert and when a man appeared he immediately challenged him and the robber ran off only to stop and fire a pistol at him, the ball lodging in the house near the Reverend's head. A trusty shot-gun, such as our ancestors relied upon, was at once discharged by the plucky clergyman and the rascal fled through the snow and left the village." Matson's daughter Kate Matson Post wrote *The Story of Richmond Hill* in 1905. (Courtesy the Lucy Ballenas Collection.)

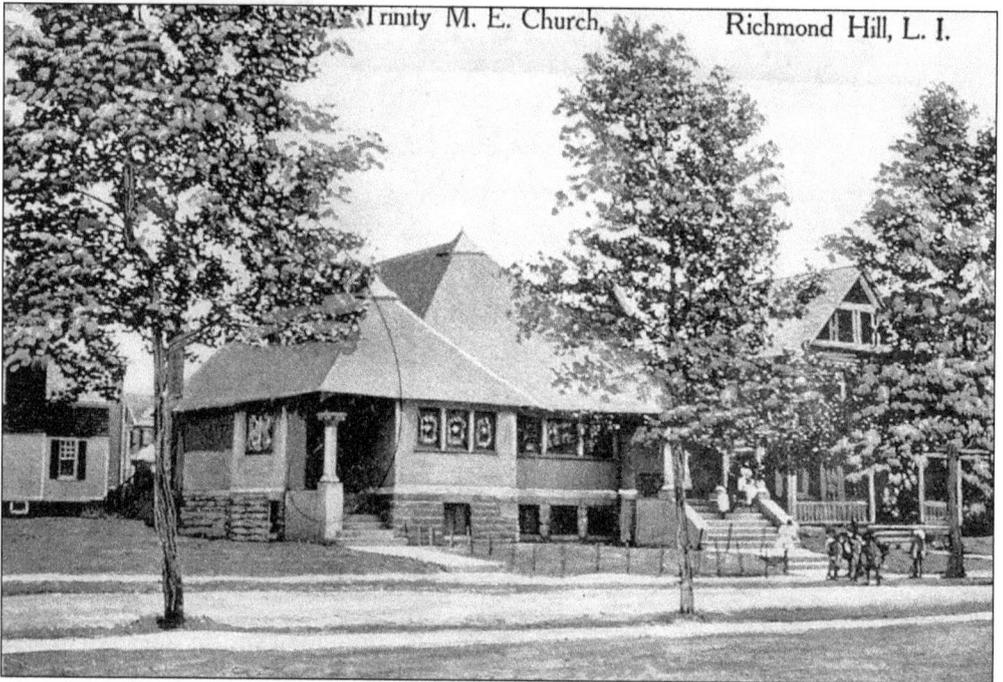

HOLY TRINITY METHODIST CHURCH. Services of this church were first held in a storefront on Jamaica Avenue in 1908. While the new church was being built, services were held under a tent, which was later destroyed during a violent storm. The congregation moved into the unfinished structure, where services were held by lantern light. It is located at 108th (Guion) Street. (Courtesy Nancy Cataldi.)

THE UNION CONGREGATIONAL CHURCH. Inaugural services were held in 1884 at Association Hall, a loft over a store. By 1886, the Union Congregational Church purchased a new frame building on Park Street. In 1893, the following resolution explains why they moved and built a new stone church on 115th Street. "Whereas, the disturbances of the religious services of this church by reason of the close proximity of steam and electric roads has already become exceedingly annoying and is likely to still further increase, and whereas the stable immediately adjoining the church is likely to become more and more offensive." (Courtesy the Lucy Ballenas Collection.)

THE FIRST METHODIST CHURCH. The organization of a Methodist church evolved in 1889 in the home of the Porters of Clarenceville. Lots were purchased at the corner of 118th and 97th Avenues and a chapel was consecrated in 1890. By 1894, a large wooden church was erected and dedicated. In 1931, a new brick building was constructed but within a year's time had been destroyed by fire. Three months later, it was rebuilt and services resumed. (Courtesy the Lucy Ballenas Collection.)

99

Baptist Church, cor. Elm St. and Fulton Ave, Richmond Hill, N. Y.

Nr. 7. Published by E. F. Van Sicklen, Richmond Hill, N Y Germany

THE RICHMOND HILL BAPTIST CHURCH. The Richmond Hill Baptist Church was organized in 1897, and its first service took place in Arcanum Hall. The little white chapel was built and dedicated in 1900. The last services were held in this chapel on March 2, 1919, and a new brick building was erected and dedicated on March 7, 1920. (Courtesy the Lucy Ballenas Collection.)

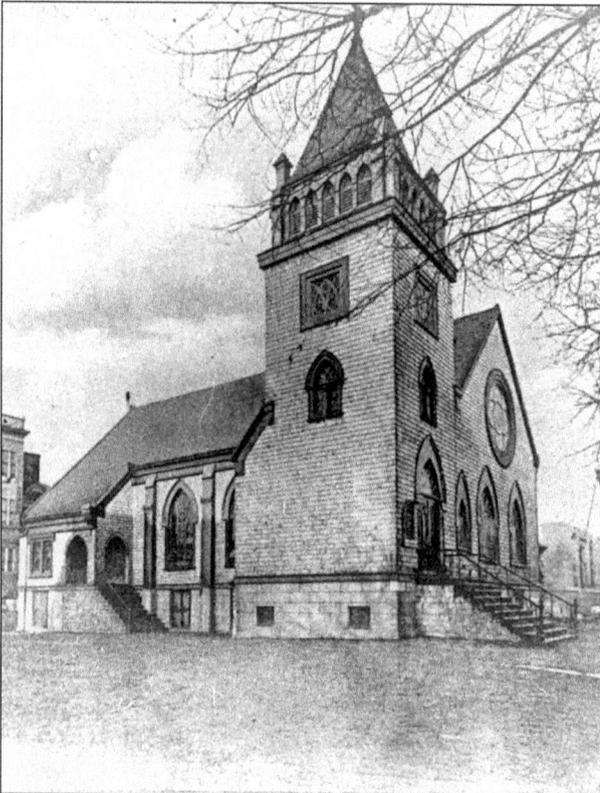

ST. JOHN'S LUTHERAN CHURCH. In 1903, a group of residents met to establish a church. They first gathered at Arcanum Hall and, by 1907, had consecrated a small wooden church on 114th Street north of Jamaica Avenue. In 1923, a new stone church in the Gothic style of the clearstory type was erected. (Courtesy the Lucy Ballenas Collection.)

100

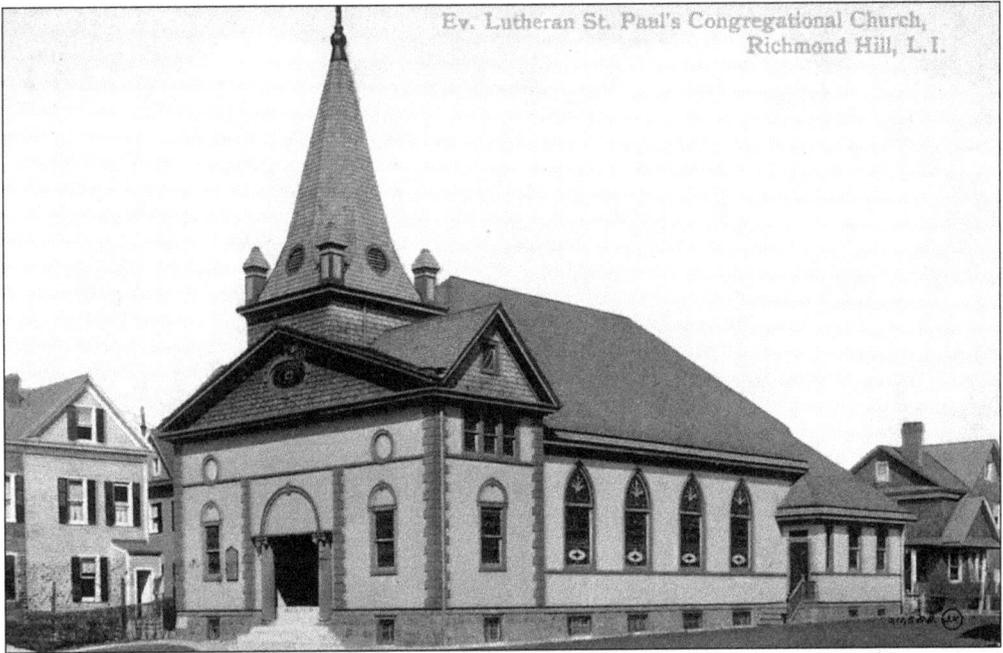

ST. PAUL'S EVANGELICAL LUTHERAN CONGREGATIONAL CHURCH. A Brooklyn minister organized this German Lutheran congregation *c.* 1895, and its first service was held at Arcanum Hall. Rev. A.N. Frey became the first pastor and stayed for about a year. Reverend Isler came and stayed about three years. Upon his departure, the congregation practically disbanded and no services were held. Rev. P.B. Frey was called to revive the church, and land was bought. In 1905, their wooden church was dedicated. Services were conducted in both German and English. (Courtesy Nancy Cataldi.)

OUR LADY OF THE CENACLE CHURCH. Bishop Molloy appointed Rev. John J. McEnearney to become the first pastor of Our Lady of the Cenacle Church. The first mass was celebrated in a tent near the Van Wyck Expressway. After the new building was finished, a midnight mass on December 25, 1923, marked the first service. (Courtesy St. Benedict Joseph Church.)

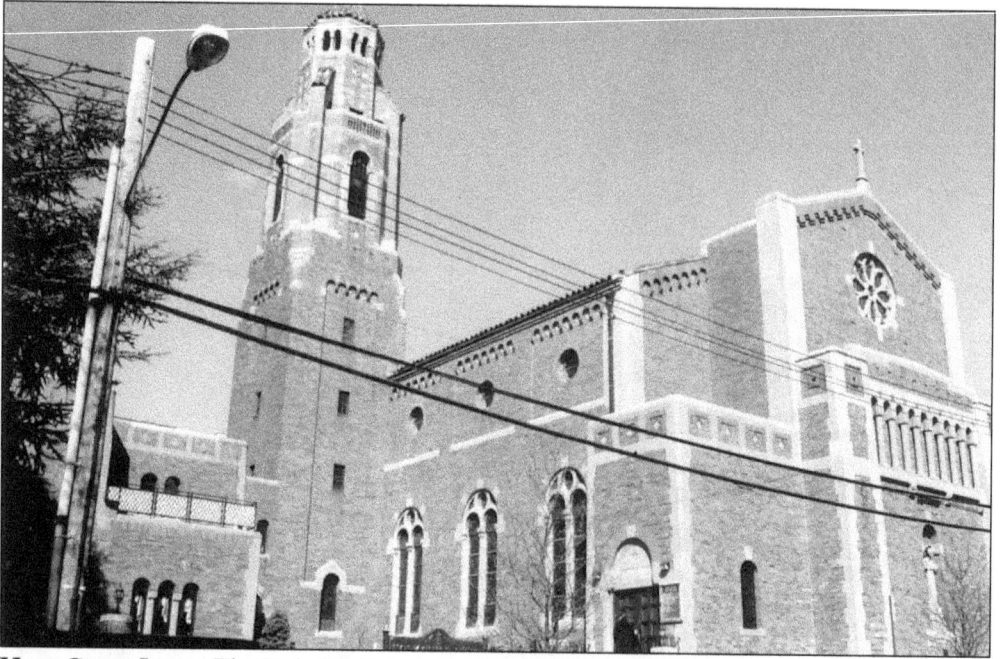

HOLY CHILD JESUS. The Holy Child Jesus parish was a "daughter" parish of St. Benedict Joseph Labre. Its first mass was celebrated on Christmas morning in 1901 on the top floor of Arcanum Hall. In 1911, services were held in the newly finished basement of the church, which was still under construction across from the rectory at 86th Avenue and 112th Street. In 1930, the current church was dedicated. The architect, Henry V. Murphy, described its style as Modern Romanesque. (Courtesy the Richmond Hill Historical Society.)

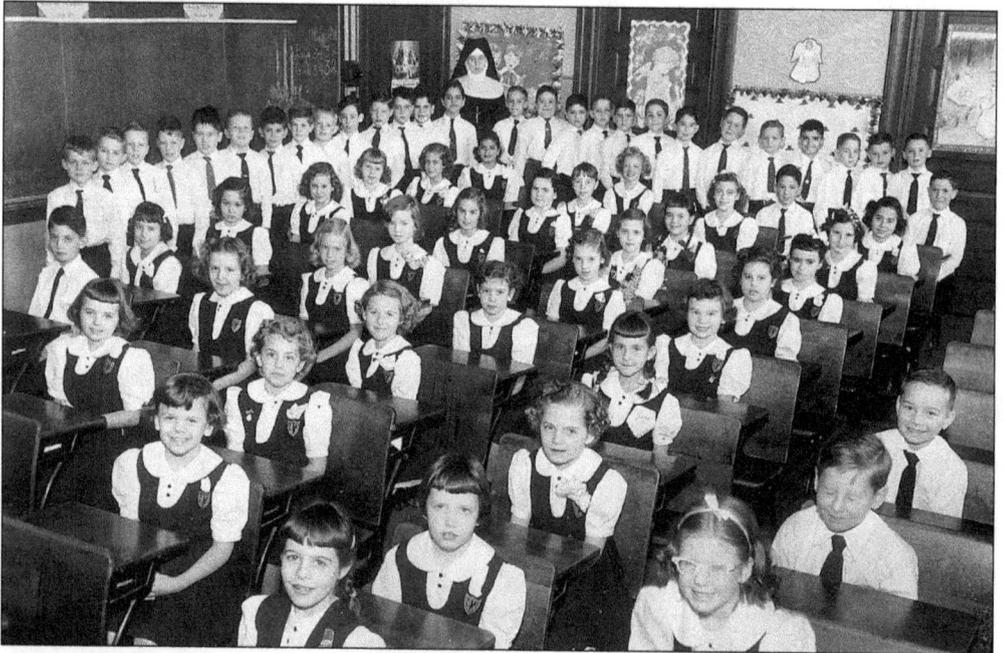

THIRD GRADE. Sr. Joseph Eucharia of the Sisters of St. Joseph teaches students at Holy Child Jesus School in 1955. (Courtesy Diane Freel.)

St. Benedict Joseph Labre Church. St. Benedict Joseph Labre Church was the first Catholic church organized in Richmond Hill. In 1892, Thomas Lally petitioned Bishop McDonnell to create a parish. Rev. William McGuire was appointed first pastor of the only parish in the world placed under the patronage of St. Benedict Joseph Labre. The first mass was celebrated in Fielder's Hall. A wooden church building was dedicated in 1893. A church school opened in 1913, taught by the Sisters of St. Joseph. In 1919, a brick church in the Romanesque style was dedicated. (Courtesy the Lucy Ballenas Collection.)

Fr. Patrick Fahey and Niece Jennie. Father Fahey was made pastor of St. Benedict Joseph in 1900. In 1909, the people of Richmond Hill celebrated Fahey's silver jubilee with gala celebrations and presented him with $500 in gold. While on a pastoral call in 1915, he saw two frightened little girls clinging to the seat of a carriage being drawn by a runaway horse. He stopped the horse but was severely injured. (Courtesy the Lucy Ballenas Collection.)

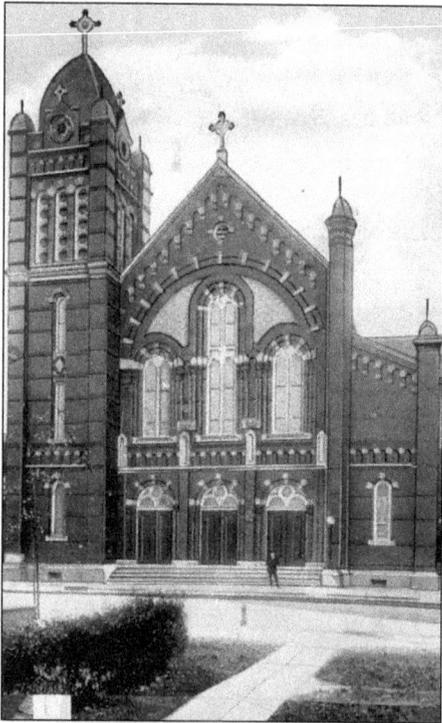

ST. BENEDICT JOSEPH LABRE CHURCH, 1919. Never fully recovered from his injury, Fr. Patrick Fahey died on July 15, 1917. As a final tribute, his casket was brought into his still uncompleted new church, shown here, to rest for a moment before it was taken to the cemetery. (Courtesy St. Benedict Joseph Church.)

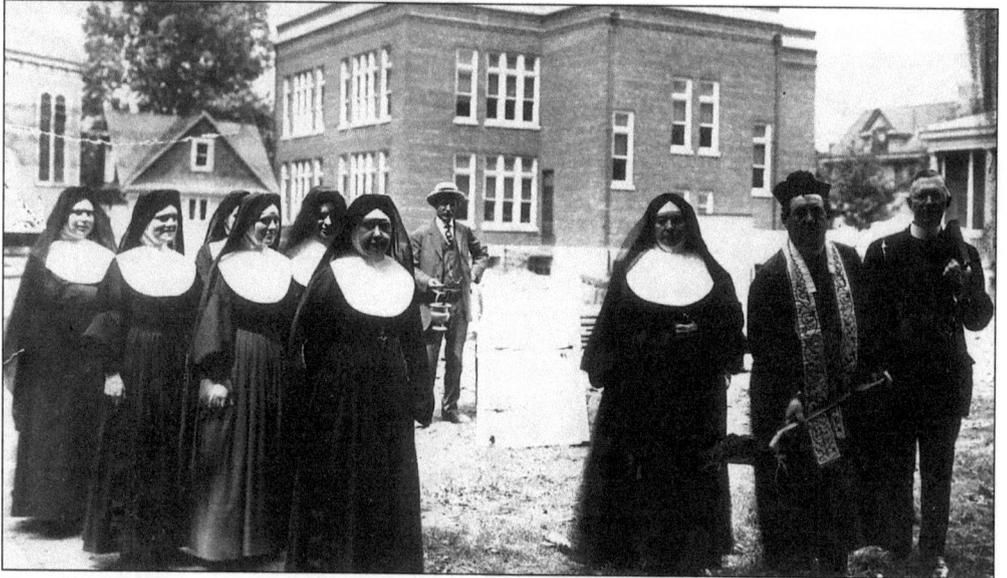

THE GROUNDBREAKING CEREMONY FOR THE NEW CHURCH, 1916. Fr. Patrick Fahey, principal Sr. M. Alipius Monroe, and school staff, the Sisters of St. Joseph, participate in the groundbreaking ceremony for a new church. Sr. Mary Agatha Hurley wrote about the first school year in 1913, "One stormy day we had some trouble getting to school. After about an hour's time we reached Richmond Hill and walked along Church St. Occasionally a head popped out looking for us. When they got a glimpse of us a loud cry went up—'Here they are!'—and all were in perfect order on our arrival—Father Fahey was happy to be relieved of his task. He was exhausted." (Courtesy St. Benedict Joseph Church.)

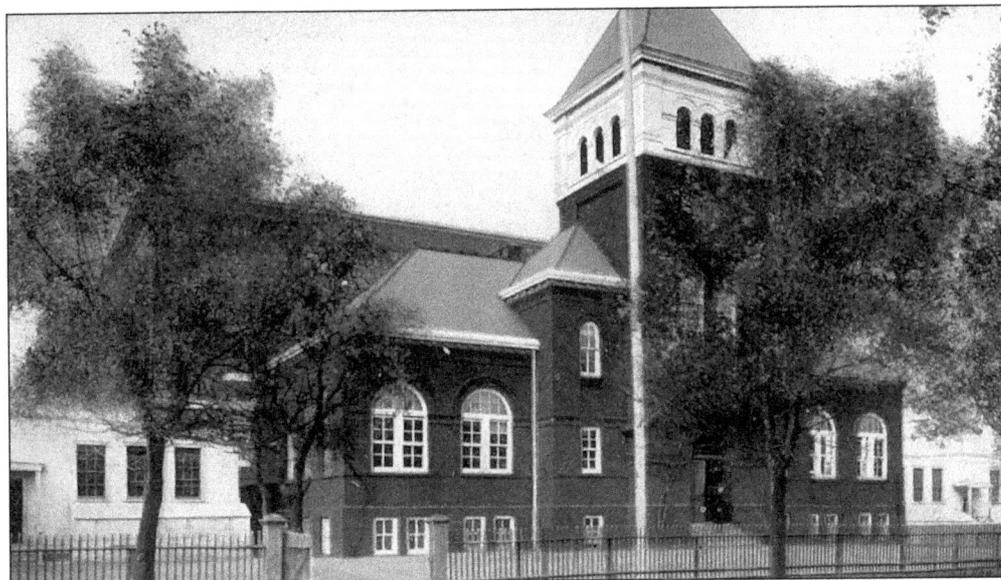

THE JOHNSON AVENUE SCHOOL. The first wooden schoolhouse on Lefferts was opened in 1872. By 1890, it had become too small for the bustling community, and a new school was erected on Johnson Avenue (118th Street) south of Jamaica Avenue. The architect was Augustus Hatfield, and the building cost $15,000. It was made of brick, two stories with all the modern improvements, to seat 200 to 250 students. The school opened on September 8, 1891, with Professor Miller as principal. (Courtesy the Lucy Ballenas Collection.)

PUBLIC SCHOOL NO. 51. The expansion of Richmond Hill was miscalculated when the 1891 Johnson Avenue School was built. By 1892, it was so overcrowded that the vestibule was converted into a temporary classroom. This photograph shows the school addition built in 1907, attached to the old school. Arthur Noone, a former student from 1900, remembered, "Most of the children lived within earshot of the school bell, and waited until they heard it ringing before starting for school. If by any chance the bell missed being rung, there was a slim attendance that day." (Courtesy the Lucy Ballenas Collection.)

105

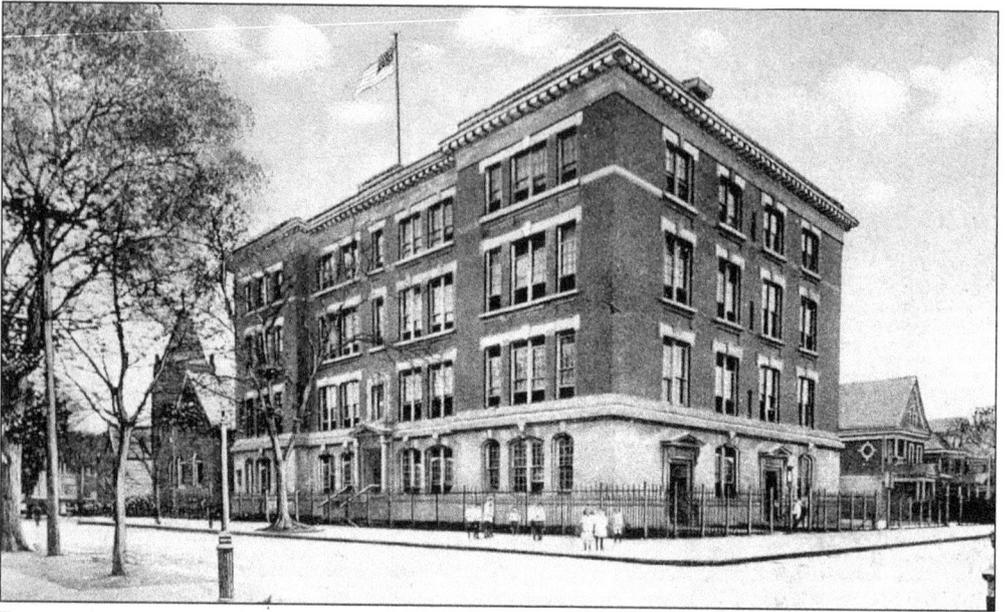

PUBLIC SCHOOL NO. 56. A wooden schoolhouse with a tower was built in 1894 on the corner of 114th Street and 86th Avenue. In 1908, it was decided to replace the school with a new brick structure. Not wanting to disturb the school year, the wooden school was moved to a nearby lot, so classes could continue while the new building was erected on the same school site. (Courtesy the Lucy Ballenas Collection.)

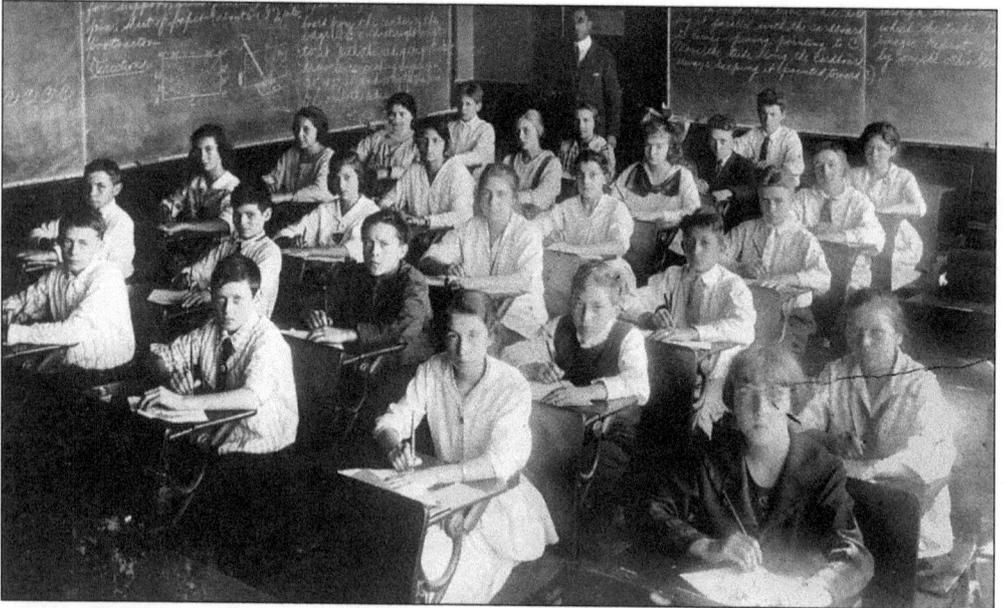

PUBLIC SCHOOL NO. 54. In 1894, the population of Richmond Hill was close to 4,000, with more than 600 children. The Johnson Avenue School was becoming seriously overcrowded; it was decided to open two new schools—Public School No. 54 and Public School No. 56. The wooden structure of No. 54 was replaced with a brick building soon after this 1920 photograph was taken. Pictured is L.F. Silvestro's eighth-grade class. Alice Helen Quortrup is seen in the front lower right corner. (Courtesy Helen A. Harrison, Quortrup Family Archives.)

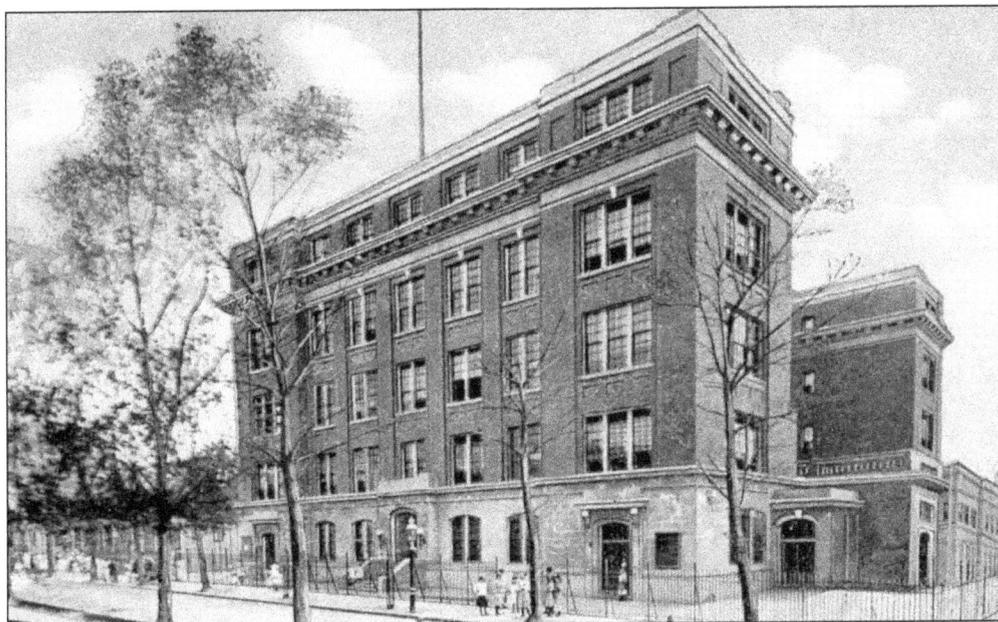

PUBLIC SCHOOL NO. 90. "At Lincoln and Washington Avenues, it will probably not be ready until spring. It is to be the largest school in Queens with 48 classrooms. Principal John A. Loope will be in charge. It is expected that the opening of the new school will put an end to the part-time classes in Richmond Hill, and that the high school will be occupied exclusively by the High School, and will not have in it any grammar grades as it is at present." —*Richmond Hill Record*, 1909. (Courtesy Nancy Cataldi.)

PUBLIC SCHOOL NO. 66, THE OXFORD SCHOOL. Situated between Tulip Street (85th Avenue) and Walnut Street (85th Road) on Union Place (102nd Street), the Oxford School opened to receive schoolchildren just as the town of Richmond Hill became part of New York City in 1898. The school was designed in a Romanesque style with a stone foundation with brick and terra-cotta facades. The bell tower, removed because of deterioration, is now part of a restoration project and will be rebuilt. (Courtesy Public School No. 66.)

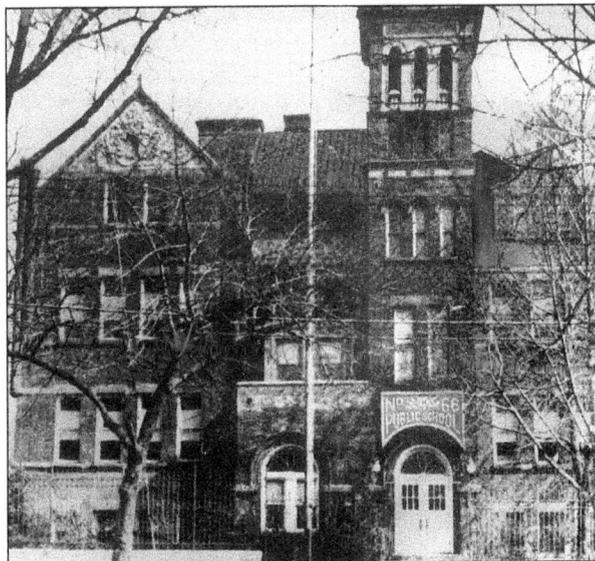

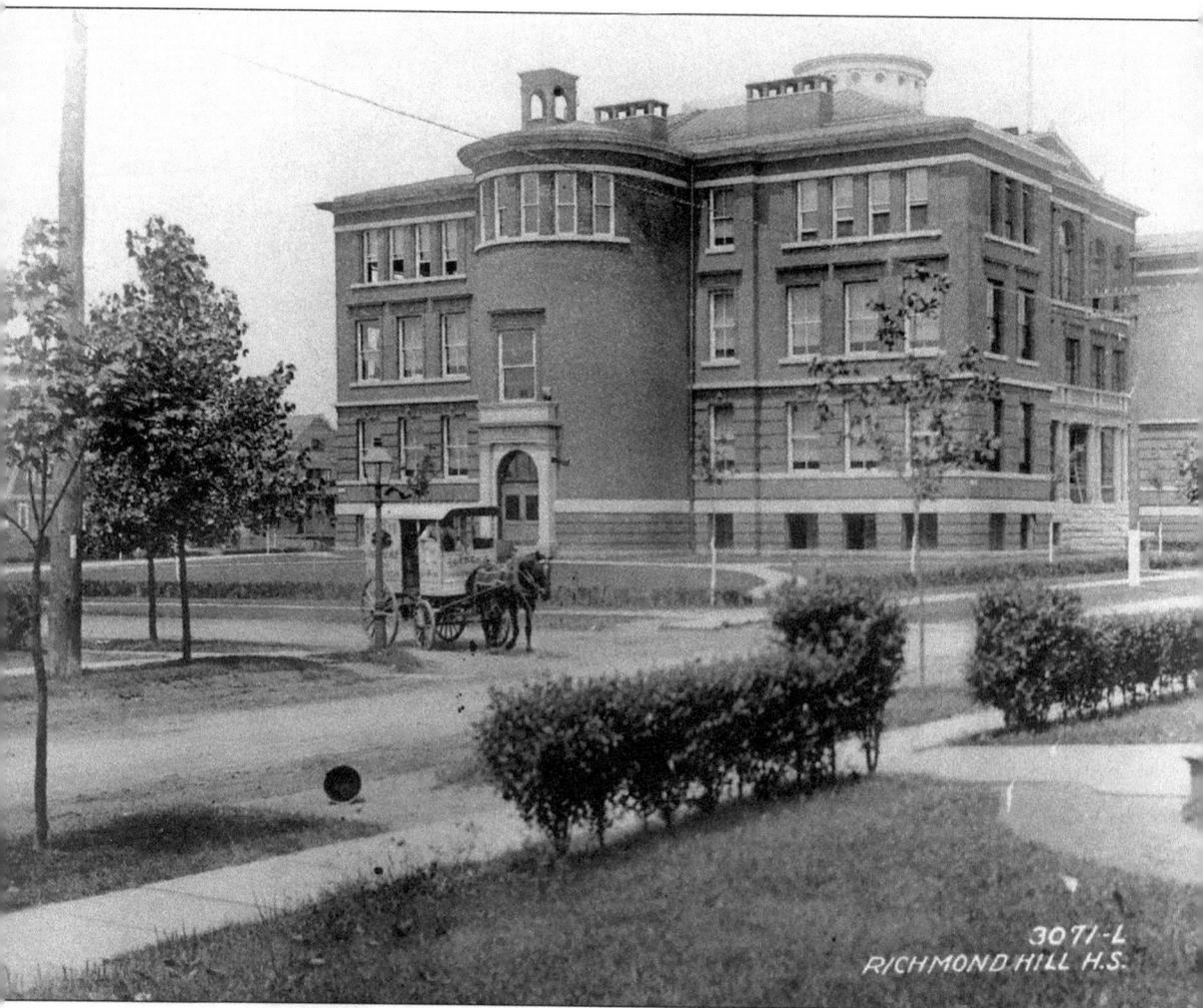

RICHMOND HILL HIGH SCHOOL, A SIDE VIEW. Prof. Isaac Newton Failor organized the Richmond Hill High School in 1900, erecting a state-of-the-art building on Elm (114th) Street. It was the only school to have an observatory for the study of astronomy, and the dome became the school symbol. "On April 11, our splendid new building was dedicated. Appropriate exercises were held in the Assembly, which was prettily decorated with palms and flowering plants. A large audience of the friends and relatives of the pupils was present, and on the platform were seated many well-known citizens interested in educational matters." —Annual of Richmond Hill High School, 1900. (Courtesy the Richmond Hill Post Office.)

Seven

THE CELEBRATED
OF RICHMOND HILL

*Look at a stone cutter hammering away at his rock, perhaps a hundred times without
as much as a crack showing in it. Yet at the hundred-and-first blow it will split in two,
and I know it was not the last blow that did it, but all that had gone before.*

—Jacob August Riis

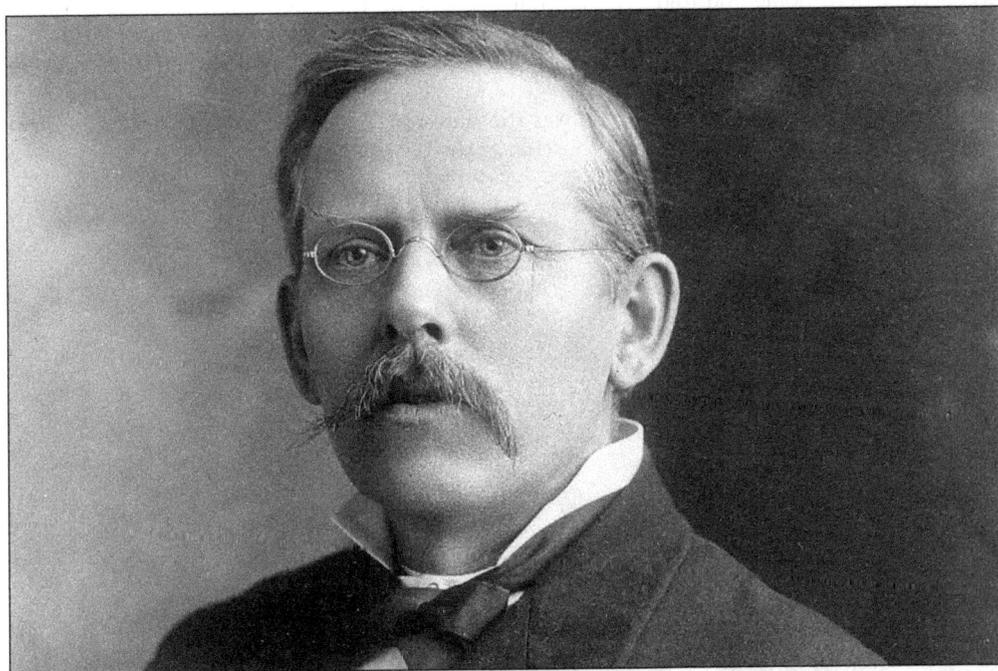

JACOB AUGUST RIIS, 1890. Born in Ribe, Denmark, in 1849, Jacob Riis came to the United
States when he was just 21. After seeking employment at various occupations, he became
a reporter for the *New York Herald* in New York City and went on to become a celebrated
photojournalist. (Courtesy Ribe Byhisotirkse Arkiv.)

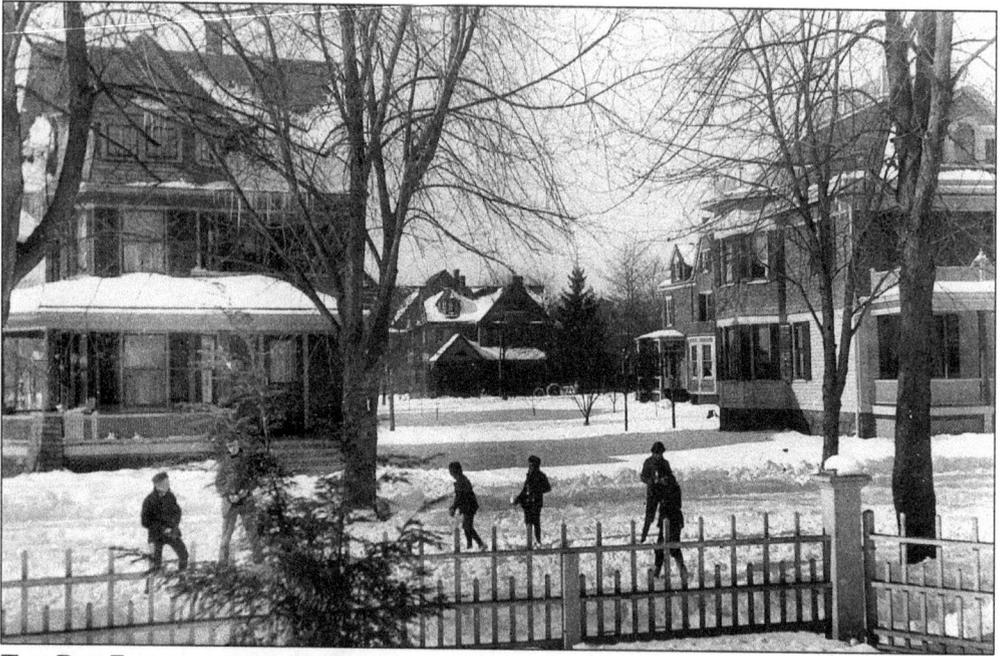

THE RIIS FAMILY, C. THE 1890S. "It was in the winter when all our children had the scarlet fever that one Sunday, when I was taking a long walk out on Long Island where I could do no one any harm, I came upon Richmond Hill, and thought it was the most beautiful spot I had ever seen, I went home and told my wife that I had found the place where we were going to live. The sick room was filled with the scent of spring flowers and of balsam and pine as the children listened and cheered. I picked out the lots I wanted. So before the next winter's snow, we were snug in the house, with a ridge of wooded hills, between New York and us. The very lights of the city were shut out. So was the slum and I could sleep." —*The Making of an American*, Jacob Riis, 1901. (Courtesy Museum of the City of New York.)

THE RIIS FAMILY HOME. "The house lies yonder, white and peaceful under the trees. Long since, the last dollar of the mortgage has been paid. The flag flies from it on Sundays in token thereof. Joy and sorrow have come to us under its roof." —*The Making of an American*, Jacob Riis, 1901. The family house was put on the National Register of Historic Places but was torn down in the mid-1970s. (Courtesy the Lucy Ballenas Collection.)

THE JACOB RIIS STUDY. During the 1800s, Riis built this study behind his home on 120th (Beech) Street, where he could write undisturbed. His work made him aware of the many injustices suffered in the slums of New York. As an author, he was one of the first to use a camera to bring to light the horrid conditions of the tenements. Due to his works, these conditions were corrected. (Courtesy QBPL, LID, the Richmond Hill Collection.)

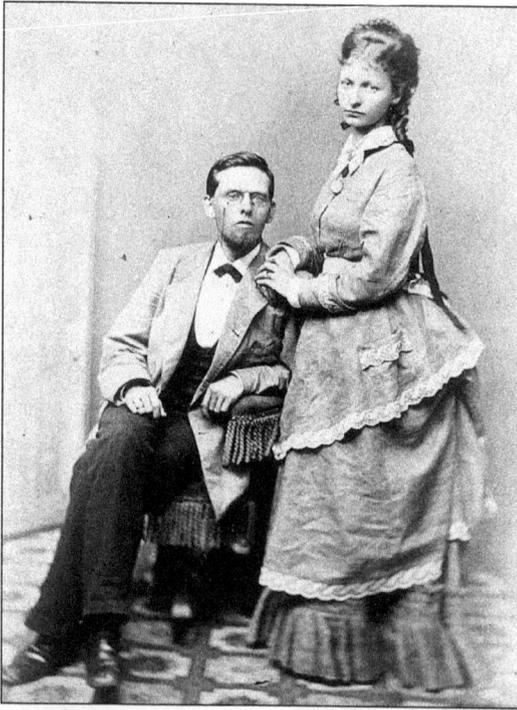

JACOB AND ELISABETH, 1876. Jacob Riis fell in love with Elisabeth when they were young. Riis was a 20-year-old carpenter, and she was 17 when he proposed marriage. Her family would not allow Elisabeth to "marry down." Devastated, with his proposal rejected and nothing left for him in Ribe, he came to America, hoping someday Elisabeth would be his. Elisabeth met a soldier who was much older with social standing and became engaged. When a fatal illness befell him, she was forbidden to marry him. Defying her parents, she moved out of their home to care for him until he died. In America, Jacob had made a name for himself as a journalist and still kept Elisabeth in his heart. He proposed a second time, and they were married in Ribe in 1876. (Courtesy Ribe Byhisotirkse Arkiv.)

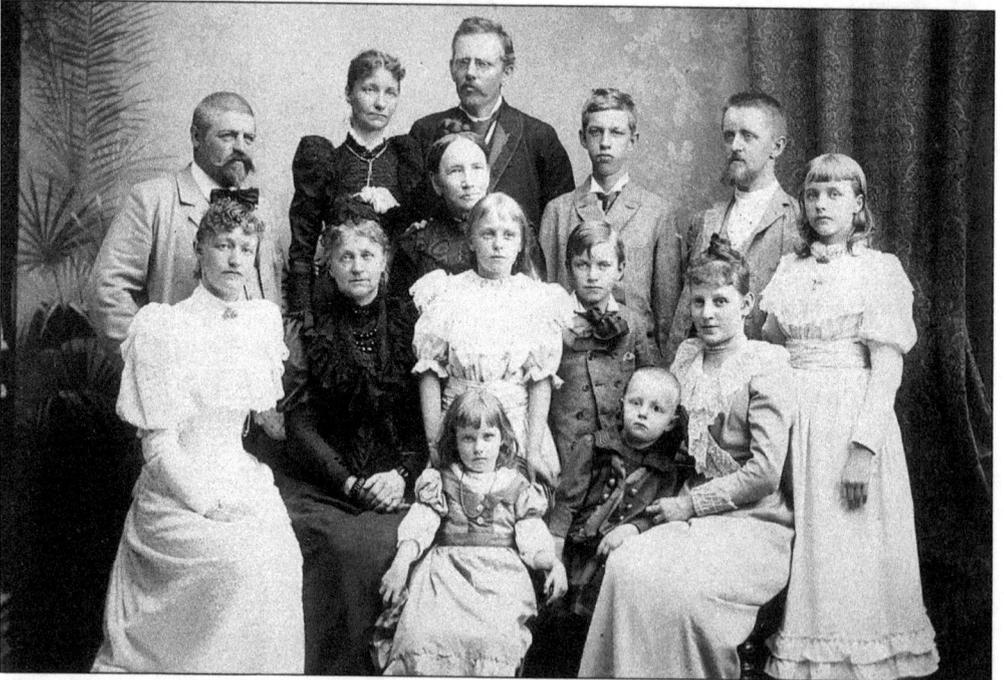

THE FAMILY RIIS. This is a portrait of the Riis and Giortz families in 1888 in Ribe. Elisabeth and Jacob are standing in the back row with their children and family members. "Anyone of Riis's children would attest that Christmas was to him—and, happily, is still to them—the most meaningful, most joyful time of all the year; for him, a time when families draw closer together and when all men feel kinship." —Jacob Riis Owre, 1970. (Courtesy Ribe Byhisotirkse Arkiv.)

JACOB AND ELISABETH, 1901.
Elisabeth was loyal to her husband
and his work and took good care
of their Richmond Hill home. She
contributed a chapter in his 1901
book *The Making of an American* on
how they met. In the same year, they
celebrated their 25th anniversary.
Jacob and Elisabeth held an open
house to celebrate 25 years of happy
married life. Many friends came to
wish them happiness, and messages
arrived from all over the world. The
King's Daughter's Settlement on
Henry Street renamed their center
the Jacob A. Riis Neighborhood
House to honor their anniversary.
(Courtesy Ribe Byhisotirkse Arkiv.)

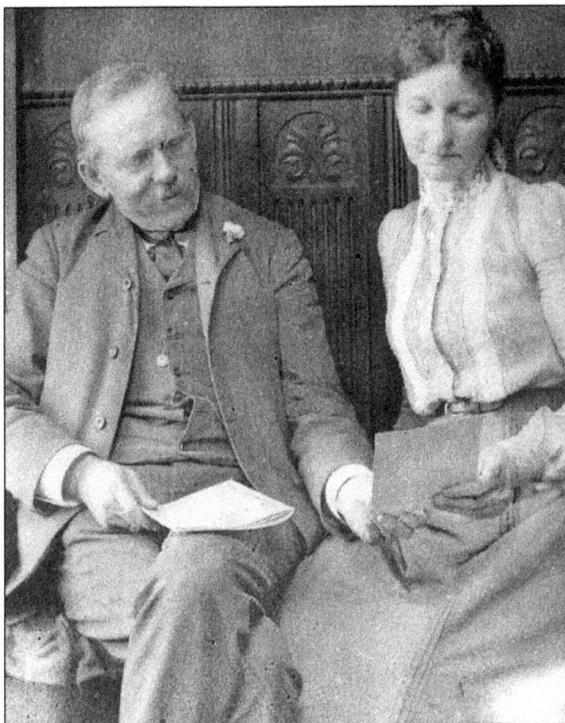

CLARA RIIS FISKE IN RICHMOND HILL. Clara
Riis and her daughters lived in the old Lefferts
farmhouse, which was moved from Jamaica
Avenue to 115th Street. In the background
is the tower of St. John's Lutheran Church
on 114th Street. In 1900, Jacob's daughter
married in the Church of the Resurrection.
Gov. Theodore Roosevelt and Elisabeth Riis
were the witnesses. Roosevelt escorted Mrs.
Riis to the church, and the crowd cheered
when he entered. The church was handsomely
decorated with palms and flowers, and huge
masses of white roses were upon the altar. The
young couple left amid a shower of rice and
ancient shoes for a trip through northern New
York. (Courtesy Ribe Byhisotirkse Arkiv.)

ELISABETH AND CHILD, 1884. Elisabeth died in 1905, devastating Jacob, but was comforted by a man he called his brother, Theodore Roosevelt: "Beloved friend. In the terrible elemental griefs no one, no matter how close, can give any real comfort. All I can say is what you know, my dear friend with the bruised and aching heart. You know how my wife and I love the dear, dear one who has gone before you; you know how we love you, how we think of you, how we feel for you and your crushing calamity. The life of you two was an ideal life. Later, though not now, you will be able to realize what a wealth of precious memories are left you. You and I, friend, are now in range of the rifle pits; and if we live, sorrows like this must befall us. May the Unseen Powers be with you as you now walk in the shadow." (Courtesy Ribe Byhisotirkse Arkiv.)

JAKE AND TEDDY. Jacob Riis (left) and Pres. Theodore Roosevelt pose in 1905. "September 8, 1903—This morning President Theodore Roosevelt stopped here on his special car on his way home from the State Fair at Syracuse with Mr. Jacob Riis and spoke a few minutes to the people of Richmond Hill. Big crowds and lots of decorations." —*Diary of Miss Ella J. Flanders.* (Courtesy the Theodore Roosevelt Collection, Harvard College Library.)

114

The Theodore Roosevelt Speech of 1903

Pres. Theodore Roosevelt made a brief whistle stop at the Richmond Hill depot, where more than 2,000 people gathered, including 300 children from St. Benedict Joseph and St. Matthews, all carrying flags. The town around the depot was decorated with flags, and the depot itself was covered with red, white, and blue streamers. The president appeared on the rear platform of the last coach and greeted the people amidst cheering and waving of flags. Rev. Joshua Kimber welcomed the president on behalf of the people.

<div align="center">

President Roosevelt Addresses the People of Richmond Hill
Praises Jacob A. Riis, Praises Fathers and Mothers
September 8, 1903

</div>

Mr. Kimber, and you men, women, and children of Richmond Hill: I am very glad of the opportunity to address the townsfolk of Mr. Riis. I wish I could talk better to all of you. I will ask of you little patience for one moment while I thank you for having come out to greet me. I am glad to see all of you, but allowing me to say that I am most glad to see those fathers and mothers who carry small children in their arms.

You know I am fond of Mr. Riis. I turn to him as an example of a decent citizen, because he practices what I have been preaching all along and the worth of any sermon lies in the way it is applied in practice.

And of course I am glad when I see a man who shows by his life that he can practically apply the spirit of decency without mournfulness, a man without false pretenses.

I want to see more decency in life. I want men to act squarely. I want to see men work, not with sour faces. I believe in happiness and the joy of living, but not in a life that is nothing but play. There is 1,000-fold more enjoyment in life when work comes first.

I want good men, but I want men who can fight if necessary. A man who is purely good and has not the fighting qualities is not worth much.

I believe in strength with sweetness, Dr. Kimber. I believe in a good man, who can fight when necessary, as you did in the Civil War. There has got to be decency in life. Now if Jake Riis when he was in the police department had carried on a rosewater reform he would never have accomplished anything.

I want to tell you how deeply touched I am on your coming to greet me. You give me strength and heart. I am glad to see so many children. I see they are all right in quantity and all right in quality.

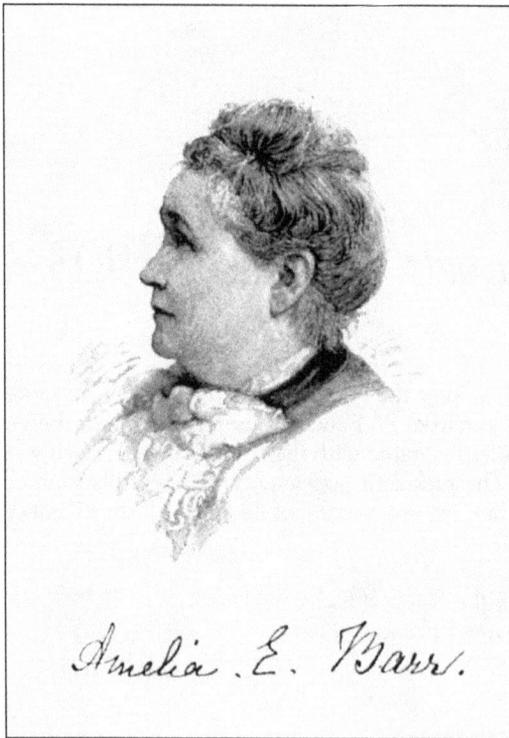

AMELIA EDITH BARR. A noted novelist of more than 70 books, Barr was born in England in 1831. She married Robert Barr in 1850. They moved to America with their children and settled in Austin, Texas, where Barr became secretary to Gen. Sam Houston. In 1867, her husband and two sons died of yellow fever. Moving to New York with her three daughters, $5, and faith in God, she started a new life. After struggling for years, in 1884, at the age of 53, she published her first novel, *Jan Vedder's Wife*, which was an immediate success. She died in 1919. Some other famous Richmond Hill residents include Rodney Dangerfield, Jack Cassidy, Freddy Roman, Cyndi Lauper, Jack Lord, Nan Halperin, Jack Maple, Anais Nin, Walter Hubbell, and Edna Blanche Showalter. (Courtesy the Lucy Ballenas Collection.)

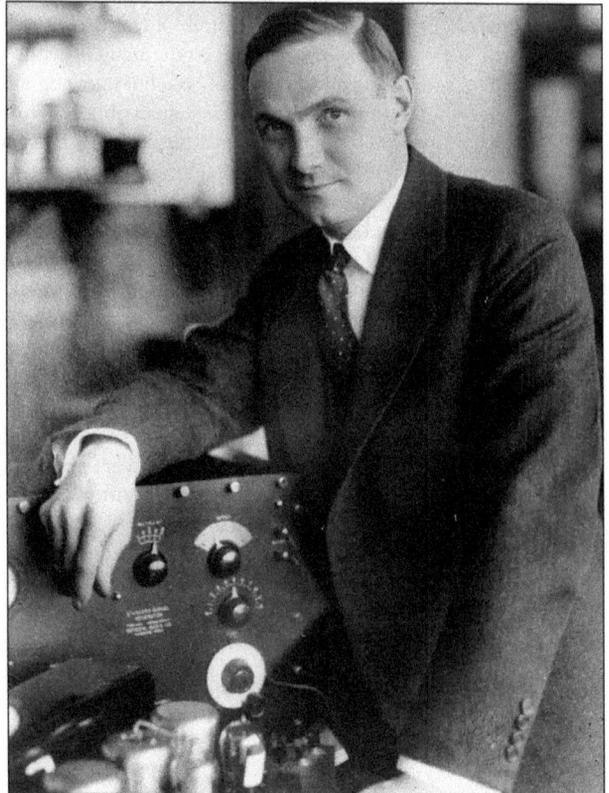

ALFRED H. GREBE. Alfred Grebe was born in 1895. While attending public school, he became interested in the wireless. At 15, he became a licensed wireless radio operator and served as such on different steamships over a three-year period. At home in Richmond Hill, he manufactured receiving sets and enlarged his facilities to keep up with the demand. He also then turned his attention to radio broadcasting stations. His first station was WAHG, which became WABC and finally WCBS, the key station of the Columbia Broadcasting System. Alfred died in 1935. (Courtesy the Grebe family.)

THE "RADIO" SHACK. In 1891, Henry Grebe bought land for his horticultural business. The land was along Van Wyck Boulevard from Jamaica Avenue to Archer Avenue. He also erected a house there. By 1915, Alfred Grebe had already been busy making radios in the tool shack behind his home. By 1922, he tore down the house and built a large factory in its place. (Courtesy the Grebe family.)

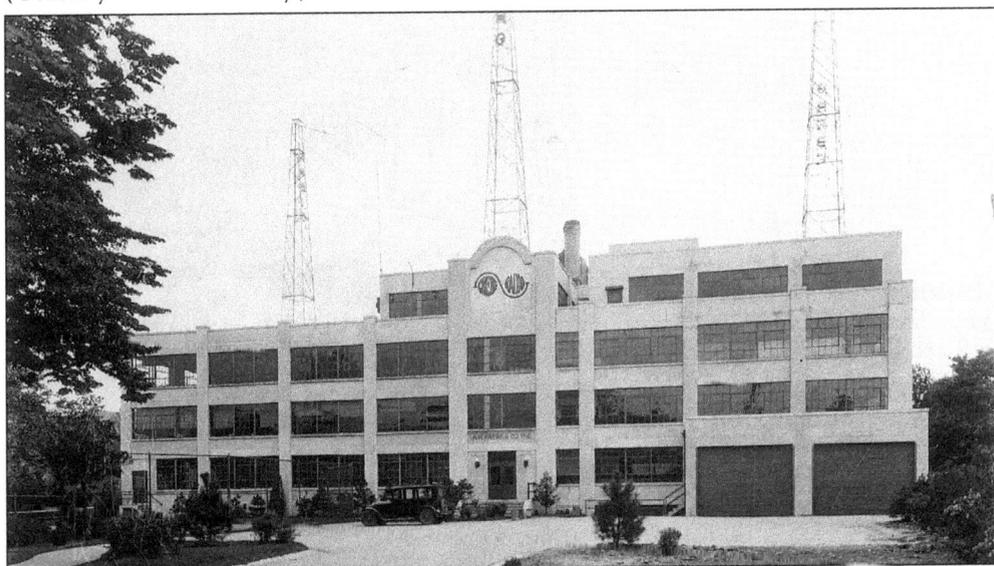

THE GREBE FACTORY. In order to stimulate public interest in radio, Alfred Grebe started several broadcasting stations. WAHG bore his own initials; WBOQ stood for the Borough of Queens. Both were among the first radio stations in the United States. "The A.H. Grebe radio studio in Richmond Hill one of the most modern and best equipped studios to be found anywhere. The studio is located at 10 Van Wyck Boulevard, Richmond Hill. The new station is designated WAHG, and operates on 316 meters. It uses the same amount of power as other high power stations." —*Richmond Hill Record*, 1924. (Courtesy QBPL, LID, the Weber Collection.)

ERNEST R. BALL. Ernest R. Ball lived at 115-26 84th Avenue. The words of Isidore Witmark upon Ball's death in 1927 immortalize the songwriter. "I shall never forget a telephone talk with Irving Berlin in which, expressing himself about Ernie, he finished up with, 'I wish I could write a song as good as his.'" "Mother Machree" and "When Irish Eyes Are Smiling" are just a few of the hundreds of successes by this prolific writer. Isaac Goldberg said, "Ernie Ball is not dead. He will live forever in his songs." —*From Ragtime to Swingtime*, 1939. (Courtesy Nancy Cataldi.)

MORTON GOULD, 1993. Musical genius Morton Gould was born in Richmond Hill in 1913. "Composing is my lifeblood. Although I have done many things in my life—conducting, arranging, playing piano, and so on—what is fundamental is my being a composer, which has shaped everything else rather than the other way around." Gould received the Kennedy Center Honor in 1994 and the Pulitzer Prize in Music in 1995. He received 12 Grammy nominations and a Grammy award in 1966. Gould died in 1996 at age 82. (Courtesy the Lucy Ballenas Collection.)

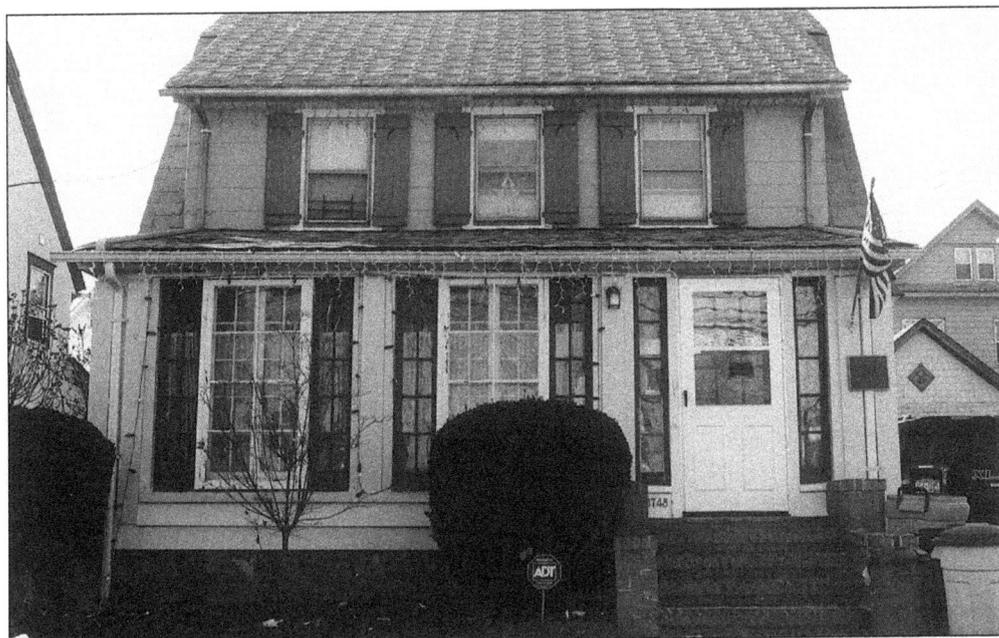

THE MARX BROTHERS HOUSE. The Marx family lived at 89th Avenue and 134th Street in the 1920s. The boys were known for such films as *Coconuts, Horse Feathers, A Night at the Opera,* and *A Day at the Races.* The house bears a plaque donated by the Native New Yorkers' Historical Association. (Photograph by Nancy Cataldi.)

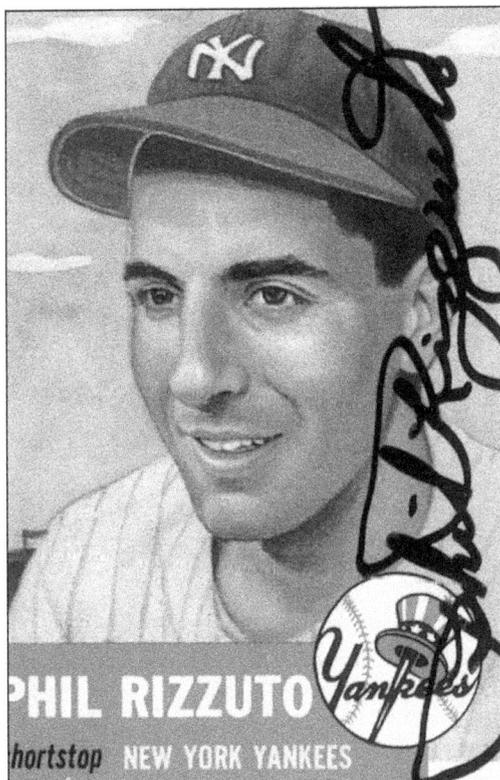

PHIL RIZZUTO. Born in Brooklyn in 1917, Phil Rizzuto graduated in 1936 from Richmond Hill High School. He overcame his diminutive size to anchor the New York Yankees, helping them win seven of nine World Series during his 13 seasons. "The Scooter" was a durable and deft shortstop, skilled bunter, and enthusiastic base runner who compiled a .273 lifetime batting average. A five-time All-Star, Rizzuto was named the American League's most valuable player in 1950. Upon his retirement, he spent 40 years as a popular Yankee broadcaster. His famed remark "Holy Cow" will live on forever. In 1985, his number (10) was retired. He was elected to the Hall of Fame in 1994. Another Yankee broadcaster, Bob Shepard, is also from Richmond Hill. (Courtesy the Lucy Ballenas Collection.)

PHIL RIZZUTO
Shortstop NEW YORK YANKEES

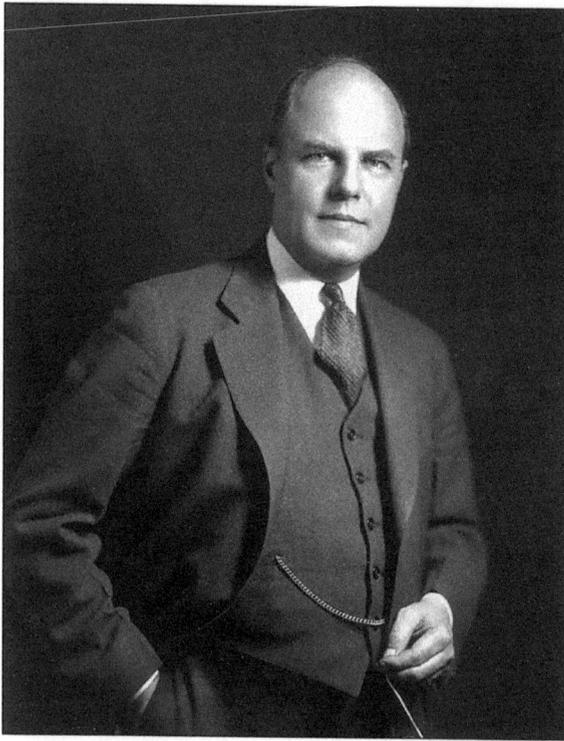

WILLIAM E. HAUGAARD. William E. Haugaard was the nephew of Henry E. and William C. Haugaard, the renowned architects of Richmond Hill. William E. further excelled in the field, serving as New York State commissioner of architecture for 16 years. Among his credits were designing buildings in the Panama Canal Zone, the Theodore Roosevelt Memorial Building (part of the Museum of Natural History), and the Alfred E. Smith building in Albany. Brother John T. was deputy commissioner of the State Division of Housing in New York; there is an annual architectural award given in his honor. (Courtesy Margarita Haugaard and William P. Haugaard.)

THE 1996 RICHMOND HILL QUEENSMARK AWARDS. Richmond Hill made news as the first recipient of the Queens Historical Society's Queensmark Award Program, led by borough historian Stanley Cogan. Twelve structures were chosen, including 10 homes, the Church of the Resurrection, and the Carnegie Library. Interest in preservation fueled by individuals, along with groups such as the Richmond Hill Historical Society and Friends of the Richmond Hill Library, has brought the community together, stronger than ever. (Photograph by Nancy Cataldi.)

Eight

OUR RENAISSANCE

Richmond Hill has reawakened as the garden city it once was. Interest in these old grand Victorian homes is vivid and growing strong. . . . Evident in the many examples of newly restored shingled homes, multicolored paint schemes, and period interiors, the Preservation movement is a contagious appreciation of history.

—Ivan Mrakovcic, architect and vice president
of the Richmond Hill Historical Society

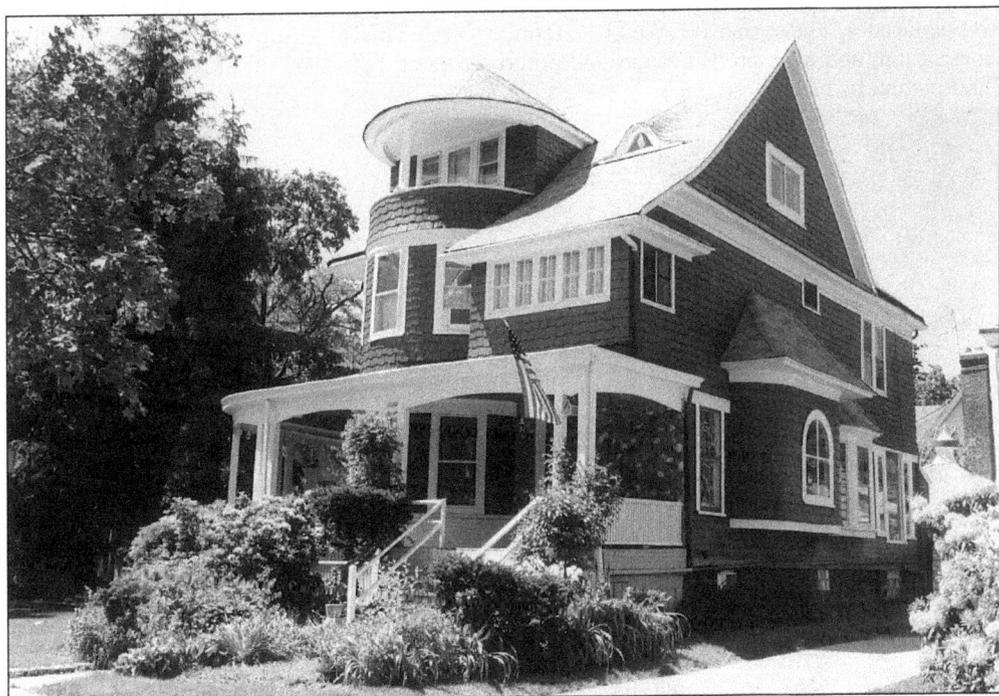

CENTRAL (85TH) AVENUE QUEENSMARK. Fine detailing with a fanciful composition is at play at this corner house. Some of the outstanding features include a sleeping porch with a whimsical single column, a roof eyebrow window, and paired groupings of columns along the wraparound porch. Textured cedar shingle walls are penetrated and adorned by stained-glass windows. (Photograph by Nancy Cataldi.)

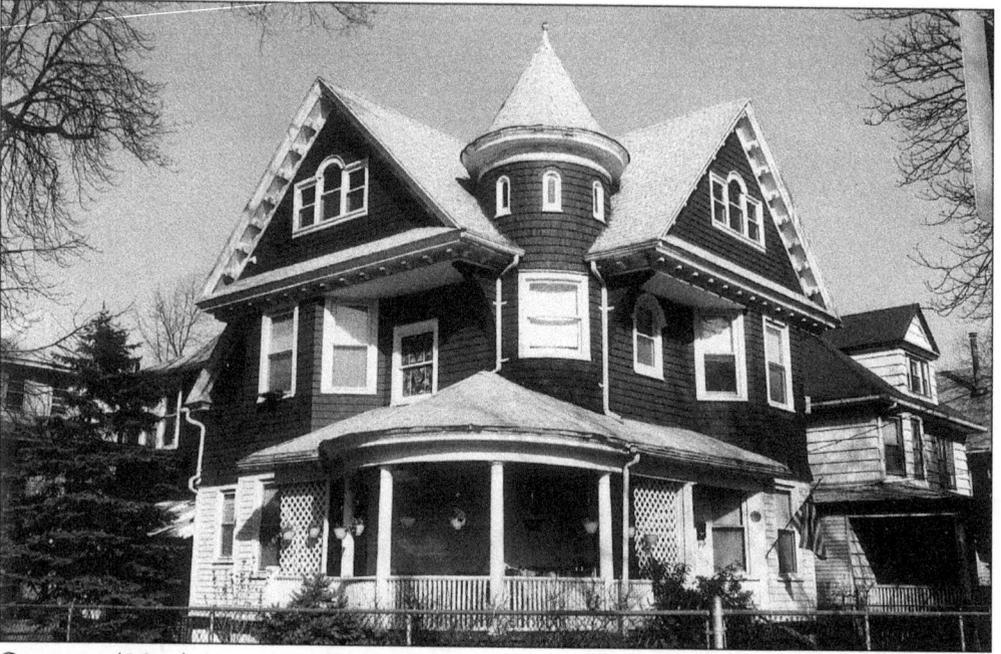

ORCHARD (86TH) AVENUE QUEENSMARK. Displaying a shingle texture, this Queen Anne–style home exemplifies a sense of place by presenting strong overhanging gables to both street and avenue facades. The corner is linked by a refined tower. The gables are detailed with Palladian fenestration, and a generous wraparound porch serves as a glorious base for the composition. (Photograph by Nancy Cataldi.)

WASHINGTON AVENUE (109TH STREET) QUEENSMARK. This is a classical and formal composition set in a garden landscape; the home is credited to Henry E. Haugaard, architect of the most elegant Victorians in Richmond Hill. The dormers, with their temple-like pediments, are arranged to give the residence a stately symmetry and are all supported by fluted corner pilasters and verandah colonnade. Henry Haugaard's brother John T. and his wife, Margaret C., lived here when it was first built in 1905. (Photograph by Nancy Cataldi.)

122

WALNUT (116TH) STREET QUEENSMARK. This unpretentious cottage and barn offer a glimpse of the lives of local craftsmen at the beginning of the 20th century. This was originally the home of Ole Levardson, a Norwegian builder who worked for the Haugaards. Ole's sister Bertha was Ella Flander's companion, and it was in this "Yellow Barn House" that Ella's diaries were found, supplying much information about early life in the village. The house, with its subtly painted fish-scaled shingles, has been meticulously restored. (Photograph by Nancy Cataldi.)

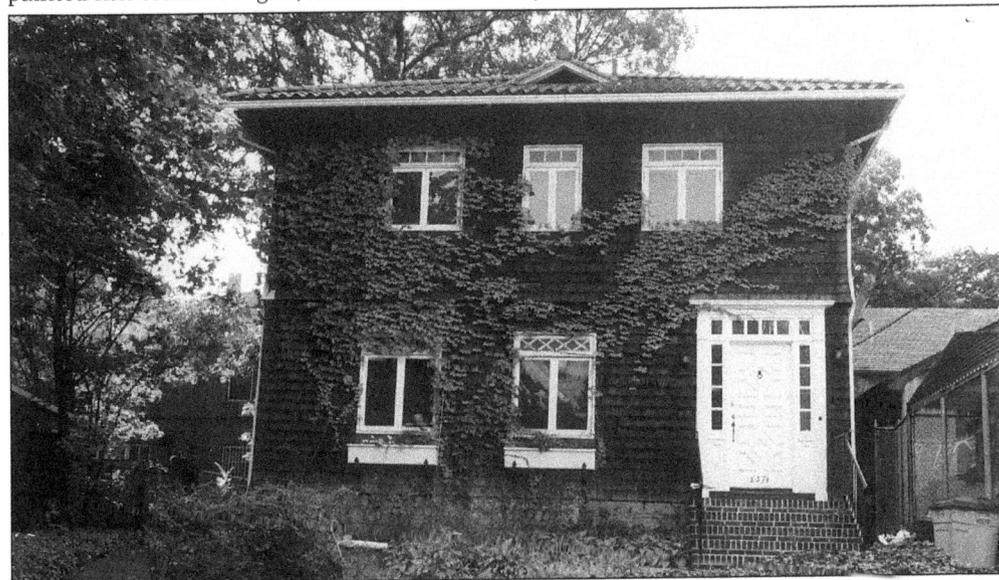

RICHMOND HILL DRIVE (117TH STREET) QUEENSMARK. A blend of Spanish Colonial and English Cottage styles, this cedar-shingled home was capped in a clay-tile roof and sat on a through lot. Although the gazebo was best seen from the west, it offered distinct facades from any vantage point. Sadly, it was demolished in 2001 to make way for large apartment buildings on its once spacious lot. John Forge, a Scottish builder who was brought to America to build the Battery Tunnel and who was a neighbor of the Man family, lived in this house. (Photograph by Nancy Cataldi.)

DIVISION (84TH) AVENUE QUEENSMARK. Majestically capped with a tower and set atop Long Island's terminal moraine (the crest of land left by the receding glaciers), this gracefully detailed home overlooks Jamaica Bay from a distance. The porte-cochere, a remnant of horse-and-buggy transportation, allowed the traveler to disembark from the carriage directly onto the covered porch. (Photograph by Nancy Cataldi.)

CHERRY (111TH) STREET QUEENSMARK. This Queen Anne Victorian, with its authentic color scheme and stately dormers, exemplifies the rich shingle textures often employed at the second floor and above. The playful array of shingles creates illusions of depth, and the classic architectural elements, including the sensitively enclosed porch, focus attention to the entrance. (Photograph by Nancy Cataldi.)

WASHINGTON AVENUE (109TH STREET) QUEENSMARK. Considered the signature of Henry E. Haugaard's architectural style, this home is identical to the Queensmark on 109th Street. It is distinguished not only by its lofty garden setting but also because it was brought back from the brink of oblivion and now serves as a true inspiration. (Photograph by Nancy Cataldi.)

CHURCH (118TH) STREET QUEENSMARK. Once the home of Brendan Byrne, noteworthy pillar of the community, this stately home welcomed travelers with its unique circular entry. Graced with a Palladian window, it had been meticulously restored and exhibited a wealth of detail. It was razed in 2002. (Photograph by Nancy Cataldi.)

MAPLE (113TH) STREET QUEENSMARK. This Queen Anne Victorian, with its particularly Japanese influence, is further proof that early-20th-century architects were employing eclectic motifs and experimenting with style. Notable details in this case include curved roof planes, open eaves with their upturned rafters, and the decorative dropped lintel along the porch perimeter. (Photograph by Nancy Cataldi.)

THE RICHMOND HILL HISTORICAL SOCIETY. Formed in 1997, the group has created a new community pride, offering walking tours, restoration fairs, and lectures. It maintains an archive of photographs, historical information, and artifacts. The society works hard to create a Historic District and will continue to educate people about the treasures of the past. Shown from left to right are the following: (front row) Ellen Leone, Rita Werner, Nancy Cataldi, and Rita Gambardella; (back row) Diane Freel, Melissa Degenheart, Ivan Mrakovcic, Laura Mrakovcic, Ron Layer, Regina Santoro, and Julius Gambardella. Missing from the photograph is Eleanor Doyle. (Photograph by Stefano Palo.)

126

RKO KEITH'S. Long gone are the days of the local movie theater, and this now serves as a bingo hall and Sunday flea market. The building has been covered in rusting aluminum siding since the early 1960s. In this view, a movie production crew removes the siding, revealing the facade underneath aged and in need of care. This building, along with many other Richmond Hill locations, has been used in the movies *Goodfellas, In and Out, Big Night* and the television show *Third Watch*. (Photograph by Nancy Cataldi.)

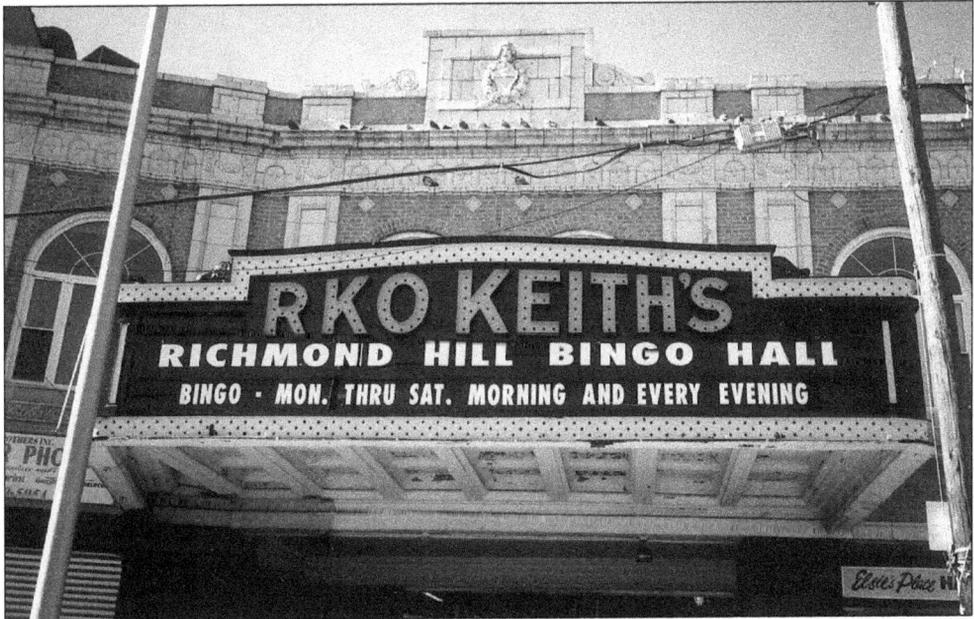

KEITH'S RESTORED. Theater owner Bob Wooldridge had the keen sense to restore the marquee, which was fortunately preserved by the siding that was removed. Bright, shiny, and colorful, the Keith's facade now welcomes visitors into the downtown triangle area. (Photograph by Nancy Cataldi.)

CHESTNUT (112TH) STREET
RESTORATION. An engaged tower effect
and a variety of porches distinguish this
restored Victorian as a prime example of
the beauty it once was. Missing columns
were replaced and jalousie windows
covering all three porches were removed. A
stately grace was reestablished with a palate
of blue and white colors. (Photograph by
Nancy Cataldi.)

WELLING (110TH) STREET RESTORATION. A hexagonal tower and asymmetrical gable
composition characterize this recently restored home as a Queen Anne in the free-classic
style. The recent removal of flat asbestos siding allows for a pristine vision; the original details,
staggered shingles, and clapboard siding all wear a new four-color paint scheme. (Photograph
by Nancy Cataldi.)

128

www.ingramcontent.com/pod-product-compliance
Lightning Source LLC
Chambersburg PA
CBHW050545110426
42813CB00008B/2258